FIGURE DRAWING
A Complete Guide

RICHARD G. HATTON

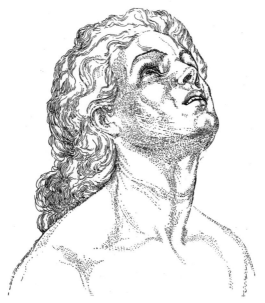

DOVER PUBLICATIONS, INC.
Mineola, New York

Bibliographical Note

This Dover edition, first published in 2007, is an unabridged republication of *Figure Drawing* by Richard G. Hatton, originally published by Chapman and Hall, Ltd., London, in 1907.

Library of Congress Cataloging-in-Publication Data

Hatton, Richard G. (Richard George), 1864–1926.
Figure drawing: a complete guide / Richard G. Hatton.
 p. cm.
Originally published: London: Chapman and Hall, 1907.
Includes index.
ISBN-13: 978-0-486-46038-3 (pbk.)
ISBN-10: 0-486-46038-X (pbk.)
 1. Human figure in art. I. Title.

NC765.H2 2007
743.4—dc22

2007008314

Manufactured in the United States of America
Dover Publications, Inc., 31 East 2nd Street, Mineola, N.Y. 11501

PREFACE

THE artist studies anatomy in order that he may the better understand what the form of the figure is. Not infrequently he finds, however, that his anatomy has not helped him very much. He finds that it asserts itself in a manner which does not improve his work. He feels overborne by the mass of " origins " and " insertions," and endeavours to learn by heart lists of muscles and bones, and fears the disgrace of not knowing, like a school-boy, all the facts exhibited in the book he happens to be studying. If he grows interested he finds, after a while, that he has been occupying himself with a great many things which, in a sense, do not matter at all, and probably begins to decry anatomical study as so much wasted labour.

The reason for such a verdict is that the study, instead of being directed to the correction and development of the ideas already present in the mind concerning the form of the figure, is dissipated among a multitude of accurate little statements. The very accuracy of the statements tends to rob them of their utility to the artist. Often a student will labour to remember the location (and even the accurate anatomical description of the location) of the insertions of a muscle, and will all the time omit to notice the general character of the muscle, and its form. He, too, soon gets to deceive himself with the idea that a knowledge of names and of insertions amounts to the knowledge of anatomy.

Artists will always owe much to such surgeons as the late John Marshall, whose works on *Anatomy for Artists* and *A Rule of Proportion for the Human Figure* have

steadied and fixed the inquiry into the structure of the
human body. One would certainly not displace the sound
thoroughness of Marshall for the less conclusive and less
certain work of his predecessors. But there can be little
doubt that the student needs something different at a
certain stage of his career. He wants to be helped with
his form and his construction, and to help him effectually
the subject must be approached from a draughtsman's
standpoint.

It is with the hope of fulfilling such a purpose that the
present work is issued.

Glancing through the book, and looking down the index,
one may be inclined to doubt that the method followed is
really different from that adopted in the usual books on
artistic anatomy. This doubt will arise from the frequent
use of anatomical terms, which, however, is unavoidable.
Moreover, a number of anatomical facts are here given not
so much because they are necessary, as because the reader
is likely to want to have them accessible.

The system upon which the book is based is this. It is
assumed that in the reader's mind each portion of the body
has a certain general form—the head being a ball, and so
on—and that this general form suffices for a crude repre-
sentation of the figure. Indeed, given good proportion and
posing, a recognisable and expressive figure can be made
from this scanty material. The task before us is to correct
these crude ideas, to modify the rude forms latent in the
mind into accurate forms. And this accuracy we seek not
from any fear of our work being unanatomical or incorrect,
but because the original crude figures are not expressive
enough. With truer form we hope to gain more powerful
expression.

No man can draw the figure who cannot draw the
skeleton, and build up from it, but a person must labour
first to correct his defective notions of form, so that he may
know what his building is to result in.

Consequently we cannot begin figure drawing by learning

anatomy, we must first be able to draw, and pose, figures—however crudely—in definite and lively action. A struggle through the delineation of the ten exploits of the renowned ten little nigger boys would, indeed, be as good a " start " as a young draughtsman with anatomical desires could make. The question of the proportions of the figure will always excite much interest in the artist's mind. Ultimately the artist will, in estimating the correctness of proportions, rely upon his eye, which he, not unwisely, trusts before all the science in the world. Whatever is said about proportions in this book is directed to the facility of drawing, and does not pretend to be the result of scientific investigation. The student who grows anxious about proportions should consult Marshall, and Schadow, and should read the articles by Dr. D. A. Sargent in *Scribner's Magazine* for 1887 and 1889.

> " Myself when young did eagerly frequent
> Doctor and Saint, and heard great argument
> About it and about : but evermore
> Came out by the same door where in I went."

The only way to master proportion is to get thoroughly acquainted with the aspect of the figure, and to help one in that direction I can think of nothing better than a constant study of Eadweard Muybridge's *Human Figure in Motion*.* The illustrations are far more useful than the usual photographs of the nude, and much more graceful.

R. G. H.

* Republished by Dover Publications, Inc.; 0-486-20204-6.
Visit **www.doverpublications.com** for availability and price.

CONTENTS

METHOD AND PROPORTION

PAR. PAGE

1. The Study of Form 1
2. Drawing in Line 3
3. Drawing by Planes 8
4. Drawing by Contour 9
5. Drawing in Thick Lines 12
6. Drawing based upon Rounded Forms 16
7. Drawing with Colour 18
8. Some Hints on Drawing the Figure from the Model 21
9. The Proportions of the Figure 27

THE HEAD AND NECK

10. The First Lines of the Front View 35
11. The Head in Full View ; its Chief Lines 39
12. The Head in Full View ; Further Consideration of the General
 Form 44
13. The Head in Profile 47
14. The Head in Three-quarter View 53
15. The Proportions of the Head 60
16. The Proportions of the Face 62
17. The Form of the Cranium 65
18. The Bony Structure of the Face 67
19. The Zygomatic Arch 70
20. The Influence of the Bones upon the Form of the Head ... 73
21. The Muscles of the Face 78
22. The Eye and its Neighbourhood 85
23. The Nose 96
24. The Mouth and Chin 101
25. The Ear 105
26. The Wrinkles of the Face 109
27. Facial Expression 112
28. The Bones of the Neck 123
29. The Sterno-cleido-mastoideus 126

PAR.		PAGE
30.	The Throat	129
31.	Some Subordinate Muscles of the Neck	131
32.	The Trapezius Muscle	133
33.	Proportions of the Neck and Shoulders to the Head	135
34.	The Form of the Neck	136
35.	The Head and Neck of a Child	144

THE TRUNK

36.	Chief Characteristics	146
37.	The Bony Mass of the Chest—the Thorax	151
38.	The Pectoral Muscles	154
39.	The Chest	155
40.	The Breast	159
41.	The Pose based upon the Pelvis	166
42.	The Pelvis	168
43.	The External Oblique and Rectus Abdominis Muscles	171
44.	The Abdomen	174
45.	The Abdomen in Woman	176
46.	The Whole Trunk in Woman. Front View	184
47.	The Whole Trunk in Man. Front View	189
48.	The Vertebral Column	191
49.	The Range of Movement in the Vertebral Column	193
50.	The Erector Spinæ and Sacro-lumbalis Muscles, and their Effect on the Sacrum	195
51.	The Latissimus Dorsi Muscle	196
52.	The Shoulder-blade and Shoulder	199
53.	Some General Remarks upon the Back	205
54.	The Proportions of the Trunk	213

THE UPPER LIMB

55.	The First Lines in a Drawing of the Arm	215
56.	The Bones of the Upper Limb	216
57.	The Triceps Muscle	220
58.	The Brachialis Anticus, Coraco-brachialis, and Biceps Cubiti Muscles	224
59.	The Order of Arrangement of the Muscles about the Arm-pit ...	227
60.	The Muscles of the Fore-arm	229
61.	General Characteristics of the Arm	233
62.	Some further Instances of Form in the Arm	241
63.	Movements of the Wrist and Hand	245
64.	Details of the Form of the Wrist	248
65.	Tendons at the Wrist	252
66.	The Hand	254
67.	The Form of the Fingers	257
68.	The Thumb	263
69.	The Proportions of the Upper Limb	265

THE LOWER LIMB

PAR.		PAGE
70.	The Bones of the Hip and Lower Limb	268
71.	The Muscles of the Lower Limb	273
72.	Remarks upon the Muscles of the Lower Limb	276
73.	The Hip ...	282
74.	The Thigh	287
75.	The Knee	293
76.	Drawing the Leg ...	296
77.	The Ankle and Foot	301
78.	General Remarks upon the Lower Limb	310
79.	The Effect of Gravitation on the Flesh	320
80.	Obliquity of Certain Details of Form ...	324
81.	Pose and Gesture ...	325
82.	The Gracefulness of Woman	329
83.	The Hair	334

DRAPERY

84.	Points and Surfaces of Support	336
85.	The Summits or Cords of the Drapery	339
86.	Various Kinds of Drapery ...	341

FIGURE DRAWING

METHOD AND PROPORTION

1. The Study of Form.

JEAN FRANÇOIS MILLET said, when asked if an artist should study anatomy, that all knowledge is useful. The questioner had in mind, no doubt, the very frequently expressed opinion that anatomy, and all such-like knowledge, is apt to clog the wheels of the artist's progress. The fear is that the unsophisticated freedom, the "thoughtlessness" of nature will be smothered by palpable study—by book-learning especially. And there are, consequently, many of the artistic fraternity who eschew all such aids, and who point to the long roll of illiterates whose work is immortal. There can be little doubt that this mistrust of knowledge is due to the excess of science in these studies. Some degree of excess there must always be, because all possible demands have to be met, while the artist in his own work can manage to evade what he cannot overcome. Nevertheless, there is often so much science that its application becomes very difficult. The reply of Millet would be truer if it ran—all knowledge is useful if it is usable. What every artist wants is usable knowledge, and of that he will never have any doubts.

Our task in the present case is to find out usable knowledge about the figure, so that when we come to draw it we may be the less likely to fall into error.

Now the form of the figure is revealed by its anatomy, but in order that the facts obtained may be of service to the artist they must be selected from his point of view, and must arise out of his manner of working. In preparing the following pages I have kept this fact constantly before me, and have found it necessary sometimes to suppress information which clearly was usurping a position that belonged to more practical knowledge. For I find, and do not doubt that the experience of all draughtsmen is the same, that one works sometimes "anatomically," sometimes "artistically." When one works anatomically one feels that too much insistence is being placed upon facts which do not apply, and the drawing plainly is getting no nearer being a lively imitation of nature, but more and more an exercise of another kind.

We have, consequently, to base our investigations upon the methods employed by the artist. We have to consider what he sets out to do, and what assistance he wants from us in the execution of his task.

We find the artist's task is twofold. He has to first fix his conception, or idea, of his subject ; and he has, in the second place, to technically express his conception.

In Volume II, which is devoted to Figure Composition, the conception is dealt with fully. It is there shown that the conception may be comparatively meagre, or rich, but it is clear that when dealing with the technical part we must assume that the conception is as full and complete as possible. We will not spend words here, then, in pointing out that a shaded drawing indicates an intention to express a fuller conception than a drawing in line would. Obvi-

ously, if one goes beyond line, and uses shading it is because one has more to say—more form, or more delicate form, to exhibit.

Yet although the conception may be rich, and demand all the resource of the painter's craft, the means employed for the representation do not at once leap to the highest level, but proceed from simple to difficult—following that best of laws, that the simple means should be exhausted before the more complex are called forth. We commence our study, therefore, with an examination of the means of expression.

2. Drawing in Line.

IT seems very formal, very didactic, to say that the representation of solid forms in line is based upon the drawing of the cube and the cylinder, and the statement is certainly an exaggeration, but as a practical rule the assertion is true enough. The principle involved is seen in Fig. 1, and briefly is—that a cylinder seen in a fore-shortened position is expressed by a curved line, an oval, at either end, and that a cubic form is represented by two lines at an angle, also at either end of it. It will be clear to any one without further explanation that modifications in the form will be followed by modifications in the de-

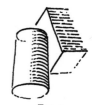

FIG. 1.

gree, and kind, of curvature, or angle. However varied the form may be, its expression by line will depend upon the simple law thus indicated. From this law of foreshortening we deduce this axiom—that where two similar lines, as A and B in Fig. 2, occur one beyond the other, the inference is that the smaller (according to perspective) is the more

remote, and that the surface from A to B recedes. Such a shape as C, if symmetrical side for side, may be a plane receding upwards, or may be a shape seen in its true form,

FIG. 2.

without foreshortening. An addition at the side, as at D, suggests that the form is receding, but only if the bottom line of the addition, d, slopes down. Of course where such

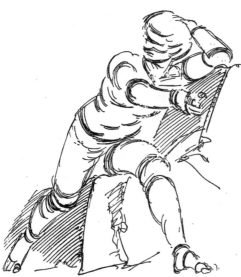

FIG. 3.—The Principle of the Cylinder applied.

is the case the form EF is truer, because the side FF would become shorter than EE. It would often be impossible to tell which end was the nearer without an edge, or side, as shown at H. This edge (H) at once indicates that the smaller end is really the nearer, and that we are looking *up* at the object. This edge belongs to the cube form—it is the return, or third side, and indicates the nearer end.

The lines by which the shading is produced are as

important as the end-lines themselves; indeed, in line-drawing the shading-lines are often the chief exponents of the form.

The application of the principle of the cylinder is seen in Fig. 3. Each part of the body recedes in a certain direction. The near and far ends of each part come, therefore, under the principle, that is, they curve backward, or away from the spectator. The drawing here given is

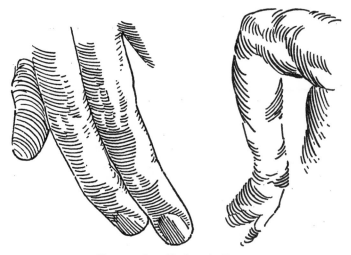

FIGS. 4 and 5.—Single-stroke Shading.

marred by being made to show the application of the rule. Its curves are too regularly circular, and the near and far ends of each part are too equal.

The shading which is done on the principle of the cylinder is of two kinds. It is either made up of strokes side by side, or of strokes crossing. How is the direction of the lines governed? It is difficult and dangerous to give a rule, but this much may be said—that in the single-stroke work each successive stroke seems to be the

edge of a new section parallel to the last, and all at right-angles to the direction of the limb. This is illustrated in Fig. 4, where the curvature of the lines varies according to the form to be expressed. It will readily be believed that this method is a dangerous one—a slight misdirection of line, or of curvature, produces false form. But dangers such as these carry with them compensating qualities—directness, and the evidence of good workmanship when things go well. What has one to guard against? I fancy Albert Dürer would have said—making the lines too straight.

If the reader will examine carefully the lines on the engraving by Dürer reproduced (Fig. 6), more particularly in the legs, he will see that the lines are well curved. This curliness of the lines is characteristic of Dürer's work, and indeed of the work of his time, and its effect is to over-model, rather than under-model, the form. Such curly shading is seen over and over again in that work, so that one is tempted to say that they preferred not to make the curve the true curve as produced by the section.

The shading by curved lines, of which we have been treating, is not the only kind. There is the cross-hatched variety. I suppose nothing could seem more merely pedantic, more superfluous than to give any instructions as to the direction the curves should take. For it seems so evident that the directions are chosen by each individual artist differently, as suits his style, his hand, and his knowledge. We may say this, however, that cross-hatching owes its origin to the fact that sometimes we want an edge of shade against light which is sharp in character, some-times an edge which is soft. Now the little strokes, more or less parallel, terminate against the light with a comb-like edge. This is the soft edge. Sometimes it is not soft

enough, and we have to continue our strokes in shorter strokes, or dots, so that the tone can be carried less harshly

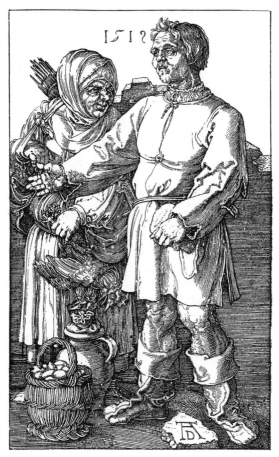

FIG. 6.—Peasants. (A Copper-plate Engraving by Albert Dürer.)

into the light. This method of softening was in vogue among the old woodcut designers, Albert Dürer and Holbein among them. But if we want a sharper, more sudden

change from shade to light we can use the strokes so that

the side of the first stroke borders the shading. In this way, especially when we allow ourselves lines in more than one direction, we are able to get a great variety of gradation. Fig. 7 merely gives one set of lines; it is evident that another set crossing them would assist much in the expression of the form. For all that, artists will, I think, generally prefer the simpler method.

FIG. 7.—Shading by Curved Lines of a more complex character.

3. Drawing by Planes.

THE most unkind comment we can make upon a drawing of the figure is that it is "sausagey." We like well-

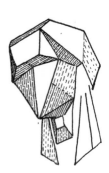

rounded limbs, but we object to any suggestion of their being stuffed, or inflated. Obviously this over-roundness can be corrected by flattening the surface here and there. To flatten the surface is to create planes, and these planes will meet in ridges.

Of course the planes are nothing like so sharp as those shown in Fig. 8, which is drawn to show that the symmetry of the surfaces must be preserved, and that

FIG. 8.—The Head in Planes.

this is done by assuming that they meet in the formal manner there illustrated.

In Fig. 9 is an oblong with a long line across it. This long line, even without any shading, suggests

FIG. 9.—Suggestions of Planes.

that two surfaces are sloping away from it. In the same diagram is shown the same line converted into shading of a simple character.

In most cases there is but one main ridge down a limb, or down the trunk. That is as much as to say that, as a rule, the surface falls into two main planes. This is further illustrated in Fig. 10, where one plane is shown in light, the other in shade.

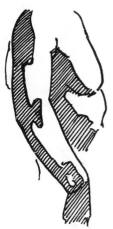

FIG. 10.—The Ridge or Eminence between the Planes.

4. Drawing by Contour.

THE oldest method of drawing is drawing by contour, or outline. In Fig. 11 we have an illustration of a Greek vase-painting, or rather drawing, for there is no " painting " in these beautiful pieces of work.

In these Greek vase-paintings the drawing is of the highest excellence, and should receive more attention than it does. The form is extremely well and sensitively rendered, and when we consider that with only an outline to work with there is much truth, bone, muscle, tendon, fleshiness, we may well doubt whether, at any subsequent

period of artistic history, there has been better drawing.
Now this is all contour work. Fig. 12 is from a lekythos

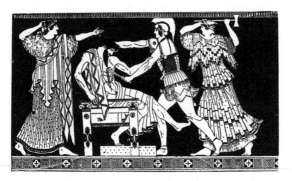

FIG. 11.—The Death of Aigisthos. (From a Greek Vase.)

in the British Museum. With all the imperfections due

FIG. 12.—From a Greek Lekythos in the British
Museum, circa 420 B.C.

to the reproduction it
is a very beautiful
drawing. The anatom-
ical form is perfect, and
even with the small
part represented the
action is easy and har-
monious, while there is
a fleshiness and elas-
ticity which is the de-
spair of the draughts-
man of to-day. There
is, it must be feared, no
technical secret which
we can learn for such
work as this. It seems
to be merely the record
of great delight in the

human form, in its mechanism, and its harmonious properties. Like Nature herself, the draughtsmanship seems to care nothing for the show of cleverness, or of knowledge, but to be solely the reflection of unalloyed delight in the subject portrayed. No draughtsman will, however, doubt that the Greek artist possessed great knowledge, and that because he possessed great knowledge he worked with the ease his drawings exhibit. No one will pretend that this drawing is drawn by a man who cares nothing for the form, and who tries to forget any fact about it he may happen to observe, or that he made this drawing from a model, posed for the purpose, and for evermore forgotten. There was then, as there always must be, a body of knowledge diffused through the artistic fraternity, kept fresh and vital by a zeal for their craft and an enthusiasm for nature.

In all periods we find this contour-drawing, in all periods knowledge. Sometimes the knowledge is not first-hand. Indeed, if we could look into those old Greek workshops we should probably find the master handing down to his apprentice the knowledge he himself similarly acquired. The early Greek vase-painting was surely traditional, else how comes it that the same characteristics so constantly recur? The Greek artists of the best period inherited a body of tradition which they sifted and developed as served their purpose. When, however, he who inherits does not freshen his knowledge at the fountain of nature, it will flag, grow awry, become conventional, as we say. Even then it may be a most powerful agent of expression, for we must not lose sight of the great fact that drawing is, after all, only a means to an end. It is not art, though the great means by which art achieves its labours. In Fig. 13, for instance, we have an example of

thirteenth-century drawing. It represents nature rather than imitates it. It is conventional ; but note this (which is true of all con-

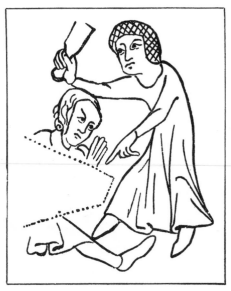

ventional drawing), it is true in the great facts, if false in the little ones. The hands particularly are good. It is possible, therefore, for a drawing to be much better in its detail, and yet not only worse on the whole, but less useful — the production of a more learned but a less sane personage

FIG. 13.—Glass-painting of the thirteenth century.

than he who drew these crude Gothic figures. And such a failure all the more enforces the lesson that the contourist must be careful, above all, of his main form, his big planes.

5. Drawing in Thick Lines.

SOMETIMES our work demands the employment of a thick line, and we can have no better exercise for our power of managing outline. We have, in the first place, to determine whether we are allowed to make our lines thick and thin as we like, or whether we must keep to one regular thickness. Even in the illustrations (woodcuts) to the ' Dream of Poliphilus,' in which the line is practically of one

thickness throughout, there continually occur slender lines,

FIG. 14.—A Pencil Drawing.

and all the lines are more or less jagged, as may be expected in woodcuts. As a rule, in all such work the line

round the figure is very bold. There is a reason for this, and the reason is that the thick line concentrates the broad

FIG. 15.—Strong Lines and simple Shading.

light of the figure —hems it in. A form surrounded by a thick line is more readily regarded as modelled than one surrounded by a thin line. This is because the thick lines, being very evident, are easily associated with one another—will associate themselves, in fact— and the form between seems to be bumped up or modelled. It is of course only when the outline is at all curved that this suggestion of modelling is produced. The indentations in the form no doubt suggest channels, or depressions, in the surface, but it would be of little service to us to enter upon a detailed inquiry into such a matter.

A comparison of the three illustrations, Figs. 14, 15, and
16, will serve to
show what ap
proximation to
the more detailed
rendering is ob-
tainable by the
use of thick lines.
Sometimes one
finds the thick line
is wholly outside
the form, sur-
rounding it. Rare-
ly, if ever, is the
thick line within
the form, except
on the shadow-
side. In Fig. 17
the outline down
the shadow-side
(the left) is within
the form, while on
the light-side it
is on the back-
ground, and does
not invade the
form. This seems
indeed to be the
only serviceable
rule one can make

FIG. 16.—Use of Thick Lines.

—perhaps no rule at all should be made.

6. Drawing based upon Rounded Forms.

IF you draw by outline you must trust almost to luck for your modelling. If you begin to model you may either

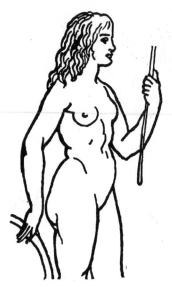

regard the form as built up mainly of flat surfaces (planes), or you may regard it as composed of rounded forms one against the other. Both of these predilections are, in a measure, wrong, as well as right ; the planes make too many sharp edges, the rounded masses make none at all. One would say, side with truth, not with imaginary standards, especially as they seem to be proving false. But the draughtsman must begin somewhere. Moreover, while he is seeking truth he must needs make use of whatever will help him to gain it. Our

FIG. 17.—The Outline on the Form on the Shadow-side, and on the Background on the Light-side.

progress in drawing, at all events, is through error to truth —and to us who have not yet done our task, our error is only error because it is not all the truth, not because it is no part of truth at all.

By a rounded form is here meant a form which mounts up, dome-wise, as illustrated in Fig. 19. Such eminences are of any kind, but the treatment is the same. It will be seen that by means of the curved lines any section can be suggested. Outline work, such as that illustrated in Fig.

FIG. 18.—Andrea Mantegna. (From the Title-page to 'The Triumphal Procession of Julius Cæsar.' Drawn by Bernardo Malpizzi, engraved by Andrea Andreani. A.D. 1599.)

18, depends largely on the principle shown in Fig. 19. Instead of different series of curved lines round about each

mound of the form there is only the outermost. All the little curved lines upon the face are the borders, or parts of the borders, of mounds, which would, in

FIG. 19.

ordinary cases, be shaded more completely by parallel curves. In order, therefore, to correctly draw such an out-line as is required in this fine portrait of Mantegna, one has to be capable of that roundabout kind of shading which Fig. 19 illustrates.

In the Mantegna portrait the shading is achieved by a different process. Two extra blocks are used, and two additional tints of colour obtained. On these colour-blocks are engraved lines which print white, and serve as high lights. It will be seen that these white lines are curved, just in the same way as the shading-lines of Fig. 19. The colour of the tones in the original of the portrait is a fine greenish-grey.

7. Drawing with Colour.

IF one compares the drawings, in wash, of Rembrandt with those of the Italian masters one sees less insistence on beauty, and more attack by planes. He boldly drew in his subject with a few fiery strokes, and enforced them with swift and sure washes of colour. Bent as he was on realizing nature as he saw it, and caring as much for its ruggedness as for its refinements, accepting nature as it came to him, he the more readily seized the relation of

plane to plane, because it gave character, foreshortening, and light and shade.

It will be seen from Figs. 20 and 21 that wash is a method which gives a class of form not readily obtained by the less rugged stroke of the pen or pencil.

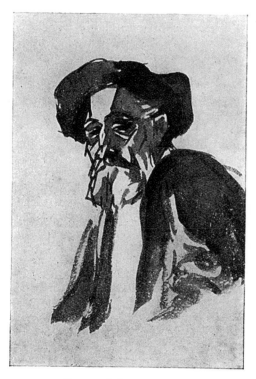

FIG. 20.—A Drawing in Wash.

The introduction of tone suggests the ever-recurring problem of its limitations, or, rather, of the limitations it imposes on the figure-draughtsman. The Impressionist principle is not merely perception of aspect, but expression by aspect, as distinguished from expression by known fact.

Thus it is a known fact that the fingers join on to the hand, the hand on to the wrist, the wrist to the arm, and so on. In an Italian work we should probably see this connection palpably expressed by the contour flowing evenly through all the parts, and the brush forms following the lines of construction. But in actual aspect there is no such connection. Each speck of tone and colour is on its own

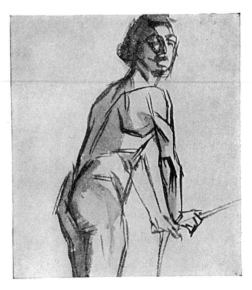

FIG. 21.—A Drawing with the Brush.

account and independent of the rest except in that general effect, of which it is, as it were, unconscious.

It is obvious that the fall of the light cannot always result in an elucidation of the form. Indeed, the painter has to learn quite as much how to lose as to express form, for he has to express something besides. He has to represent the whole effect of his subject, and often the great masses of form demand a treatment which tends to

the obliteration of the minor details. While the painter must attend to these matters, and will not be much of a painter if he does not, yet when he is drawing the figure, and particularly when he is studying it, he must adopt methods which lead to clearness and knowledge, for all study must be directed to tangible results. It is clear, therefore, that he who would master the figure must not adopt vague and obliterative methods when he is studying. The student, consequently, who omits that incessant investigation into form which all the great masters found so necessary, will some day find a lack of strength and a lack of interest in his work, and will find himself driven out of the fold of the figure-draughtsmen.

8. Some Hints on Drawing the Figure from the Model.

THE drawing must be made in as long lines as possible, there must be no patching together of little bits. Indeed drawing must be done very much as writing, except that the whole arm should be moved and not the wrist and fingers only. The letter W is in writing as complicated a letter as we have, and yet he would be a sorry penman who wrote it in little strokes.

The general mass and shape of the figure must first be built up, so that the proportion and pose can be secured and tested. It is a great mistake to expect to begin at the top of the head and gradually work down to the feet, putting in all the details, and with proper proportion and pose. No error is greater than to regard the rough blocking of the figure as a waste of time. It is no doubt very nice to pass all down once, and have it done, and get to something else, but not unfrequently such

a proceeding results in an ill-posed and ill-proportioned figure, which has to come out after all. At the same time, the student must not omit to make many studies in which no blocking is used. For in these the blocking will really be done in the head.

Then in actually drawing the lines, they may be either placed in the order shown in Fig. 22, A, that is, first the two sides of the arm, then those of the fore-arm, and finally of the hand, or they may be placed as in Fig. 22, B, fixing the outstanding points first. Probably it is best to combine

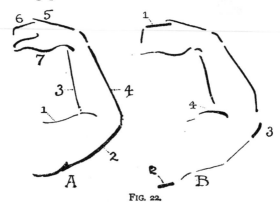

FIG. 22.

the two, first looking over the ground as in B, and then proceeding in the more structural method A. B is the better as regards proportion, A as regards the organic connection of part to part.

The best method of securing proportion is perhaps to find the centres between noticeable points. Thus in Fig. 23 the draughtsman will see that the centre from the top of the head to the end of the foot is about the centre of the abdomen, as is indicated by dots. Then the height of the line of the thigh from the ground, marked by crosses, repeats at the eye. Then the distance from the

seat, marked by a ring, to the elbow, repeats at the thumb. The same system may be followed down to the smallest detail. Thus, find the centre between the arm-pit and the chin, it falls within the arm ; try then to repeat the width of the arm at the arm-pit, up towards the face, the repeat falls at the end of the nose. This system of finding the centres is very valuable in simple drawings, as in the freehand copy at the side of the figure. It is

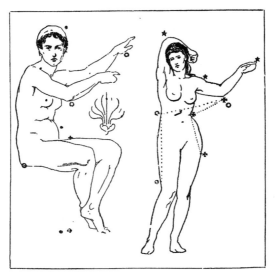

FIG. 23.

also of great use in drawing drapery and hair, cases in which one is sometimes appalled by the mass of detail. Other examples of proportioning by repeating distances are exemplified in the standing figure (Fig. 23).

It must be understood that these measurements must only be used once, as the living figure is always subject to movement.

In guessing the centre between two points the thumb,

finger, or pencil may be held before the model and moved till it is felt to correspond with the true centre, though the

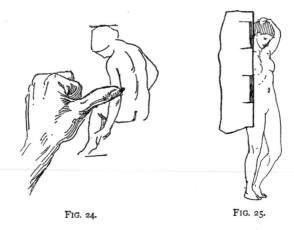

FIG. 24. FIG. 25.

first guess should be made with the eyes only. Every measurement taken without previous guessing puts back the progress of the training of one's eye. Nevertheless when the centre is being found by semi-mechanical means, it is well to have it done accurately, and therefore instead of the clumsy thumb or pencil method, a slip of paper with a few divisions upon it will be found much more reliable and satisfactory (Fig. 25). In taking the size of the head it is customary to take in the hair as well, as it gives a definite limit.

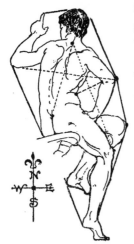

FIG. 26.—Slanting Lines.

Another way of securing proportion is by taking slanting lines connecting prominent points, as is shown in Fig. 26. Somewhat in the same way as in the

geometrical problem, the angles being equal, the figures are equal. In Fig. 27 two methods of starting are shown. In A the head is drawn first and the forms radiate from it. In B the first line drawn was the slanting line through the elbows to the foot, as base; then the two other sides of the triangle giving the knee. Then one elbow is seen to occupy about the centre of the base-line, which thus becomes divided into two halves. In the left of these the head occurs a little to the outside of the centre. These methods of finding centres and employing slanting lines may be used

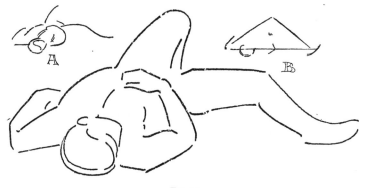

FIG. 27.

in drawing from imagination, for it is of very little use one drawing out of one's head if one does not see the figure lying on the paper almost as if it were verily present there. It only needs marking over.

Fig. 28, which was drawn without any pencilling, was drawn in the way just indicated. Dots were first placed at the right side of the thigh, and the left of the nose of the dolphin, then on the hair above the forehead, and so a triangle encompassing the whole was defined by three dots. Then the side of the abdomen near the umbilicus was seen to be about half-way along the base-line, and

was fixed also by a dot. From it by slanting lines the arm and breast were reached, and so to the head. Of course it is much easier to do a shaded drawing in this way than one of rigid open lines. Thus the subject

FIG. 28.—Part of a Frieze. (By Clodion.)

becomes a pattern of dark patches, and the process is impressionistic.

The draughtsman must always bear in mind the fact that the figure is a solid. As he draws each part he must remember that there is a part hidden from him as well as a part presented to him. He must endeavour to express

the fact that there is air all round the figure, and that it stands free by itself, with a background distant behind it, and space on every side. How to represent this fact is almost beyond telling, but it is probable that whatever the draughtsman holds in his mind will find expression in some mysterious way in his drawing.

It is a fault, and a grave one, to allow oneself to regard a drawing of the figure as merely an assemblage of lines decoratively arranged, and to forget that a figure should never be drawn but to represent some one, some veritable person, which person will certainly be solid, and have air all around him.

9. The Proportions of the Figure.

THE artist rarely or never uses the tabulated proportions, which always appear so useful and prove so inapplicable. The division of the figure into eight heads is well known, and is here illustrated in Fig. 29. The division is really into seven and a half heads, for eight heads give too tall a figure. For the lower limb the rule does not apply except in the case of the knee-joint, which is six and a half heads from the top. The upper measurements, those that fall on the nipples and the umbilicus are useful, but of course a very little movement serves to disturb the distances.

From the investigations published by anatomists the average height of a man is 67 inches, and of a woman $63\frac{1}{2}$ inches. Persons above these heights seem to rank as "heroes," though men of five feet ten and women of five feet seven are not exactly rare.

Since one so constantly sees figures of the normal height (67 inches) in illustration of proportion, I have

here drawn one of 70 inches, and I find that my guess-work figure corresponds fairly accurately with Schadow's 70-inch hero. Head 9″, chin to pit of neck 3½″, calf 5″, knee 4½″, waist 11½″, across external oblique 12½″, across chest 13″, middle of chest to outside of deltoid 9½″.

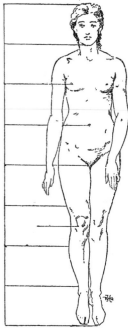

In Fig. 31 the figure of the woman is 67 inches in height.

A rule of proportion to be of value to the draughtsman must follow as nearly as possible the system a draughtsman adopts in securing ordinary proportions. No matter what is being drawn, whether a figure, or a tree, or any other object, he should first fix the greatest dimensions, in all probability the height, or the width. The total size thus determined, the next thing to do will be to find the middle and to fix the nearest definite feature of the object to it. By this means any error in the one half will not affect the other half. Thus with a figure, if the head is drawn first, then the neck, then the body, and so on downward, in all probability the lower part will be too long or too short. This may be partially obviated by finding the middle.

FIG. 29.—The Female Figure divided by eight heads.

Hence as regards the proportions of the figure, the measurement the draughtsman wants is a middle, as exact as possible, dividing the figure into halves. Next, if possible, he will find a division for each half, preferably

at the middle of each, or at the thirds, as being the
next easiest to fix rapidly.

It is always easier to compare measurements approach-
ing equality than those that are palpably unequal. Thus,
if one line is
eight and an-
other nine, it is
easy to see, first
that they are
similar in length,
and then which
is the longer,
and by appar-
ently how much.
But if one line
is three and the
other fourteen
and the arith-
metical calcula-
tion is not em-
ployed, it will be
difficult to estim-
ate whether the
shorter is a quar-
ter or a fifth of
the longer. It
was because of
the greater value

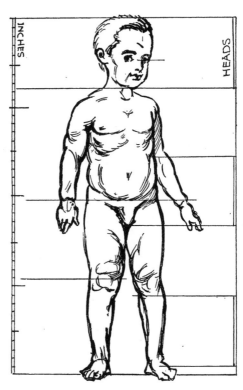

FIG. 30.—The Proportions of a Child.

of halves and quarters, that the artists in the past came to
use eight heads for the figure, and made all the parts settle
on these divisions, or on the halves or quarters of them.

The centre of the standing figure is agreed by the
scientific investigators of the subject to fall at the middle

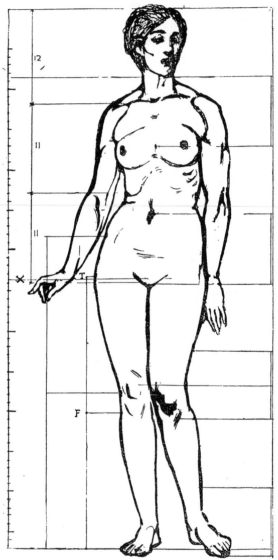

FIG. 31.—Figure of a Woman, with a scale of inches, and divisions
into "heads," etc.

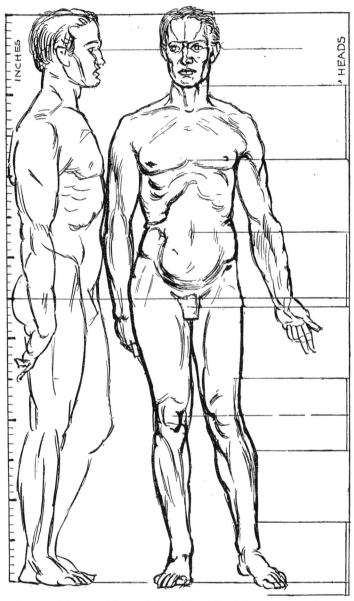

FIG. 32.— Figure of a Man marked with "heads" and other measurements. A scale of inches (70) is given at the side.

of the lowest part of the trunk, below the groin, that is. Taking this level across the hips, it will be seen to arrive at the trochanters of the thigh-bones. In man the bottom of the trochanter, in woman the middle, is on the middle line of the figure. This, then, determines the centre of the figure, and divides it into trunk and leg.

The lower limb is, taking the total length of the thigh-

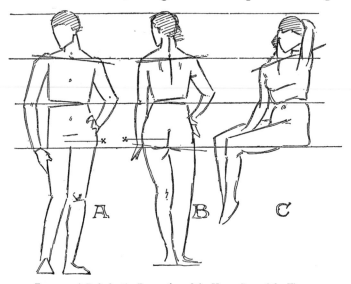

FIG. 33.—A Rule for the Proportion of the Upper Part of the Figure.

bone including the ball by which it articulates in the acetabulum, exactly divided into half at the knee-joint. So that from the centre of the figure, or the trochanter, the head of the fibula or bottom of the patella marks the half-way.

It will be found that the waist and shoulders fall very nearly at the thirds between the top of the head and the end of the whole trunk. The three divisions thus extend below the middle line of the figure. In woman the middle

space is rather smaller than the other two; it must be diminished by lowering the line of the shoulders, and raising the line of the waist. In man the line of the waist should be lowered. These alterations we easily remember because the thorax is smaller in woman, and relatively large in man. The rule applies in the back view as well as in the front view, and also in the seated figure.

In Fig. 34 are given some instances of recurring measurements in the figure. These need no verbal description.

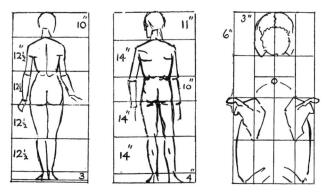

FIG. 34.—Some Instances of Equal Measurements.

After all, the only true guide an artist can have to proportion is to know it when he sees it. He must get to know what is reasonable proportion, and rely upon his eye. The diagrammatic figures given, and necessarily given, in " rules," are all stiffened out in an unnatural manner, and are really of no assistance. To train the eye in proportion one thing alone seems necessary—to always look at the several parts, limbs, of the figure, one after another, and so get acquainted with the appropriate relative sizes. Bad proportion comes from keeping the attention too long exclusively upon a particular detail. The student should

train himself by drawing, detached from one another, several parts of the same body—a thigh, then an ear, then a foot, then the trunk, and so on.

It is in the width of the shoulders and the hips that the figure of a woman differs from that of a man, so far as casual observation is concerned, but an even more important difference is to be found in the length of the limbs. A man's limbs are longer than a woman's, as if they were more developed, for the hands and feet are larger and more serviceable. By observing the position of the wrist in relation to the middle of the height, we see at once the comparative shortness of the arm in woman—a shortness even more pronounced in the child.

The proportion of the different parts are dealt with in their proper places.

THE HEAD AND NECK.

10. The First Lines of the Front View.

WHEN the artist begins to sketch in his figures he represents them by bold sketchy lines, which, though drawn rapidly, are sufficient for the purpose of summarizing the form and fixing the proportions. For a head, seen in front view, the first lines resemble an acorn in its cup. The oval of the acorn represents the face, while the more rounded curve of the cup gives the cranium and hair. It is in the woman's head that the curves are seen in their greatest purity. For the heads of men and children a more angular treatment is advisable. Of course, the form of the head, whether of man, woman, or child, is entirely built upon curves; there are no actual angles, and the different parts glide into one another by the most beautiful fluctuations of the form, without any jerks or sharp corners. Nevertheless, when the various lines are taken, not so much in their delicacy as in their general character and position, their relation is angular rather than flowing. Throughout this study we shall lean toward the angular, or toward the curved, just as serves our purpose. In sketching in the head of a woman a generous curvature helps us; while in sketching the heads of men and of children, a more angular form is of assistance.

35

In Fig. 35, A, a woman's head, we have a broad, full
oval for the face. It is well that this oval should not be
pinched and too pointed, for the outline represents the

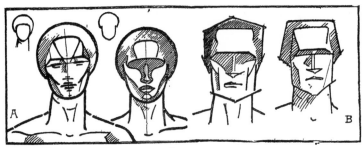

FIG. 35.

jaws rather than the cheeks—and one of the commonest
mistakes is that of narrowing the jaws, which is done in
the hope, no doubt, of securing refinement. Observe .that
the eyes are a little below the middle, and that the hair

FIG. 36.

falls down obliquely, making the
forehead not too wide.

In Fig. 36 several points, which
need to be considered here, are
illustrated. The curve for the head
was first drawn with a rather rough
line—which is more appropriate
when the hair is not confined to
the head—and the oval for the face
was added. This face-line is broad
and ample, and even a little angu-
lar, threatening to give the head
a masculine character, which was
avoided, however, by the hair-line, which is distinctly
feminine. Now, as a rule, when the head is upright, and is
neither looking up nor down, the mouth is in that position

which would be passed by the curve of the head if continued, in a circular manner, across the lower part of the face. In the present case such a continuation of the curve of the head would place the mouth very near the chin. We know, therefore, that the head must be 'slightly raised and fore-shortened. The foreshortening of a head is best attacked in the line of the brows. The eyes are generally a little more than half-way down from top to bottom of the head, the brows a little less. If when he first sketches in the ovals for the head the draughtsman casts a few lines across the brow, he will easily see, if he has any eye for form, whereabouts the brows and the eyes will fall. The more foreshort-

ened the face is, the more curved he should make these lines.

The neck both in Figs. 35 and 36 is represented by lines which diverge somewhat as they descend, and which are slightly convex above and slightly concave below. Usually these lines are unsymmetrical, not because the neck is unsymmetrical, but because the attitude rarely allows the two sides to appear the same. Note that the side upon which the more curved (convex) line is found is that toward which the head is turning. The neck will be seen to be in length about equal to its breadth, in woman; in man it is shorter.

The sloping lines of the shoulders strike the neck some-where about the middle; but so great is the variation caused by the different attitudes, that little guidance can be found in any rule. Just as the lines for the neck suddenly turn outward below, so these lines for the

shoulders as suddenly turn upward as they meet the neck. (Fig. 36.)

In Fig. 37 we have the commencements for the heads of children of four, six, and one years of age. In A the lines are rounded, in B pointed, and this difference is not to characterize the age, but to illustrate various modes of attacking the work. The pointed method of B is the better, though it is well to consider the pointing as a refinement upon the curved form. In all cases the face is short, and consequently broad. The neck also is short, but it must appear narrow as compared with the head, as if it were weak. The face of a child has, moreover, a great

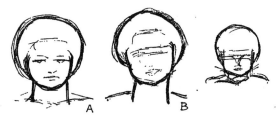

FIG. 37.—Commencements for the Heads of Children.

deal of squareness about it. The puffy cheeks are nearly the same width as the brow above, and the chin is very small, and does not as yet assert itself.

The difference between the heads of a man and a woman is seen when we convert one into the other. Comparisons may be made in Figs. 35 and 40.

To convert the head of a woman into the head of a man we give it a squarer or more box-like character. We keep its lines more vertical. We widen and shorten the neck, and reduce its mobility. We give the jaw more angularity; we make the mouth and the nose wider; but, above all, we expand the forehead, making it taller and more capacious above.

11. The Head in Full View; its Chief Lines.

IF we draw an oval for a head, but do not develop the internal space with lines or shading, the form will be regarded as egg-like in its rotundity. Of all forms, the egg-like and the sausage-like are the least acceptable in the rendering of the human figure, or, indeed, of any organic structure. Growth always seems to manifest itself in the pushing out of extremities and ridges. Consequently the form tends to become angular, and to consist of planes or surfaces of infinite variety, adjusted to one another at all sorts of angles. The form is never, in the human figure, of that hard angularity seen in crystals; it is smoothened, rounded, and the surfaces, far from being flat planes, in addition to being convex or concave, are more or less twisted. There is always a twist —that may be taken as one of the great facts concerning the form of the figure.

Now if it be true that the form is always tending toward a condition of plane against plane, it follows that it is of the very greatest importance to the draughtsman that he should seize these planes at once, for in the ridges which separate one from another lie the chief means of expression. Just as life and motion create form, so the sensitive rendering or revelation of form expresses vitality and movement. Outlines and ridges will therefore be to the artist the first and readiest indications of the form. A line within the outline will suggest that the form changes there; it will form a ridge or eminence between planes which will seem to shelve down to either side.

This method of working by planes is illustrated in

Fig. 38. The lines are drawn with uncompromising
straightness, as it is well to first secure the direction in
which the ridge is lying, because any lingering after
flowing form will consume time, which must not· be spent
at this stage on the less important details of form.
For there can be no doubt that the form in its essence is
seen in the rather rough-hewn condition which straightish

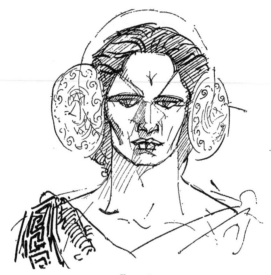

FIG. 38.

lines produce, devoid of a softness which is too often both
meretricious and paltry.

The chief lines of the face are given in Fig. 39. They
are—the brow-line; a line down each cheek pointing to
the outer side of the chin; a line branching off from the
last, but carried to the top of the mouth; and two lines
obliquely across the forehead to near the top of the nose.
Then, besides, there is a triangular shape on either side ·
of the nose, and a somewhat diamond-shaped form (with

a line across it horizontally) for the end and wings of the nose, and there is also a triangle for the chin.

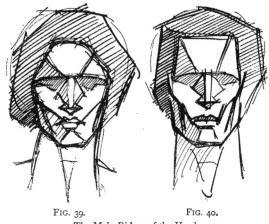

FIG. 39. FIG. 40.
The Main Ridges of the Head.

If we would give the head a masculine character we treat it as in Fig. 40. We broaden the forehead above, and keep the sloping lines throughout the face more vertical,

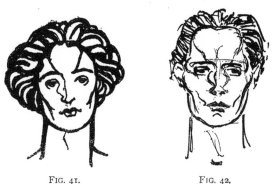

FIG. 41. FIG. 42.
The Ridge-Lines curved.

and do not permit the form to point forward so daintily at nose, mouth, or chin.

As seen in these diagrams the form is not very attractive, chiefly, no doubt, because the rigid angular lines prevent any relaxation of expression. If we curve the lines, as in Fig. 41 or Fig. 42, we obtain at once a nearer approach to a natural effect.

It is by no means claimed that the lines here given as the first are the only set of lines to which that denomination could be given. The first lines sometimes represent the features; indeed, very often the features alone are drawn, the form not being otherwise developed. Of such a method Fig. 43 is an instance.

FIG. 43.—The Features drawn, the Ridge-Lines omitted.

One has to beware, however, in drawing the features unaccompanied by modelling that one does not fall into shallow prettiness.

Prettiness is not compatible with seriousness, beauty is. We have thus some indication of the quality which restrains prettiness and converts it into beauty. If one begins one's head with a serious expression one runs little risk of producing an empty, merely pretty face. It should be noted, however, that the senseless smile is not the only expression which is not serious. A startled, half-crazed look is as far from serious as the definitely frivolous. Indeed, an intelligent smirk is, after all, a serious expression, and is not to be confounded with the vacant smile of the brainless individual. The danger of relying upon the features is due to their being capable of representation in a symbolic manner—if the use of the word "symbolic" may be permitted in this connection Every

child will draw you an eye—of a sort, and in all periods of art-history some kind of conventional representation has been accepted. These symbolic forms have sometimes been based upon form, or form and colour (as in the Greek vase-paintings), or solely on colour (as in Dresden china figures). Wherever the symbol is based upon form it admits of greater and nobler expression, because the actions which we call expressions affect the form rather than the colour, and because the use of colour is frequently accompanied by a carelessness of form.

But where the symbol is limited to colour, as when, in the eye, only the eyelashes and the pupils are shown, and in the mouth only the lips are shown, the expression can hardly be more than trivial. This is, however, saying too much, for form is so readily introduced that even where the basis is colour a sufficient measure of form could be introduced to avoid a senseless expression.

When the face is set out by means of the features the procedure is as follows. The oval of the head being drawn, seven lines are cast across the face. The first line is through the eyes, and is half-way down. Above it is next drawn the brow-line, somewhat arched. Then half-way between brow and chin is cast a line for the end of the nose and below it three lines for the mouth and one for the top of the chin. The middle line for the mouth is about

FIG. 44.—The Seven Lines for the Features.

a third the distance from the end of the nose to the chin.

12. The Head in Full View; Further Consideration of the General Form.

WE have just been considering which should be the first
lines drawn to develop the form of
the face from the
mere oval outline
with which it is
always commenced. We have
seen that form is
better than features, and have
given preference
to such lines as
express the form,
for the features
are sure not to be
omitted. We now
carry our study a
little further, and
shall find ourselves converting
our simple and
broad planes into
others of greater
variety. Fig. 45
gives the head of

FIG. 45.—Head of the Venus of Milo.

the Venus of Milo. Fig. 46 is an analysis of it in planes.
If this diagram be compared with earlier ones, it will be
found that the planes are more numerous and have outlines

of considerable variety. In the forehead there is, as before,
on either side a ridge-line sloping inwards towards the

nose, but there is also a second ridge
somewhat parallel to it coming down
to the point where the eyebrow turns
down. Then at the top of the nose
there is a small receding flame, the
glabella. The lines down the cheek,
one going toward the outside of the
chin, the other to the mouth, are
modified, especially the latter. This
inner line expresses a point of shade
penetrating from the region of the
ear across toward the eye. Just be-
low the patch of shade is a light car-
ried over the cheek-bone. Immedi-

FIG. 46.—A Diagram illus-
trating the Planes into
which the Form of Fig. 45
may be reduced.

ately below this light the shading again invades the cheek,
as if to join the shading which projects from the nose;
but this slight encroachment at once gives way to a broad
light, revealing the fulness of the cheek, or rather that
part of it that is upon the front of the face. Below this
fulness the shading runs in to the mouth, and sharply
recedes again to form a fulness beneath the corner of the
mouth. The end of the nose is also less diagrammatically
expressed than in the earlier illustrations; the wings are
shown with more substance.

In Fig. 47 are given the feature lines and the "oval"
for the same head.

The treatment of the eyes in Fig. 46 should particularly
be noted. It will be seen that a vertical line divides a
projecting surface so that one side takes light, the other
shade. This is as much as to say that the modelling of
the eye, roughly considered, is bulging forward from side

to side, but not from top to bottom. Let it be noted also, that the space between the eye and the eyebrow is subject to light and shade, and is divided, it may be said, by a

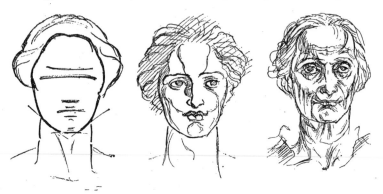

FIG. 47.—The Oval and the Feature-Lines. FIG. 48.—The Ridges expressed by Curved Lines. FIG. 49.—Old Woman's Head derived from Fig. 46.

prolongation of the vertical line down the eye, of which mention has just been made, so that where the eye takes shade the brow takes light, and *vice versa.*

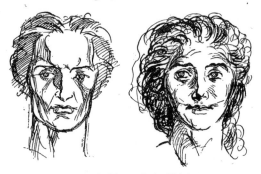

FIGS. 50 and 51.—Head of a Man and of a Girl derived from Fig. 46.

In Fig. 48 we have the lines and planes expressed with curved strokes, so that the effect is more natural and less diagrammatic. Figs. 49, 50, and 51 are all variations

upon the same theme, and were all drawn over the diagram, Fig. 46, which has consequently provided the form in each case. Among them is the head of a man; its character, as has been explained in a former page, was secured by keeping the forehead broad, the lines less sloping, the whole form squarer, and the front of the face flatter.

13. The Head in Profile.

THE first lines for a profile are commonly those shown in Figs. 52 and 53, which are respectively of a woman and of a man. We note that the hair-line, from the forehead to the ear, divides the face from the cranium and leaves them about equal in area (the face the smaller); that the line for the front of the face can be divided into three equal divisions

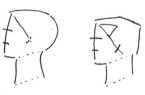

FIGS. 52 and 53.—First Lines of the Profile, in Woman and Man.

for the brow and the end of the nose; that the top of the head rises as it recedes, definitely in woman, less definitely in man; that the line at the back of both head and neck is, in woman, a beautiful curve, while in man it is more vertical and less continuous. We note also that the hair-line in man must be sharply deflected, and that the same grace or squareness that characterizes the back of the neck in woman or man respectively must also characterize the front of it. But for the front of the face a single line is not of much service. The projection of the nose makes it imperative to separate very soon the upper from the lower part. Hence we have Figs. 54, 55, and 56. The line down the nose may be said to radiate

from the top of the forehead with the face-line. With
the end of the nose
suggested we can
add the mouth,
one-third the way
down to the chin.
We must be par-
ticular to note that
the back-line of the

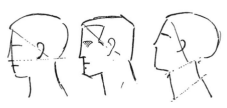

FIGS. 54, 55, and 56.—Development of the Profile.

neck commences and finishes higher than the front-line.
(Fig. 56.)

In Figs. 57 and 58 the mouth and chin are developed;
in 57 by a flowing-line down the front corrected by a pro-
jection for the lip, and a notch
between lip and chin. In 58
the lip and chin are made with
a continuous curve.

In the profiles of women we
must be careful to make the
throat full and graceful, and
the under-side of the jaw also
full.

FIGS. 57 and 58.—The Mouth and
Chin developed.

If we follow the planes in the head when seen in profile
we find that three lines come down from the forehead.
These are—one dividing the face from the cheek, one
dividing the temple from the forehead, and one dividing
the forehead itself. These three lines are shown in Figs.
59 and 60. The one dividing the face from the cheek is
developed by curves corresponding to the similar lines in
the full view. In the diagrams here, shading is used to
make the alteration clearer. We note that the curves give
us first a light running from beneath the eye along the
cheek-bone, then a fuller light for the facial part of the

cheek. Then the curve approaches near to the mouth, and

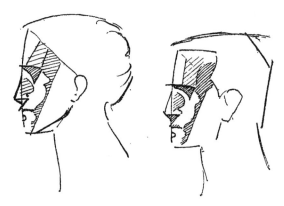

FIGS. 59 and 60.—The Chief Lines in the Profile.

then passes suddenly out round a small eminence, and returns to refine the chin.

In Fig. 61 another fact, especially of the head of the woman, is illustrated. From the cheek-bone across over the ear is drawn a ridge. This ridge divides two planes which slope backward toward the forehead and toward the chin.

In all these diagrams the sloping side of the nose is indicated by a curve which returns again round the wing of the nose. In this respect the technique follows that employed for the front view.

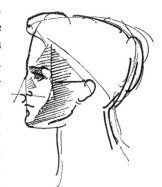

FIG. 61.—The Planes of the Temple and of the Cheek separated.

The analysis of the head of Venus may be compared with Figs. 59 and 61. Two important changes from the form in Fig. 63 is made in Fig. 64. The upper part of the nose

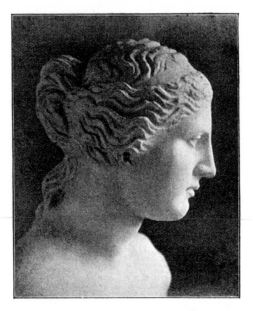

FIG. 62.—Profile of the Venus of Milo.

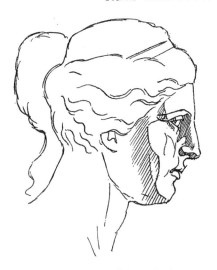

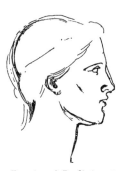

FIG. 64.—A Profile based
upon Fig. 62.

FIG. 63.—An Analysis of Fig. 62.

is set back, and the jaw is robbed of some of its fulness by the accentuation of the bone. The head thus approximates to a type rather like that made famous by Sir Edward Burne-Jones. With this again may be compared the

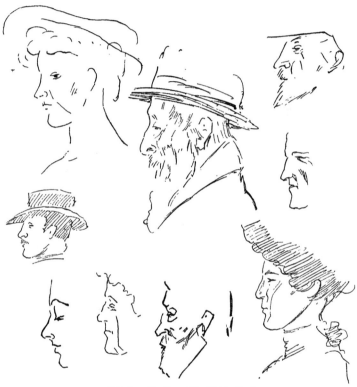

FIG. 65.—Profiles of the Unidealized.

profile Fig. 200, which is of an unidealized English girl.

There is no need to enter into a disquisition upon the variations upon the theme above propounded which are given in Figs. 65 and 66. It may be said that he who would collect such examples will find his task the easier if

he has grounded himself in that general knowledge of form
which it is our main business here to study.

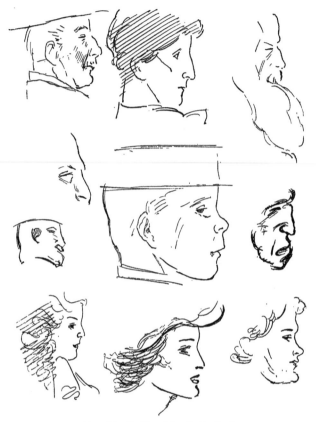

FIG. 66.—Profiles of the Unidealized.

Whether Fig. 67 is idealized or not, we can never know.
It is, however, a fine example of the sure and delicate
drawing on the Greek vases.

14. The Head in Three-Quarter View.

THE three-quarter view is one of the most usual in art. It is particularly convenient, for it combines, or seems to combine, the "simple" or repre-sentative views of the features. Thus the eye is practically in full view, at all events the nearer eye is. The off eye has always been a worry, and it is surprising how often in old work the responsi-bility is cast upon the other. Then the nose is in profile, or appears to be so to the uninitiated. The features, moreover, are not liable to be mixed with the background.

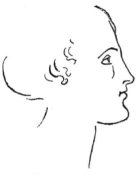

FIG. 67.—A Greek Profile. (Vase in British Museum.)

This is a distinct gain, as any one who has drawn heads with backgrounds will admit.

The three-quarter view cannot be profitably reduced to

FIGS. 68 and 69.—The First Lines of the Three-Quarter View.

only one or two lines. The cheek-profile may be expressed in two lines making an angle at least half-way down the head. This is shown in both Figs. 68 and 69. The top and back of the head may be differ-ently expressed in the two sexes: the man's by three angular lines, the woman's by an ovoid curve, though often the angular massing will suit best in that case also.

The internal lines are three. There is the one bounding the hair, that for the jaw, and one running down the cheek,

and corresponding with the outline of the face against the
background. Of course if a sufficiently sinuous line were
used, it could trickle round all the form, hair, ear, and jaw,
but the object of our present task is to find out the first

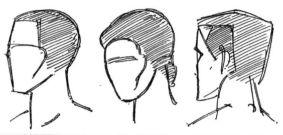

FIGS. 70, 71, and 72.—The Form at its Simplest.

lines with which we begin our work, not those which
ultimately are used when full and complete form is
rendered. Our first lines turn the form into a crystal—
into a solid with planes meeting in ridges. Consequently

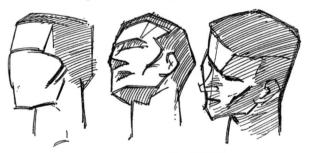

FIGS. 73, 74, and 75.—The Chief Planes.

we use lines, at first, which emphasize these conditions. In
the present case we use three : hair, cheek, and jaw.

The hair-line in man is so irregular that it must be
simplified. This irregularity is due to the hair receding
over the temple, and coming forward again in a zigzag
manner. Both in the man and in the woman the hair

extends beyond the ear, so that it can be said to follow a line from the top of the forehead to the bottom of the ear. Fifty years ago the ladies used to hang their hair like curtains, down either side of the forehead, in a droop-

FIGS. 76 and 77.—The Chief Planes.

ing curve which was looped up behind the ears ; the fashion survives in the wooden doll.

If the reader examines the drawing of the head in the

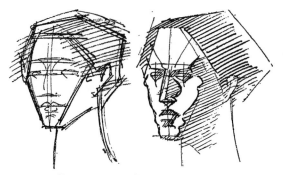

FIGS. 78 and 79.—The Form developed.

many illustrations seen in the ephemeral publications, he will find that the three-quarter view is very often employed. Indeed, I have heard it said of one of our humorous draughtsmen that he always draws his heads in that aspect. It is useful to the student to consider the degree

of foreshortening involved in this three-quarter view. The
eyebrow is practically half lost, since it is partly on the
forehead, which remains in view, and partly on the plane
of the brow, running back to the ear. It is this part,
running back to the ear, that is lost. The far eye is quite
unlike the near one, which is seen in its true shape. Both
the upper and lower lips are reduced to almost specks ;
indeed, they are often so represented on the far side.

FIGS. 80, 81, and 82.—The Ear and Nose in relation to the Outline.

The nearer side of the lips, like the eye, is practically the
true shape ; even the full view of the face does not give the
form of the lip so accurately.

There is little that need be said in explanation of the
accompanying diagrams. They are, indeed, only new
views of the facts of form spoken of in the preceding
pages. They are intended to illustrate the various planes
and ridges which characterize the normal form. It is this
normal form which is so important to the draughtsman,
for it is that which he handles when he puts his heads

into perspective. It is singular how easily students over-look the influence of perspective on the head. Often a drawing is quite spoilt through neglect of what should be to all artists the first technical principle. When a

FIG. 83.—The Unidealized.

head is above the spectator, obviously he will be looking up into the brow, and the little plane which runs from the eyebrows to the back of the eyes will have to be managed just in the same way as the under-side of any projection; and this applies to the nose, lips, and chin.

The mouth has two corners, and therefore, when the head is turned so that one is looking at the under-side, the farther corner will be the lower. Now it is not likely

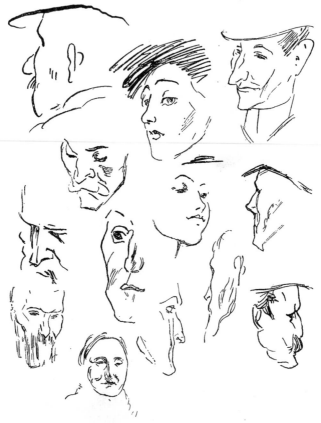

FIG. 84.—The Unidealized.

that the draughtsman will succeed in this foreshortening if he has not control of the planes into which the form can be summarized.

An important fact of proportion concerning the three-

quarter view is that the ear and the nose both touch the outline. (Figs. 80, 81, and 82.) That is to say, if, as we draw, we find the nose touching the outline of the cheek, we can draw the outline of the back of the head down to or through the ear. And in the same way, if we find the

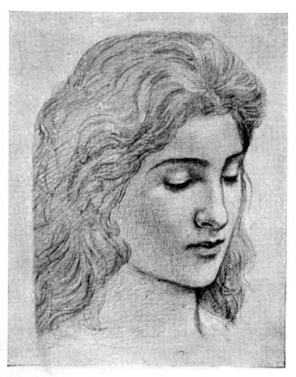

FIG. 85.—A Woman's Head.

nose is within or clear of the outline of the cheek, we can allow the ear to project beyond the back of the head. No definite rule can be observed, however, because heads vary so much, and ears and noses vary so much ; the ears some- times sticking out, and sometimes lying flat against the

head. The artist has to judge whether the head he is drawing seems to be such as would have the ears projecting or lying flat, and must order his work accordingly.

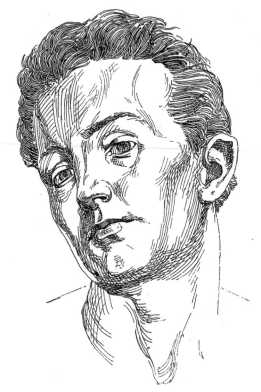

FIG. 86.—A Man's Head.

15. The Proportions of the Head.

THE head, as a mass, falls in profile into a square of 9-inch sides for a man, and 8½-inch sides for a woman, the hair being omitted. (Fig. 87.) This proportion is, however, not of very much use, since while it is easy

enough to recognize the height of the face, it is not so easy to recognize the height of the head, because the level of the chin has to be carried in imagination backward till it falls under the highest point of the top of the head, and similarly the width is not easily recognized because the square is reached by the projection of the nose, whereas one would more naturally omit the nose in consider-ing the width (front to back mea-surement, that is) of the head. More-over, comparing measurements is far more safely performed if the two dimensions meet at a common point, as do the two lines of the letter L, and not when they are placed cross-wise as in the letter T. Thus, in all proportionings it will be best to find out those which have one common end-point. The head consists of the face and the cranium, and the important measurements are the length of the face and the pro-jection backwards of the cranium. The length of the face is in man $7\frac{1}{2}$ inches, and the cranium from just above the eyebrows to the widest part behind about 8 inches. But if the top of the face—the limit upwards of the $7\frac{1}{2}$ inches—be taken as a centre of two dimensions, one going to the chin and giving the facial length, and the other to the back of the head, as shown by the crosses in Fig. 88, A, then these two dimensions will be found to be about equal. It must be noticed that the angle enclosed by the two lines is less than a right angle, the triangle approaching the equilateral.

FIG. 87.—The Head in a Square.

Or the matter may be regarded from the basis of the hair-line. In men the hair-line diverges far over the

temples ; but in women, owing in a great measure to their method of dressing the hair, the line is more direct. (Fig. 88, C.) For practical purposes it may be said to pass from the top of the face to the middle or bottom of the ear. On either side of this line, as at B, the face and the cranium lie in about equal masses. This is seen better in F, where the mass of the face is traced down in the space of the cranium. It will be seen that the chin falls at the proper place at the back of the head. More head has to be added above ; but what is required of the rule is the width backwards, rather than the height,

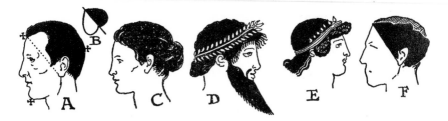

FIG. 88.—The Proportion of the Face to the Head.

and this is obtained. D and E are heads from Greek vases of the best period. The hair is worn very low on the forehead, but the massing can be estimated. The ears are remarkably short. It may be remarked that when a head appears in a drawing too large or too small, it is more probably the face that is wrong.

16. The Proportions of the Face.

EXCLUDING the hair, the face is divisible into three equal divisions, falling at the eyebrows and the tip of the nose, while the eye is placed at the half-way between the

extreme top and bottom of the head, when it is held in
the normal upright position. (Fig. 89.) The mouth falls
a third of the way down
the lowest division.

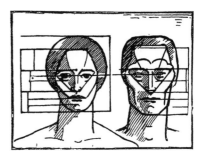

In starting a head, it
will be found best to
first draw the full mass,
and then to separate the
face from the cranium,
or, broadly speaking, put
in the hair. If the hair
is not falling low on the
forehead, the hair limit,

FIG. 89.—The Proportions of the Face.

or top of the forehead, can be used, and in this case the
proportions of the face will be best secured by the placing
of the eyebrows and the nose according to the fact of the
three equal divisions, as in Fig. 90, A. If, however, the
hair falls over the forehead and hides the upper limit, it
is perhaps best to place the eye first, half-way down the
whole head, then to add the eyebrows above them, then

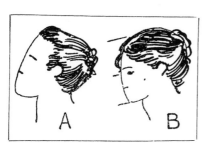

FIG. 90.

the nostrils half-way
between the brows and
the chin, as in Fig. 90, B.
The same means can
be adopted for fore-
shortened faces; but
with those there is, as
is only to be expected,
far greater chance of
going wrong.

Of the more detailed proportions the following may
be of service. First, the lower eyelid is seldom lower
than half-way between the eyebrow and the top of the

wing of the nose. (Fig. 91, A.) The height of the
brows above the eyes varies considerably. There are
beetle brows, and the reverse, and therefore the brow-
line must perhaps not be regarded as having the fixity
of a bony prominence. It is chiefly in the faces of
women that the space between the eye and the brow
is of any extent; frequently in men it is almost hidden
by the overhanging brow. B illustrates how the line
from the eye to the wing of the nose is not parallel to
the line of the nose, but slightly convergent upwards.
A similar convergence downward is seen in the case of
the mouth, as at C. In Greek heads the nose, being

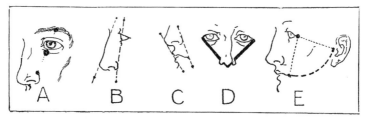

FIG. 91.

higher at the root, allows the line from the eye to be
parallel to it. The convergence downward in C applies
only to views nearly or quite in profile. By D it will
be seen that by joining the outer corners of the eyes to
the tip of the nose, a right-angled triangle is formed.
E demonstrates how the distance from the corner of the
eye to the front of the ear is the same as from the corner
of the eye to the corner of the mouth. This applies
particularly to heads of women, in men the ear is a little
further back.

The space between the eyes in men, women, and
children is the same, namely, the width of one of the

eyes; therefore in this one particular the three are alike. But if the length of the nose, and the width of the nose and mouth, are taken into con-
sideration, the result is an ap-
pearance of greater size in the
eyes of women and children, or
less in the mouths and noses.
The widening, in men, of the
nose and mouth seems to throw

FIG. 92.

the eyes nearer together. The width across the wings of the nose in men is equal to, or greater than, the width of an eye; in women it is slightly less, in children less still. The mouth is much larger in men than women, and smallest in children.

Very frequently the lowest third in the face of a man appears much longer than the nose portion. This is often to be seen in photographic portraits.

17. The Form of the Cranium.

THE face is properly that part below the brows and before the ears. All else is cranium.

The cranium, although its fundamental shape is ovoid, is modified by certain peculiarities, which in the heads of men have so great an effect, as to some extent to substitute a polygonal form for the ovoid.

Taking a side view of the cranium, the oval will require to be smaller at the face end, the front. Modifying this oval to agree with the actual shape, the first change will be to flatten the forehead by the line A in Fig. 93. Then it is quite possible that the vault of the cranium, traced backward, may keep to the oval, till at the back it suddenly bulges out at the occipital protuberance E,

and at the occipital spine F, where the neck begins. From
F to G (the mastoid process) is the line of the junction of
the neck with the skull, the space underneath between the
two mastoids (G) and the occipital spine (F) being the
base of the skull, or, rather, the hinder part of it.

The most important line in the cranium is the temporal
curved line B ; it rises over the outer end of the brow, and
traverses the side of the head, in a path almost parallel
to the outline of the vault. There are of course two of
these temporal curved lines, and they to some extent

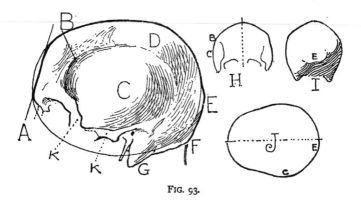

FIG. 93.

flatten the sides of the head. The flattening is palpable
just above the brow, in the temple, that is, but gradually
diminishes as it proceeds backward. It is generally
evident in men as far as the dot of reference, B. The
flatness of the side of the head is somewhat assisted by
the parietal eminences D. By placing one's palm on one's
head, one may readily feel that the head is slightly flatter
at D than in the region just before it.

The oval space in which the letter C is placed is the
temporal fossa or hollow ; it is bounded by the *curved line*
B. It becomes a hollow by being walled about by the

bony prominences K, otherwise it is rather a mound than a hollow, providing, in fact, the greatest width of the cranium — six to six and a half inches.

The front and back elevations shown at H and I exhibit the varied extent to which the characteristics that have been referred to influence the form ; the example I is very much more angular or pentagonal. At J are tracings from two skulls, cut through at the greatest length horizontally. It will be seen how very much purer the oval is in the upper one. In the lower one will be seen the prominence of the bulging at C, with the hollowing of the temples to the left of it, while the slight extent laterally of the occipital protuberance E will be noted, a fact which is expressed by the shading in I.

The vault, as seen in side view, has often an undulating outline similar to the upper curve of J.

18. The Bony Structure of the Face.

THE body of the lower jaw, or inferior maxillary, lies somewhat horizontally, and has two ascending ramuses, rising to the sockets beneath the zygomas, and thus forming the hinge of the jaw. Upon the teeth of the lower jaw rest those of the two upper jaw-bones, or superior maxillaries. These superior maxillaries reach as high up as the inner corners of the eye-sockets, providing also the sides of the nose, and sending out on the outer sides brackets upon which rest the malar or cheek-bones. These malar bones are roughly star-shaped, four-pointed. One point stretches towards the nose, and forms the outer side of the lower border of the eye-socket, one proceeds vertically upward, and forms the outer border of the socket, another proceeds backward and becomes a bracket to support the

zygoma, while the last is less pointed, and falling vertically downward makes the lower border of the cheek-bone. The nasal-bones are very small, and start from the internal angular process of the frontal bone, between the eyes, and project just so far as to make the bridge of the nose. The rest of the shape of the nose is built up of cartilage, or gristle. The frontal bone, or bone of the forehead, caps the whole face; it provides the upper

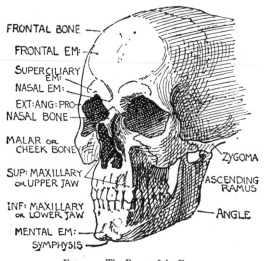

FIG. 94.—The Bones of the Face.

borders of the eye-sockets, and by its external angular processes forms part of their outer, and by its internal angular processes part of their inner, borders, and the root of the nose.

Viewing the bony structure of the face as a whole, the first thing to notice is, that the fore part of the upper and lower jaws presents a surface almost at right angles with their side parts. The division is observable in Fig. 94 as an outline on the left side, and a shadow

line on the right, being slightly curved outward, and suggestive of a line from the root of the nose to the eminence of the chin. The front surface of the jaws is not flat, but slightly convex; the eye-teeth, answering to the fangs in beasts, however, assist the idea of the angularity of the jaw in the region of the teeth. The next noticeable fact is that of the almost equal prominence of the lower border of the eye-socket throughout its course. Just as the jaw surface already spoken of proceeds from the nose downwards, so there is a ridge passing from the nose to either side, and forming a very prominent lower border to the eye-socket. From this ridge the parts of the upper jaw-bones, and of the cheek-bones, which are below it, fall back more or less; less in the case of the cheek-bone, more in the case of the upper jaw-bone. The hollow thus formed is continuous with the flanking back of the back-teeth. Broadly speaking, it may be said that the prominences of the bones of the face, viewed from before, are in the shape of a T.

Below and above the teeth there is a distinct sinking; thus at the bottom of the nose the bone lies further back than the teeth. And similarly there is a depression, between the lower front teeth and the eminence of the chin.

The lower jaw-bone is originally a double bone like the upper jaw; the point of conjunction, or fusion, is the symphysis of the chin, which occurs exactly in the centre. At the lower end of the symphysis or central joint there is a slight notch, which throws into prominence the mental (*mens,* the chin) eminences, which meet on the symphysis a little above the notch. The under border of the jaw is not a straight edge from the angle to the point of the chin, though it is somewhat of one.

From the symphysis to a point just below the last teeth, the outline is a gentle curve continuous with the outline of the "ascending ramus." So that the "angle" is, as it were, an addition ; or, in other words, there is a slight depression above and below the angle. This is a matter of considerable importance.

19. The Zygomatic Arch.

THIS is a bony connection between the malar, or cheek-bone, and the temporal, or bone of the ear. It is narrow

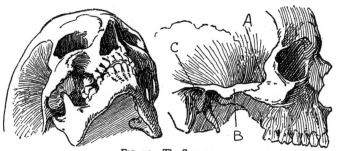

FIG. 95.—The Zygoma.

but wider at the cheek end, flattening out there, and prolonging the flat surface of the malar bone which plays so important a part in the appearance of the side of the face. It must be noticed that the zygoma runs horizontally backwards, on the level of the lower edge of the eye-socket. Passing as it does over the orifice of the ear (C, Fig. 95), it is suggestive of the fastenings of spectacles, which indeed lie as much on the mass produced by the zygoma as upon the ear. The thong of the spectacles is, however, a little higher than the bone of the zygoma. The sharp angle A must also be noticed ; the bones forming it stand

about an inch away from the body of the skull, and are
not rounded to any extent, being very thin. The sharp-
ness producing this edge is very evident in old people;
even in well-fleshed subjects this part *looks* hard and
bony ; in children particularly so. It is one of the hardest
problems in figure drawing, to give a bony look to a part
that is not definitely angular ; there is of course a similar
difficulty in making the lymphatic parts look tender and
easily pressed.

It must be observed that this zygoma prevents the

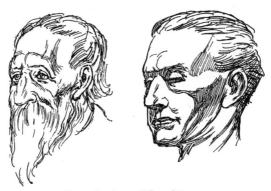

FIGS. 96 and 97.—Effect of Zygoma.

hollow of the temple joining the hollow of the cheek.
The most important fact connected with it is, however
its prominence. Viewed from above it presents the
appearance of a gently curving arc—an arc of a large
circle. It is highest at its thinnest part (Fig. 95, B), about
half-way between the orifice of the ear and eye-socket.
The face is widest therefore a little before the ear, so
that the width *at* the ear is only a very little greater
than the width at the cheek-bones.

The effect on the form is first to add a mass between

that of the cheek-bone and the temporal prominence, and just before the ear. This addition receives light and throws shadow, the light slanting up into the temple, the shadow down into the hollow of the cheek, as in B.

The effect of the zygoma on the form varies greatly. Sometimes the projection is very evident, sometimes not. When it is not evident, there is formed an almost precipitous wall across the side of the head. This is seen in

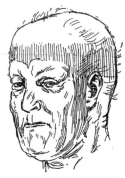 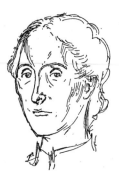

FIG. 98.—The Ridge of the
Zygoma lost in Man.

FIG. 99.—The Narrowness
of a Woman's Head above
and below the Zygoma.

the heads of men, rarely in women, because the cranium in woman recedes above the zygoma. A woman's head and a child's head are so definitely wide at the zygoma that one may say they always recede, both upward and downward from it. Nothing perhaps illustrates this fact so much as the action of taking the head in one's hands. The smallness of the jaw and neck, succeeded by the breadth across the zygomas, tempts the hands to hold the head there.

20. The Influence of the Bones upon the Form of the Head.

THE dimensions of the male and female heads are virtually the same, but this is more because the measurements which are taken do not affect those parts in which differences occur, than because the heads are similar.

Allowing the height to be comparatively the same in

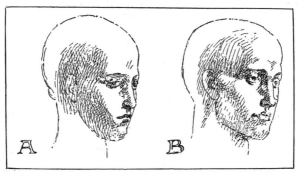

FIG. 100.—Comparison between the Forms of the Head
in the Two Sexes.

both, it is in woman further back, or, in other words, the frontal bone does not rise so high as in man. (Fig. 100, A and B.)

The chin occupies the same position in both, but the angle of the jaw is in a woman much less pronounced than in a man. Moreover, the distance from angle to angle across the throat is less, from cheek-bone to cheek-bone is less, and from zygoma to zygoma is less. The cheek-bones are less prominent forwards, and are, so to speak, further behind the chin. Thus the chin becomes more pointed, the fleshy line from the cheek-bone to the

chin assumes a little more importance by the retiring of the angle of the jaw, and so the face becomes rounder and smaller.

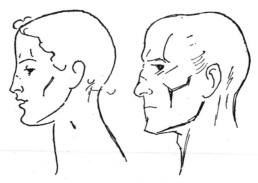

FIG. 101.—Profiles of the Head in the two Sexes.

The result of these differences is to flatten the female head in the region of the ear, and also to soften the general form, and to emphasize that obliquity, which is so typical of both the cranium and face of a woman.

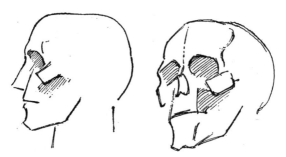

FIGS. 102 and 103.—The Malar Bone in simple Form.

The head of a man is squarer, and its parts project more definitely. The forehead is higher, the zygoma, cheek- and chin-bones are more prominent, and the angle of the

jaw more pronounced and squarer. The front of the face at the mouth may be said to be flatter.

The parts (in some cases the *points*) of the skull which

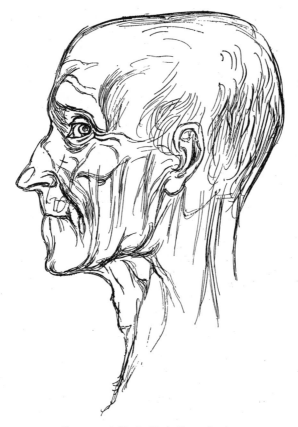

FIG. 104.—A Head with the Bones showing.

particularly affect the form are as follows. First, the whole surface of the cranium, the details of which have been pointed out on a previous page; then the malar bone, which is of the greatest importance. The malar

bone may be regarded as a squarish plate lying obliquely, and occupying a position between the front of the face and the side. The malar is connected, forward, with the bone beneath the eye, and across to the nose, upward, with the brow, and backward, with the zygoma running above the ear. These connections differ in their character. The connection with the nose is ridge-like, or bridge-like; it does not sink back, or very little, as may be seen in

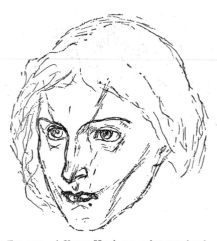

Fig. 94. The connection with the brow is rather "disjointed," that is, the process descending at the outer side of the eye dives, as it were, into the head, and its connection with the malar is hidden. There is, consequently, a channel for the wrinkles from the eye to rest in.

FIG. 105.—A Young Head, somewhat emaciated.

The lower border of the malar is of great importance. It practically always shows, though sometimes with the extremest delicacy. This lower border produces two depressions, one on the face below the eye, and one a little further toward the ear on the cheek. In Fig. 104 they are shown separated by a fold of the skin. The depression on the face is that which indicates a more advanced age or degree of emaciation, but even in the youngest heads its influence is seen. In Fig. 105 both these depressions are evident.

The bony form next in importance to the malar is that

made by the upper jaw-bones. The upper jaw-bones, as will be seen in Fig. 94, together present a front and sides. The front is not flat, but gently curved. The angle between the front and the side is occupied by the eye-tooth. The sides are hidden within the mouth and do not affect the surface, but the front provides the basis of the form. By again referring to Fig. 94 it will be seen that the front becomes narrower as it ascends, but the measurement is greater than that of the nose, so that the bony front of the face must be maintained on either side of that organ. And although the crease which flows down from the side of the nose round the mouth covers a hollow, it is yet supported, in its upper part, by bony substructure. A fault in modelling is to delve the hollows on either side of the creases too low.

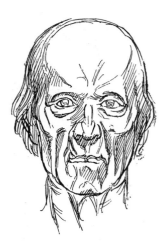

FIG. 106.—The Bony Projections of the Head.

The lower jaw governs the whole form of the lower part of the face, but the angle and a prominence on either side of the chin are more evident as features than are other parts of the bone. Although the angle is very slight in woman, it is yet sufficient to give an extra boniness to that part of the jaw, or shall we say that the draughtsman must "remember it" (for it is almost too delicate to be separately expressed), and must insist upon the form there if he does insist upon it anywhere.

The illustrations will serve to indicate better than words

the importance, character, and form of the various bony features of the face.

The reader will not fail to notice the great prominence of the frontal eminences in man. Bulging out over the brows they give power and character to a head. Their

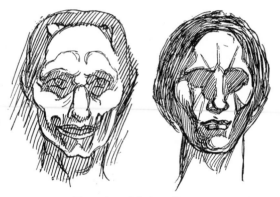

FIG. 107.—Illustrations of the bony Forms of the Head.

absence in woman allows the forehead to appear slightly more forward above than just over the brows. Indeed, the draughtsman will find that he will succeed more readily in the representation of a woman's head if he projects the forehead above than if he slopes it back.

21. The Muscles of the Face.

IT will be seen by the diagram, Fig. 108, that in the face there are three muscles of circular form, and called therefore *orbicularis*. They close the eyelids and the mouth, and their names consequently are the two *orbiculares palpebrarum* and *orbicularis oris*. Their similarity of shape affords a good starting-point in the consideration of the muscles of the face. But while their shape and functions

are similar, there is between them a marked difference, in the fact of the *orbicularis oris* being the centre for almost all the other muscles of the face, while *orbicularis palpebrarum*, or muscle of the eyelids, has hardly any round it, and those of little importance. They are, however, the *pyramidalis nasi* and *occipito-frontalis*, the former an extension of the latter, and both concerned in wrinkling the skin—the *pyramidalis*, that of the nose ; the *occipito-frontalis*, that of the forehead.

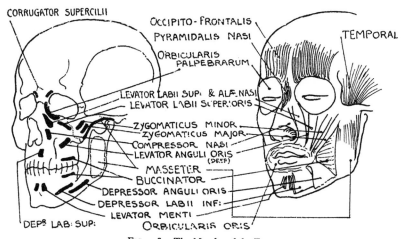

FIG. 108.—The Muscles of the Face.

Generally a muscle passes from one bone to another bone, the connection with the bone being a tendon, sometimes long and sometimes short. There are many cases in which instead of attaching to bone they attach to tendinous sheaths, to ligaments and similar non-bony parts. The orbicularis oris provides a number of these cases ; the muscles which pull the mouth up, down, or backward—to briefly summarize their functions—arise from bone, but find their insertions in and among the fibres

of the orbicularis oris. Hence it is that almost all the
muscles of the face have only one location in the bones.
The orbicularis oris itself has no bony connection, and it is
the recipient of the ends of some nine others, which have
one end attached to bone. Reading from the nose, there
are the elevator of the upper lip and also of the wing
of the nose (*Lev. lab. sups. et alæ nasi*); the proper
elevator of the upper lip (*Lev. lab. sup.*). Beneath
these the elevator of the angle of the mouth (*Lev. ang.
oris*). Then the zygomaticus major and minor, arising
as they do from the cheek-bone near the zygomatic
process. These are opposed below by the depressor of
the angle of the mouth (*Dep. ang. oris*), the depressor
of the lower lip (*Dep. lab. inf.*), and the elevator of the
chin (*Lev. menti*), which being also a depressor of the
lower lip, corresponds with the depressor of the upper lip
(*Dep. lab. sup.*), situated under the nose.

The list of muscles round the mouth is completed
by the buccinator or cheek muscle, the most artistic use
of which is made by the trumpeter. The inflation of the
cheeks is due to the lungs, but the buccinator compresses
the space within the mouth, and forces the breath
rapidly through the constricted lips. Attached as it is to
the corner of the mouth, its action produces a dimpling
there, as well as a puckering of the cheek just behind the
corner.

The *compressor nasi* compresses the nose as in smelling ;
the *dilator nasi* lies upon and expands the wing of the
nose.

The *masseter*, or masticatory muscle, is one of a pair
which in conjunction with the *temporales* performs that
office. The *temporalis* rises in the broad space known
as the temporal fossa, which is bounded by the temporal

curved line. (Figs. 108 and 93, B.) It is gathered together into a fan shape and passes under the zygoma, to be inserted in the *inner side* of the ramus of the lower jaw. The *masseter* arises from the edge of the cheek-bone and zygoma, and attaches to the *outer side* of the ramus.

Of all, perhaps, *zygomaticus major* claims first consideration. This muscle provides the ridge between the plane of the face and the plane of the cheek. In form the zygomaticus major is somewhat strap-like, narrow and long, but care must be taken that it appear to die into a

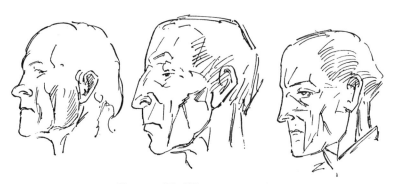

FIG. 109.—The Effect of the Masseter.

broader, rounder mass both at the cheek-bone and the mouth (Fig. 110). In a summarized drawing a line made up of three distinct parts is used, the parts expressed being the cheek-bone, the muscle, and the oval muscle round the mouth.

Next in importance to the zygomaticus major is the masseter, the great muscle by which the lower jaw is drawn up, as in chewing. This muscle is more useful to us in sketching a man's head than a woman's, for the expression of it tending, as is always the case, to exaggeration, leads to emphasizing the jaw, a thickening of the bulk there, and

to a rather vertical treatment of it. In direction the mass covering this muscle, and which to the artist is the muscle, runs backward as it descends, or is vertical ; in any case, it does *not* follow the downward and forward slant of the jaw, or rather, shall we say, the draughtsman will find his drawing more successful if a backward rather than a forward direction be followed. In bulk this mass of the masseter is often very considerable, and in its modelling firm and muscular, not merely rounded as if swollen. It generally presents a ridge some little distance before the line of the jaw, as if the muscle did not extend so far back as to obscure the bony form. Of course this mass is greatly augmented by the folds of skin on the heads of elderly people. The lines of the folds

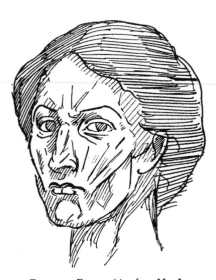

FIG. 110.—Forms arising from Muscles.

run athwart the muscles whose action produces the wrinkling.

None of the other muscles of the face make themselves evident in a very marked fashion, in the production of form. Practically all, however, make some visible difference to it. This fact is illustrated in Fig. 110, where a large number of muscular lines are introduced without the form being very anatomical. In Fig. 111 the same lines are present, though in less aggressive form ; this illustration

shows again how much anatomy can be put into a face without disfiguring it. Let it be noticed, moreover, that this use of the anatomical forms gives severity to the drawing, and prevents its having a silly expression. It will be observed that in this drawing there are introduced indications of the several muscles between the nose and the ear. These muscular forms are invaluable in expressing age, but they are found in all heads from the young child's through all the phases of youth.

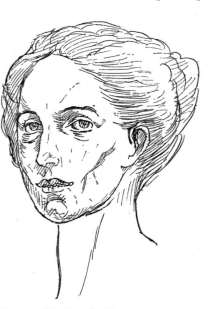

Some instances of the effect of the *masseter* are given in Fig. 109. The reader will probably have noticed the resemblance of these forms of the masseter to the "mutton-chop" whiskers.

The chief forms due to the prominences of the bones and muscles may be summarized as follows.

FIG. 111.—The Muscular Lines less Emphasized.

The frontal eminences (A, Fig. 112) give the full roundness to the forehead. They are separated by a very slight hollow, which continues to the root of the nose. Just above the nose on the brow are the nasal eminences B, with the superciliary eminences C close by. These nasal and superciliary eminences are much more developed in man than in woman, and therefore assist in determining the appearance

of sex in the head. In men a line, U, is generally traceable over the superciliary and nasal eminences. These eminences of the forehead form a sort of front to it, bounded by the line D, which becomes a shadow line when the light favours it. It will be seen in the paragraph upon the eye and its surroundings, that there is a sort of corner in the brow, in Fig. 112 marked E. It is the junction between certain masses, or forms, of which the superciliary and nasal eminences form one, and the mass which covers the eye

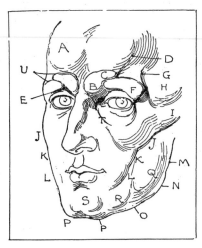

FIG. 112.

on the outer side (F) is another. This latter mass is made up of the external angular process, covered and thickened by the orbicularis palpebrarum muscle. Close behind this is the temporal curved line starting upward (G), and surrounding within the temporal fossa, the temporal mound covered by the temporal muscle, and making a low but important projection above the ear (H). Below this is the zygoma (I) receiving light, in all probability.

From the under side of the zygoma starts a line, which divides the face from the cheek, and runs down to the chin. This is a most important line, since it expresses the modelling of the face. Its counterpart is the outline of the other side. Following this line down there is first the curve for the cheek-bone (J), then the curve formed by

the muscles of the cheek, edged by the zygomaticus major (K). Next comes a curve formed by the orbicularis oris (L), while the line dies away around the lower border of the mass to which that muscle may give its name.

The shape of the jaw is pretty well expressed by the ramus (M), the angle (N), the curve (O), and the corners (P P).

Upon the jaw the masseter muscle lies, slanting backward with a fairly strong border, in the hollow of the cheek (Q). Below is the mass of the depressers (R). The mass or masses of the chin (S) are some little distance above the outline. Below all these will be noticed a narrow space, just on the outline of the jaw before the muscles are reached. The skin and the fat beneath it of course blend together all these forms, and obscure them more or less, particularly in women.

22. The Eye and its Neighbourhood.

THE eye-socket, or orbit, is a deep cavity with four well-marked borders which form a rectangle of considerable regularity. The upper and lower borders are the longer, and they slant downwards. One must hasten, however, to correct an impression which naturally forms in the mind when one thinks of the oblong cavity of the orbit. The borders of it are *not* in one plane. The outer border sinks back, and rises again, as if the outer corner of the eye were pushed back. In fact, in modelling, one frequently corrects defective form in this region, by merely shoving back the bony ridge where it descends to the outer corner of the eye.

Every one is familiar with the miserable expression of the skull. This miserable expression is entirely due to the

downward slope of the eye-socket. The bony form of the eye-socket, or orbit, is given in Fig. 113.

The borders of the orbit had better be noticed in detail. Fig. 114 represents the complete fleshed eye, with however the eyebrow omitted; also the same view of the bony orbit. The first detail to call attention to is the notch in the upper border, marked A in both figures. To the left of this notch is the external angular process which is enlarged by the orbicularis palpebrarum muscle. In both figures this mass is marked B. In both, the temporal

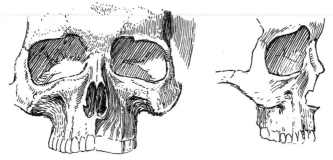

FIG. 113.

curved line is visible (C)—sharper in the skeleton—where also the descending external angular process (B) seems tolerably continuous with the cheek-bone and its ascending process, D; but in the living model there is a great degree of separation. Thus the mass B often takes shade, whereas the mass D, which continues along the zygoma, takes light. Indeed, the surface B seems to plunge more or less into the head downwards, and the surface D seems also to plunge into the head upwards. There is of course no sharp division between the two.

The obliquity of the orbit greatly modifies the extent and shape of the lids. Each lid is fuller, or shows more,

where it has most room. Thus the upper lid is seen at its fullest just below the notch A, while the lower is wider at the outer side.

In old people the tear-pouch, E, becomes very marked, and in them the shape of the bone is more plainly seen than in young people. The smoothest part of the border of the orbit is beneath the nasal eminence, F, and is indicated by shading on the skeleton. It forms a kind of

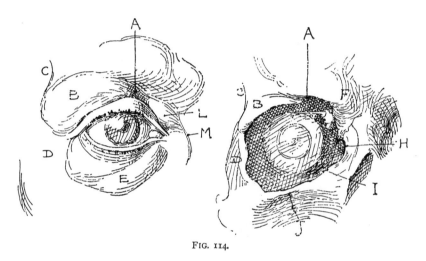

FIG. 114.

entrance to the hollow of the orbit, and is well known to modellers.

The nasal bones also provide a very smooth declivity into the orbit, although the edge, H, is sharp in the skull. Hence in old people the border of the piece, I, shows very plainly. This part will be seen to be an expansion from the narrow ridge, J, towards the nose. This expansion is very important. Being bone it does not waste, and consequently takes light in persons of all ages. Below J the surface of the maxillary bone runs backwards at a gentle

angle. It is this hollowing which, throwing up the ridge J,

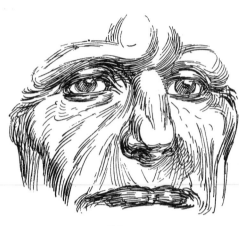

FIG. 115.

assists the ghast-
liness of emaci-
ated faces.

One very im-
portant detail of
the eye is the
surface L. It
occurs to the in-
ner side of the
notch in the up-
per border, and
is in form oval
or almond-shap-
ed, and placed

obliquely. It terminates in a blue vein-line, M. This
small surface occurs over a trochlea or pulley, through

which one of the
muscles of the
eye operates.
The position of
the trochlea is
shown in the
anatomical dia-
gram.

The mounds
marked F and L
in Fig. 114 vary
very consider-
ably in different
persons, as is
shown in Figs.

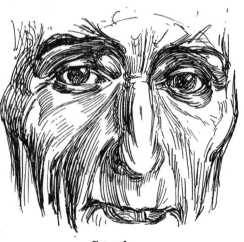

FIG. 116.

115 and 116. In the former the bony ridge is very bulbous,

and the mound between it and the eye very slight. In the latter the ridge is deficient and the mound very prominent.

If we note more particularly the form of the eyes we make the following observations. Part of the circular iris is always cut off above, except when the eyes are staring widely. The lower lid also very often cuts off a portion of it below. The degree to which this lower curtailment is done depends upon the extent to which the lid opens. Sometimes the "white" at the outer side of the iris is of considerable area, sometimes it is very restricted. An eye which exposes a fair amount of the white there is certainly more beautiful than one which is closed up. See Fig. 117, and compare it with the Greek drawing, Fig. 67. We might say that the open eye was the nobler, and consequently that the closed eye has more character. The closed eye suits the wizen and pettifogging housewife.

FIG. 117.—The Outer Corner well open.

There is something shrewd, shrewish, and suspicious about the eye that is rather closed at its outer corners.

The oval opening between the lids varies very greatly. It is perhaps safest to regard it as a narrow oval with blunt ends, leaving the pointed corners to be dealt with afterwards. Sometimes indeed it is better to carry curves right down round the corners, as if there were none, for where none are evident there are none, and the artist's task is to deal with the evident. The eyes of Fig. 118 were commenced in this way.

The upper lid follows the form of the eye-ball much more closely than does, or can, the lower lid. The edges

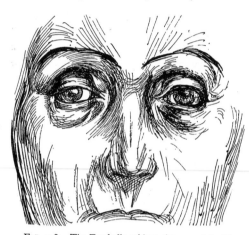

of both lids are thickened, and are somewhat square in section, so that when closed two flat surfaces meet. The eye-lashes project from the front edge of these flat surfaces. The thickening of the edges ceases, and the lids become

FIG. 118.—The Eye-balls evident above, and the Eyes drawn without Corners.

thinner rather suddenly. The thickening also stops at the corners, as if it would be in the way of the mechanical attachments.

The details of the eye are shown in Fig. 119. The various lines radiate from a white knot, K. Upward from this knot runs a slight "string," B, and downwards another, E. When the eye is wrinkled up

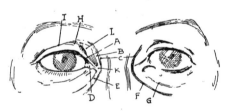

FIG. 119.—The Details of the Eye.

closely these two lines are shown pretty equally. The lower one, E, is however rather a space than a definite line. In the diagram it is expressed by two lines which are of great importance. They are shown again in F and G. F is

the upper border of the bony flank of the nose, and is of more consequence than G, chiefly because it more definitely denotes a change of plane. This line (F) is a continuation of the line C, which is really a hollow with a blue vein running down it. Of all the lines of this part of the face this one (C and F) is the most valuable. C is the margin of the bony root of the nose. From this blue line to the other on the other side of the nose is sometimes a very short distance, less in some cases than the width of the nose.

Returning to the white knot we notice a very straight tendon connecting the upper lid with it. It seems as though the upper lid followed the form of the eye-ball, and did not itself form a corner, and that therefore a tendon had to be stretched from the lid to the " anchor " beside the nose. Between this tendon A and the string B is the mound L, of which we have before treated.

The lower lid is not connected with the white knot in the same way as the upper. It seems to gather itself to a corner against the caruncle, or lachrymal wart, D, and then to be connected with the white knot by a looser string upon which the baggy lower part of the lid hangs, like a curtain on a cord.

From the tendon A a membrane runs down to the eye-ball, and sharply defines the oval of the eye.

The lower lid has no definite lower border unless the tear-pouch is baggy. The lower lid indeed hangs curtain-like, and is to be expressed by lines radiating from its inner corner but not forming a continuous curve.

At the outer corner of the eye the lids pursue different courses. The upper continues on to the cheek, as if producing the wrinkles which in mature life begin to appear. These wrinkling lines (Fig. 115) are not suave continua-

tions of the line of the lid. The lower lid appears to plunge up under the upper. Its thickness suddenly stops, and its lines meet those of the upper lid at right-angles.

The upper border of the upper lid is subject to the fulness or meagreness of the brow above it. Usually the clear curve is impinged upon by a fold of the skin, I, in Fig. 119. Sometimes also a second fold appears at H.

On the right-hand side of the same diagram is shown an eye in lines such as one uses when drawing. The corners are less pointed; the inner lower corner is expressed by a

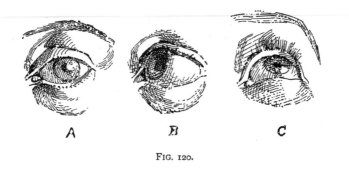

A B C

FIG. 120.

bold curve; the top border of the upper lid is broken by the depression of the skin.

When the eye is seen in other views than the normal front view its lines become more ovoid—less regular. In Fig. 120, B, we note the ovoid shape, the membrane at the outer corner, and also that the pupil (which is recessed within the eye) is not in the middle of the iris. The lower lid of the upturned eye, C, is not a curve of a single arc, but is somewhat doubled. Indeed, the lids are not clear circular forms, though they often approach that character. One has only to glance at the drawings of Dürer to see how cockled the lids can be.

In Fig. 121 is illustrated one of those rules of thumb which we are sometimes allowed. It is—that the distant eye is very much of the same shape as the near eye, only that the corner is rounded off. The lines drawn for the upper lids are very similar.

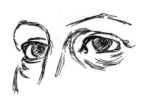

The partial closing of the eye for any reason, as when laughing or when the sun shines in one's face,

FIG. 121.

alters the form of the opening of the eye. In the latter case it makes the opening triangular. (Fig. 122.) In a laughing face the wrinkling of the skin

below, and at the side of the eye, makes convex curves all round it. These convex curves are often very useful, even when the face is not laughing. The eye is then practically surrounded by such lines, not unlike cloud forms. (Fig. 123.)

Sometimes one gains by regarding the eye as part of the surface of the brow, as if the eye made no projection whatever and only the lids came forward into the light. The lower lid is at the place where the one plane succeeds to the other.

FIG. 122.

The eye in side view is remarkable for the variety in the curves of the lids. In young persons the only change is between the lid and the little wrinkles at the side, but as age advances the curves of the lids become less simple. The wrinkling invades the lids themselves, which become puckered almost throughout their whole course. The part that last of all yields to the crinkling is the middle of the upper lid. This part often appears swollen, as if inflamed,

and has a smooth surface. One must not overlook the numerous folds of the skin which droop down, almost like lids, over the eye. From beneath these the lid itself projects, its corners almost lost.

Sometimes the eyeball shows very clearly not only on the inner but on the outer side of the upper lid. When the head is erect but the eyes are looking down there is necessarily a large area of eyeball visible beneath the lid. One suspects that in the middle ages there must have been a fashion among the ladies of holding the head and eyes in this way, for it is very frequently seen in the drawings and sculpture of the period. The fashion apparently lingered

FIG. 123.—The Eye surrounded by Convex Lines.

till the time of Raphael, for in his day the erect head and downcast eye were very prevalent, as witness the works of the master himself.

A useful method of drawing is that illustrated in Fig. 125. Therein the prominences are surrounded by lines, as if they were pools. In this way a drawing can not only be started with success, but can be amended. By this method the extreme flatness, which usually results from too great an insistence upon the outline, is

FIG. 124.—The Eyeball Evident.

avoided. In the present example the eyelids were drawn as if they were merely short narrow ovals, the pointed corners being left out. Frequently, of course, the prominences are the only parts that take light, so that by surrounding them with scribble, which encroaches more and more upon the space round about, darkens the hollows and contributes to the desired effect.

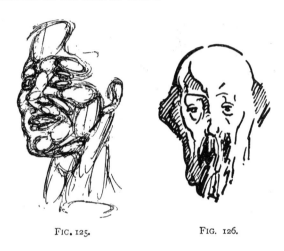

FIG. 125. FIG. 126.

Another important consideration concerning method is connected with the use of the outline. It is often not the outline, but the shadow line—where the shadow begins— that is the most expressive in line work. Thus, in the annexed example the lines for the eyes and eyelids are not the extreme limits of their form, but the modelled form as revealed by the shadow line. Just as an outline flattens the drawing, so the shadow lines model it.

Perhaps a greater difficulty than drawing the eye is placing it. A good eye out of place is worse than a bad one in its proper position. Our only safety is in carefully plotting out the planes, and the corners of the different

surfaces, foreshortening them constructively as soundly as possible. The planes are emphasized in Fig. 127, and are plotted out in Fig. 128.

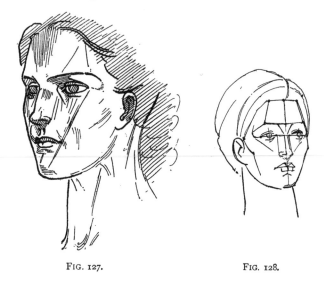

FIG. 127. FIG. 128.

The cornea, or lens over the iris, is a bulging mass upon, and in excess of, the eyeball itself. It raises the lid a little beyond its ordinary projection, sufficiently generally to catch a little more light.

23. The Nose.

THE length from the hollow to the tip is about two inches. The bone provides comparatively little of the structure, the nasal bones being short, and ceasing at the bridge, which is scarcely half-way down ; the rest is built of cartilage.

The central cartilage of the end A, Fig. 129, proceeds further down than the side cartilages—the wings, B. The

wings are in form between the circular and the angular. There is always a degree of angularity about them, but they are sometimes nearer the round, as in L, and sometimes nearer the square, as in M. Both the central cartilage A and the wings B curl up into the nostril. From the wing there passes a buttress, C, over the nostril to one bulb of the tip D. This buttress is less voluminous than either the wings or the tip, which stand up a little above it. Further, the buttress is hollowed above, as is shown in C and L. The tip consists of two symmetrical bulbs, D and E, between

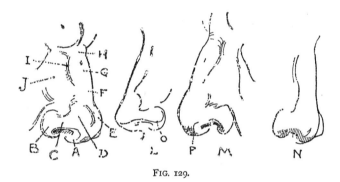

FIG. 129.

which there is generally a slight depression. From the tip the column starts upward, first being somewhat rounded at F, then flatter, wider, and bony at G, next thinner and rounder again at H.

The roundness continues till it reaches a slight hollow, I, which is observable in the skeleton. The side of the nose, J, is hard and bony, being built upon a plate of the superior maxillary. This surface is not flat, but slightly depressed at all its borders, and thus becoming similar, in bulging to one side of an almond.

The nose of a woman is narrow and less boldly modelled than a man's. There is less width across at J J,

and less across the wings B B, and hence its walls are more precipitous. The modelling of the wing and tip are also much less forcible than a man's, and the nostrils have not the same appearance of dilation, but look pinched. L is the nose of a woman, but it also serves to show that the most projecting point is not absolutely at the end.

In Fig. 130 are shown the planes of the nose. 1 is the

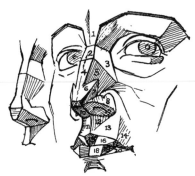

glabella, receding. 2 and 3 are the front and side of the bony upper part of the bridge. The ridge which separates them from 4 and 5 is valuable; it is the limit of the bone, and can often be suggested with effect in a drawing. The dark upper border of 3 is the "blue line." 6 and 7 are the two sides (if

FIG. 130.—The Planes of the Nose and of the Lips.

such they may be called) of the fulness above the tip. 8

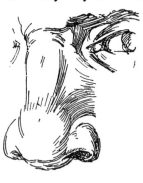

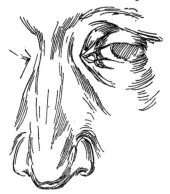

FIG. 131. FIG. 132.

is the sloping "roof" of the end, and embraces the wing

part of the tip and the buttress between them. 9 is a
plane about at right-angles with 8. 10 is the central car-
tilage; it is the lowest part of the nose, and does not
run so far into
the head as 9.
10 is not so flat
as is here repre-
sented; it is con-
vex downwards.
All these planes
are of course ar-
bitrary,and other
arrangements,
equally true,
could no doubt
be made. The
planes are re-
vised in another
diagram on the
same illustra-
tion. This second
nose is more
feminine.

The surfaces
12, 13, and 14
are particularly
important, chief-
ly because one
generally knows

Fig. 133.

nothing about them. 12 is the plane which connects the lip
with the tip of the nose; 13 and 14 represent the fulness of
the lip. As for the real lips their surfaces are sufficiently
explained by the diagram, and comment is unnecessary.

The reader will find the surface indicated by planes 6

and 7, in Fig. 130, is often represented in the illustrations in this book by an oval line. It is indeed a form of great importance. Though not bone, it stands up with all the prominence that bone gives. Moreover, the oval necessarily represents only one of the two forms, and consequently if we draw an outline of the nose and then add this oval we at once model the form, because the oval pulls up the side of the tip which is near us.

Figs. 131, 132, 133, and 134 further illustrate the form of the nose, and especially individual variations.

FIG. 134.

Often a curve is a more useful outline for the nose, as is shown in Fig. 135. This indicates that the bridge is not made very much of. Some artists have kept the bridge well back, and

FIG. 135. FIG. 136.

have made a good deal of the tip—getting a sort of tip-tilted, or snub nose, not lacking however in beauty. (Fig. 136.)

24. The Mouth and Chin.

THE mouth, or more properly speaking the lips, form
a mass, as distinctly in excess of the ordinary surface of
the face as the nose or chin. In modelling a face a
separate mass must be added. It is the lips that form
the projection, the ends of the slit of the mouth being in
the general mass of the face. Every one knows the three
lines of the lips, and how the central and upper ones are
in shape somewhat like a Cupid's bow. The simplest
delineation of the mouth is shown in the small drawing,
Fig. 137, A. In this it will be seen that starting at the
centre between the lips, the slit forms "a line of beauty
and grace," a double curve that is, to either corner. This
arrangement is repeated, slightly varied, in the line of the
upper lip. If this diagram (A) be compared with the
mouth in the larger drawing, it will be seen that in the
latter the lines of the lips are much more complicated.
The slit describes two gentle curves before it has com-
pleted the one side of the lips proper; and then, what in
the diagram A is an ascending curve to the corner, is here
first an arched curve, similar to those previously traced,
followed by a sharp ascent to the corner. The same thing
is observable in the upper lip, except that the first curve of
the two is more rapid. The upper lip does not extend to
the corner as might be implied by A, although it is longer
than the lower. The curve of the upper lip in diagram
A is, however, far from untrue, for its extension to the
corner is based not on red lip, but on the *shadow* line
of the rapid turn of the modelling at B. The lips stand
high, as has been remarked, and the fleshy fold covering

the corner of the mouth stands high also, and between them, both above and below, is a hollow, depression, or gutter (C C), which folds into the slit at the side of the mouth, and assists very greatly in giving delicacy and beauty to the feature. The direction of the upper of these two channels is indicated by the shading lines.

In diagram A the corner appears wide, whereas in actual fact the slit is there hardly perceptible. This width of corner represents not so much the end of the slit or lips,

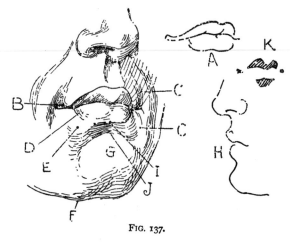

FIG. 137.

as the hollow or dimple formed by the fleshy fold already spoken of.

The mouth is made up of *alternating* channels and eminences. Thus, there is the well-known central eminence of the upper lip; this is opposed by the slight channel in the lower lip, a channel formed by the meeting of the two mounds of the lower lip, and therefore not at all inclining to a *concave*, but to a V-shaped channel.

These two mounds of the lower lip are opposed in the upper by a very gentle softening or depression. The

lower lip terminates abruptly, the mounds rounding off boldly (D). As if to balance or contrast with this sudden finish, the upper lip opposes a little extra fulness to the vacancy in the lower caused by its termination, and dies, but *not* abruptly, into the slit.

Another item of contrast between the two lips is that

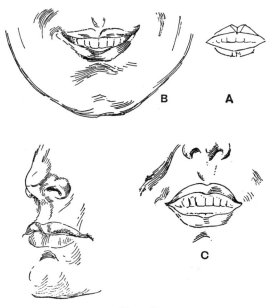

FIG. 138.

the upper has one high point, the whole forming more or less a point forward. The lower lip has two mounds of equal height, and thus presents a flattish front.

The two mounds of the lower lip are repeated in the two surfaces (E) beneath it, and again in the two bony prominences under the chin (F). The chin itself has its greatest prominence rather high, where the letter G is, and is remarkably similar in profile to the tip of the nose,

and the upper lip (H), all three being not only squarish
in form, but obliquely placed, and at much the same angle.

A "clear-cut" mouth has considerable sharpness at the
edges of the lips, a sharpness sometimes continuing the
whole length of the upper lip, but confined to the front
of the lower, since the rapid curving in D tends to make
a hollow rather than to throw up a ridge. The sharp
part of the lower lip (I), as well as the top of the chin (J),
are important in drawing, as they are generally sharply
accented. In "impressioning" the mouth one would seize
the little mass of shadow between these lines, the shadow
on the upper lip and the specks in the corners (K), thus

arriving not a thousand
miles from the treat-
ment of the mouth on
a child's doll. Diagram
K will further serve to
illustrate the fact, that
the corners are not on
a level with the division
between the lips, but
somewhat at the sides
of the lower one. This
is important; indeed
nothing looks so bad
as a gashy mouth.

The curved lines on
the lips in Fig. 138
indicate the direction
taken by the different
parts of the form. The

Fig. 139.

surfaces are modelled from the edges of the lips in to the
mouth. The lips may be said to be tethered to the corners

of the mouth by lines representing the edges of the opening beyond the lips themselves. These lines, as in A Fig. 138, are at an angle to the lips. This angularity is of great value in some cases, as in the mouth C.

Note that in the mouth B, in the same diagram, the lips are drawn against the teeth, which interfere with their form.

The relation of mouth, nose, and chin is further illustrated in Fig. 139. In that diagram we may also notice the direction taken by the folds of form round about the mouth. That is—from the nose to the cheek-bone, and then from the cheek-bone to the chin are folds of the skin forming a diamond shape. We observe that these folds are athwart the directions of the muscles. The muscles radiate from the mouth—these surround it.

25. The Ear.

THE names of the different parts of the ear will be found on diagram A, Fig. 140. The simplest outline shape of the ear is shown at D, and consists of an ovoid curve with a loop below, and another similar curve within it. The shape of the ear varies very greatly, and consequently a considerable latitude is allowed the draughtsman. Thus, the lobule below is sometimes small and drop-like, and sometimes broad, in which case it forms a fairly continuous ovoid curve with the upper part of the ear. As a rule, however, there is a distinct change of curve from the helix to the lobule. Between the helix and the anti-helix is a groove deepening and widening as it ascends. This sometimes appears quite wide and sheet-like in the ears of men, F. The width of the helix itself varies very greatly. It is a rolling over of the edge of the ear into the groove between it and the anti-helix. This rolling over is some-

times more and sometimes less complete and perfect. It
is more frequently well rolled in women than in men.
At all events it possesses, and generally exhibits, in the
upper part a sharp edge partially concealed by being
rolled or curled inward, which can easily be felt in one's
own ears. It is scarcely necessary to point out that the
helix wanders round the mass of the ear, receives a sort
of buttress from the cheek, and then proceeds further
inward and dies away about half-way down the ear,—a

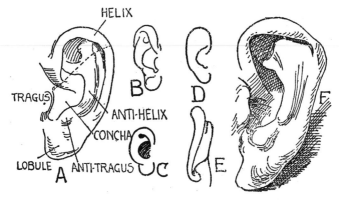

FIG. 140.—The Ear. F is a Male Ear.

useful landmark. The anti-helix starts at the eminence
called the anti-tragus, which makes a very considerable
elevation. From the anti-tragus the anti-helix turns
rapidly backward, and proceeds upward somewhat parallel
to the helix, finally dying away into the fold of the ear
by two extensions. The inner line of the anti-helix is,
as shown in D, not dissimilar to the outline of the ear.
The tragus occurring just before the concha, or *shell*, or
hollow, takes its name from the fact of its sometimes
bearing a number of coarse and long hairs, which suggest a
goat's beard.

It is of very great importance that the modelling of the ear should be studied quite as much as the outline or diagrammatic shape. An ear that looks flat is intolerable. It might almost be said that the modelling falls broadly into two masses, one upper and one lower. In Fig. 140, A, a dotted line will be seen frcm the tragus passing upward and backward. This virtually divides the two masses. The effect may be fairly seen in Fig. 141, C. The dotted line is roughly the nearest line of the ear to the head. From it at one side the helix sets off, and rises fairly high, forming the top of the ear, and descending as it approaches the other end of the dotted line. Similarly on the lower side of the line, what there is of the helix below gradually rises, the gradient being continued in the lobule, the higher part of which is to the backward, from which the modelling sinks to the cheek edge of the lobule. The modelling of the anti-helix and anti-tragus is bolder. They may rise as high as the helix where it joins the lobule, but not higher. Viewed from somewhat before, the anti-helix hides part of the helix, as is shown in Fig. 140, B, where also the palpable twist of the upper part of the helix is shown.

Broadly speaking the ear is as two arches, one above passing from before backward, and one below passing vertically upward *under* the upper arch.

In expressing modelling as opposed to flatness, no artist has excelled Dürer; he was never insipid, never tame, and one reason is that his modelling was so distinct and bold. In his ears he carries out the same system, the convolutions intertwine like serpents. The diagram C is enlarged from a very small ear in one of his wood-cuts. The means of production, the coarse wood-engraving of the time, compel him to epitomize. There are therefore very

few lines, but he has expressed exactly the in-and-out character of the feature.

The back view of the ear shows the outside of the concha supporting the main mass, E.

The position of the ear is just upon the edge of the jaw. In men it is almost vertically placed; in women it is inclined considerably backward, and is smaller proportionally.

It must be observed that the masses seemingly round in section are often flattened or doubled. The expression "doubling" may stand for the placing of, say, two smaller curves in place of one large one, or representing, instead of a half globe, a form which approaches that shape, but has two mounds. In

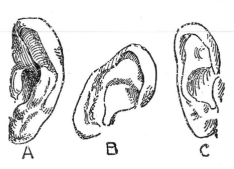

FIG. 141.—Three Female Ears.

the ear there are many instances of doubling, sometimes trebling and quadrupling. Thus the lobule contains really not *one* domed surface, but several. (See Fig. 141, A and B.) The helix is very often doubled, especially in men, there being a suggestion of two circular cords twisted in one mass, rather than *one* circular cord of equal bulk. This results in flattening. (Fig. 140 F, and 141 A and B.) The latter two examples are taken from a book on drawing published in Venice in 1762. A bad period, the reader will say. Bad for many things, unfortunately, but the flesh always looks fleshy, perhaps even doughy, and there is an excessive care for the "doublings," as they have been called

above. Artists of this period seem to have carried their study and expression of fleshiness and squareness of form rather too far; but it is doubtful whether we shall run to quite such lengths; and a glance at their works may be rather beneficial than otherwise.

26. The Wrinkles of the Face.

WRINKLES form at right-angles to the direction in which the muscles act which produce them. Wrinkles *hang* like drapery from the most prominent points—or appear to do so. The thickness and weight of the part wrinkled affects the direction, as also does the combination of several muscles of somewhat different direction.

Where the substance is considerable the wrinkle becomes a "fold."

The wrinkles of the face follow the laws specified above, and are illustrated

FIG. 142.

in Figs. 142 to 147.

The brow may be corrugated, as in Figs 142 and 147. Some trace of these wrinkles, above the nose, always remains. Or

FIG. 143.

FIG. 144.

the forehead may be wrinkled horizontally, as in Fig. 145. This action leaves permanent wrinkles also. From the root of the nose there flow wrinkles down under the eye, and down the cheek under the jaw. There is one fold from over

FIG. 145.

the wing of the nose, and another beneath it over the corner of the mouth. These two are present in all heads, and the student must note that he cannot make one fold serve for the two. Even in the heads of girls, which are supposed to be free

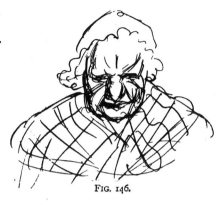

FIG. 146.

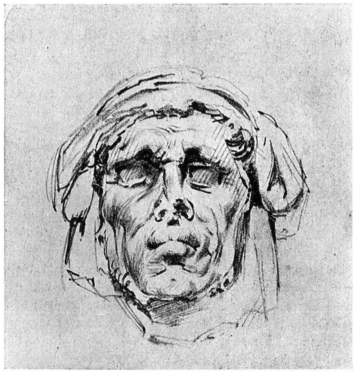

FIG. 147.—Terra cotta Mask by Michael Angelo, in the Victoria and Albert Museum. Size of the original.

from all evidences of age or trouble, there must be one
fold over the wing of the nose, and one over the corner of
the mouth.

Beneath, one might almost say on, the lower lid of the
eye a crease forms between the lid and the edge of the
tear-pouch. (Fig. 143.) Then above the eye another comes
from the root of the nose, and twists round the brow into
the temple. From the outer corner of the eye a set of
very definite wrinkles spread out, and come down in front
of the ear.

In front of the tragus of the ear wrinkles, belonging to
the drooping lines of the cheek, arise, as if the tragus were
a stationary point.

Reference has already been made to the folds surround-
ing the mouth, contrasting therefore with the directions of
the muscles. Compare Figs. 139 and 147.

27. Facial Expression.

THE artist understands expression to be the peculiarity
of form which arises from, and which consequently indi-
cates, particular actions and emotions. The peculiarity of
form is produced either by necessary mechanical move-
ments of the body, or by apparently unnecessary changes
in minor parts. These unnecessary changes affect chiefly
the face, and we consequently speak of facial expression.
But the minor parts also include the fingers and toes;
indeed, there is a tendency for the whole body to undergo
some sort of convulsion or relaxation. The result is that
whatever is free enough to suffer change does so to some
extent, and the most mobile parts are the muscles of the
face, the fingers, and the toes.

Why certain movements of the body accompany certain

emotions the artist need not inquire. He must work by feeling, and his "feeling" is as sure a guide as is the theory, or observation, of the scientist.

The draughtsman must be careful therefore to carry the expression throughout the body, and not to limit it to the features. Especially should the hands be considered. Wilkie said a man had one head, but two hands. The two hands must both belong to the one head, and they

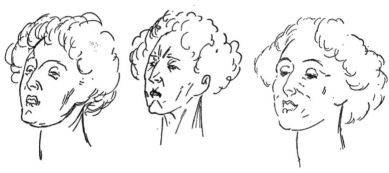

FIG. 148.	FIG. 149.	FIG. 150.
Haughtiness.	Dignity offended.	Dignity gracious.
Fulness below jaw, mouth slightly open, lower lip forward, nose constricted, eyes closed partially, brow raised.	Mouth closed by lower lip being held firm, brows frowning and corrugated.	Wing of nose relaxed, smile developed by corner of mouth being drawn up and back.

must evince the same emotion. Such movements of the hands as are thus necessary are to be rendered with the greatest delicacy. It is not the gesture merely, but the gesture in its refinement that is expressive. This means that some delicate turn of the wrist, some delicate relative position of the fingers, and so on, have to be considered.

We have said that the artist need not trouble himself with the reasons why the different emotions are connected with different muscular actions, but some guide to the co-relation between the expressive action of feature and

limb would be useful. The expressions seem to arise from some kind of self-assertion or self-reservation. Self-assertion is accompanied by—lowering of the brow, scowling—by opening of the eyes—by dilating the nostrils—by pushing the lower lip and the lower jaw forward—by puffing out the upper lip and the cheeks, the mouth being closed as in blowing a trumpet—by expanding the frame and opening the limbs, keeping, that is, the shoulders back, the chest high, the back straightened, the elbows back and

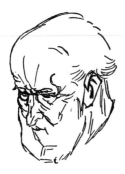

FIG. 151.
Thought or concentrated attention, as in prayer.

FIG. 152.
Thought or concentrated attention, the Head being raised.

FIG. 153.
Thought, with casual observation. Thinking out ways and means.

palms forward, the wrists firm, the thumb out, the knees firmly back, the toes gripping the ground.

In self-reservation the opposite actions are employed. The brows rise—the lip and jaw recede—the eyes close—the nostrils are contracted—the body bends on itself (curls up)—the shoulders crouch—the elbows come forward—the arms cross the body—the slack wrists curl inward—the fingers fold up, and their action is towards tightening (augmenting) the curling—the knees come together, and bend—the heels separate, and the great toes meet.

An emotion does not always rank itself entirely on the side of assertion or reservation. Very often there is quite a complicated mixture of abasement and assurance. For instance, haughtiness, aloofness, or carrying the head high is accompanied (Fig. 148) by certain assertive actions— the erect neck (extended) and the projecting lip and chin are assertive, but the raised brow, the closed eyes, the constricted nose are indications of reserve. Haughtiness, or an "aristocratic bearing," is a combination of assertion and reservation. If something offensive occurs and ruffles a lady's serenity, she will probably add another assertive action—frown, perhaps, as in Fig. 149. Or if she is pleased she may relax her haughtiness, and show a little affability. In such a case she smiles. A smile indicates satisfaction of the smiler at something or other; it is not an aggressive action, and yet is due to rather a lack of restraint (and reserve implies restraint). The smile is indeed, and the laugh is its big brother, an expression on its own account—it is an assertion of one's own personal satisfaction.

The quietest expression is *thought* or *silent contemplation*. The head is usually bent down (Fig. 151), but it may be held up if there is no aggressive expression (Fig. 152). The eyes look either downward or outward, but not sideways. If the eyes look sideways the thinking is less concentrated, and becomes rather of the order of thinking out ways and means. The sideways looking of the eyes generally suggests casual observation, though, as has been said, a wandering eye denotes speculative thought, as if the person were seeking some idea, and was not reflecting upon some definite theme. "Prayer-time" would be a good subject to bring out one's powers of managing the fixed or the wandering attention.

In all these expressions much depends upon the degree

to which the eye is shown in tight movement. In the more meditative emotions the eye is not actively used ; in actual observation, whether attentive or suspicious, it is purposely moved about, and the drawing must show that it is. When the eye is used with a purpose it is rolled further, and its lids are opened wider, than in the casual movements.

In severely concentrated attention, as when the thinker would ward off extraneous ideas and defend himself against interruption, some pugnacious assertion is usual. Such an

FIG. 154.
Inward communion.
Knit brow, pro-
truding lip.

FIG. 155.
Light turn of Thought.
Eye turned, lip and
jaw relaxed.

FIG. 156.
Contemptuous dignity.
Corner of mouth de-
pressed, fold forms
beneath it.

expression is common in prayer, as in Fig. 154. A light turn of thought at once sends the projecting lip back and relaxes the jaw. (Fig. 155.)

The protrusion of the lower lip is closely connected with contempt. Contempt is expressed by closing the mouth and pulling its corners down by means of *Depressor labii inferior*. This muscle wrinkles the skin below the corner of the mouth, and at the same time stretches the fold of skin which comes from above the wing of the nose down round the mouth.

When one is sceptical one is somewhat contemptuous, and consequently one depresses the corner of the mouth. At the same time one raises the brows as in surprise. Two degrees of this expression are given in Figs. 157 and 158. Note that this expression is a mixture of assertion and reserve. The raising of the brows is abnegatory, as if one would disparage one's opinion ; while the lowering of the mouth is aggressive, as if one would oppose what is suggested.

If, however, one can brush aside and laugh at the

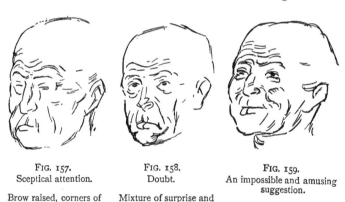

FIG. 157.
Sceptical attention.

FIG. 158.
Doubt.

FIG. 159.
An impossible and amusing suggestion.

Brow raised, corners of
mouth depressed.

Mixture of surprise and
contempt.

suggestion one is doubtful of, one relaxes the contemptuous expression, but retains that of surprise. (Fig. 159.)

In severity and anger there is a knitting and lowering of the brows, a pushing of the mouth and chin forward, and the contemptuous drawing down of the corners of the mouth. (Figs. 160 and 161.)

How easily anger may be turned aside (in a drawing) is illustrated in Fig. 162. There the corners of the mouth are made to slope inwards, with an immediate amiable effect.

The elements of the smile and laugh are given in Fig. 162, B.

One of the most important details connected with the expression of laughing is the pursing up of the lower eyelid.

In laughing the mouth is drawn back toward the ear, and is opened. All the muscles from *Zygomaticus major* round to *Depressor labii inferiores* seem to take part in the action. Of all, however, *Risorius* (which is a thin superficial muscle stretching from the corner of the mouth back over

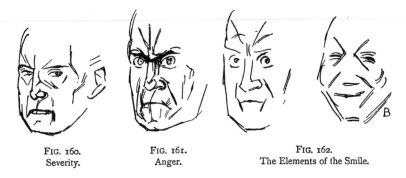

FIG. 160. FIG. 161. FIG. 162.
Severity. Anger. The Elements of the Smile.

the cheek) is the chief. Although a laugh is much the same as a smile, it differs in being a more general movement, and affects a larger surface of the face. The opening of the mouth is what distinguishes it from the smile, which is a raising of the corners of the mouth, or rather a drawing of them backward and upward, without the mouth necessarily being opened.

When to smile and when to laugh, or perhaps what degree of the laugh should be permitted to give vigour to the smile, has long been considered an art too difficult for the masculine sex to master.

A grin is a restrained laugh, a sort of smile made with

the laughing-muscle. A laugh has always a beginning, a
middle, and an end—phase following phase. A grin is too

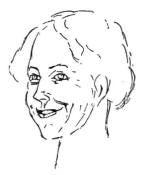

FIG. 163.
Smiling.

Corner of mouth pulled up by zygomati-
cus major, lower eyelid raised, upper lid
lowered so that the eye is nearly closed,
depression of brows in the middle, and
raising at the outside.

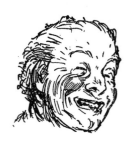

FIG. 164.
Laughing.

Cheek puckered by risorius muscle,
inner part of eyebrow raised, wrinkles
formed against and beneath the eye.

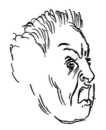

FIG. 165.
Surprise, Disgust, and
Vexation.

Outer brow raised, inner
brow depressed, wing of
nose raised, corner of
mouth depressed, upper
lip curled, lower lip for-
ward.

FIG. 166.
Surprise and Amuse-
ment.

Outer brow and corner
of mouth raised. Wing
of nose toward ear.

FIG. 167.
Pure Smile.

Corner of mouth back
and slightly raised.

FIG. 168.
Derisive Laughter.

Lower lip down and
retiring.

stationary to be a laugh, and is rather the expression of
the recognition of a humorous situation than of pleasure
derived from it.

Very nearly related to the expression of joy is the expression of sorrow. A depression of the lower lip, or rather of its corner, and a raising of the upper lip, but not of its corner, are the evidences in the face of the emotion of sorrow. As laughing passes to crying, the corner of the lower lip, the corner of the mouth, instead of being drawn back is drawn down, a distinct opening of the mouth at the corner being observable. As the smile passes to the " sickly smile " of grief, the border of the upper lip, near, but not at the corner, is raised—by the *Zygomaticus minor*.

Fig. 169.
Fright.
Eyes open, corners of mouth depressed. Action of platysma myoides.

Figs. 170 and 171.
Grief.
Inner brow raised, inner part of upper lip raised, corners of mouth depressed, cheek depressed, nose constricted.

With the grief becoming settled and positive, the lip more toward its middle is raised by the *Levator labii superior*. The last of the series of muscles raising the lip, *Levator labii superiores et alæ nasi*, supplants the expression of grief with that of contempt.

This, consequently, is the muscle of the supercilious expression and of consequential dignity. The raising of the nostrils is, however, only permitted to dignified personages when they wish to express that they are grossly offended, as by something malodorous. To raise the

middle of the upper lip without at the same time raising the nostrils is one of the refinements of expression.

Ardent grief is accompanied by a depression of the nostril, with a consequent pinching together of them, and that death-like tension is obtained which so constantly accompanies noble grief. It is a question for the individual artist whether in god-like grief there is not a dilation rather than a constriction of the nostril, for it could be said that god-like grief was, after all, only transitory, and should not have any suggestion of death confused with it. On the other hand, no human grief is greater than that which continues till death.

The yawn, like the laugh, has its phases. When it begins the brows are raised, the person is dead tired and opens his mouth to its fullest extent. (Fig. 172.) When this is going on the cheek is bulged out considerably by the ramus of the jaw coming forward before the ear. In this stage, too, the eyes close, and the folds of the face are due to the mere stretching apart of the jaws. The next stage is more lively, and the climax of the stretch is reached. The nose and cheek become puckered by muscular action, the brows are suddenly brought down and corrugated, and the eyes open partially and look wildly about. The last stage, Fig. 177, shows the mouth closing after its exertions and the other contortions slowly relaxing.

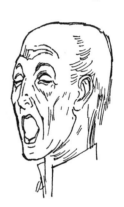

FIG. 172.

In singing there is no corrugation, or raising or lowering of the brows, the throat is held more firmly by the muscles, and the eyes are not subject to change.

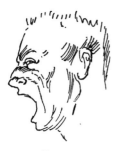

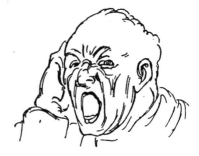

FIG. 173. FIG. 174.

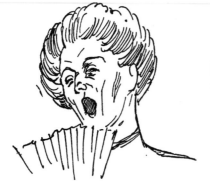

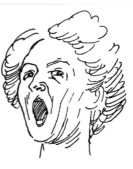

FIG. 175. FIG 176.

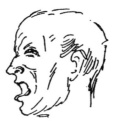

FIG. 177.

Phases of the Yawn.

28. The Bones of the Neck.

TWO views of the bones of the neck are given in Figs. 178 and 179. The names of the different bones and of the parts of them will be found on the diagrams. It will

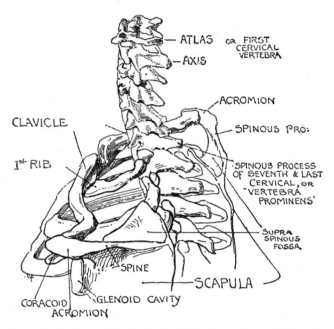

ATLAS OR FIRST CERVICAL VERTEBRA

AXIS

ACROMION

CLAVICLE

SPINOUS PRO:

1ˢᵗ RIB

SPINOUS PROCESS OF SEVENTH & LAST CERVICAL, OR 'VERTEBRA PROMINENS'

SUPRA SPINOUS FOSSA

SPINE

SCAPULA

CORACOID GLENOID CAVITY
ACROMION

FIG. 178.—The Bones of the Neck with the Clavicles and part of the Scapulæ.

be seen that the neck-bones proper are an elongation of the back-bone, and that the part of the back-bone which occurs immediately below supports the ribs, and the ribs support the breast-bone, the sternum. It will be further seen that the collar-bones and the blade-bone, which

together form the shoulder girdle, are attached to the bones of the trunk only by the articulation between the collar-bones and the hilt of the sternum.

It will further be seen that the collar-bones lie on the top of the front end of the uppermost ribs, and again it will be observed that there is a bony ridge, the spine of the scapula (blade-bone), and that this ridge forms a continuation of the narrow surface of the collar-bone round

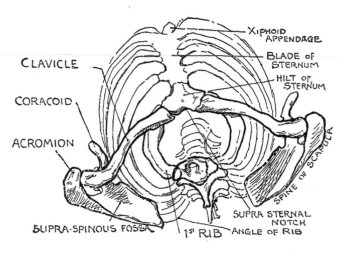

FIG. 179.—The Bones of the Trunk viewed from above, showing the shape of the bony base of the Neck.

the shoulder and on to the back. This continuous ridge is well seen in Fig. 179. The two collar-bones (clavicles) form a well-rounded front to the top of the chest, and then gracefully turn out again, and have their outward curve continued in the acromion process of the spine of the scapula.

There is a joint therefore at each end of the clavicle, and these joints are fairly supple.

At the moment, we are considering the bones in relation to the neck, and notice therefore that this continuous ridge made by the clavicles, the acromion, and the spine of the scapula forms the outer base of the neck, while the uppermost pair of ribs forms the inner base. Both of these are of the very greatest importance.

We must notice particularly that the clavicles are very well rounded in their first half. It is better to think of the clavicles as going round to the spine, than to think of them as straight lines going to the shoulders. In the diagrams in this book in which the neck is introduced it will be noticed that this curved part of the clavicles is generally shown boldly curved, and as if passing into the volume of the neck.

The top pair of ribs is also of great importance, especially in the necks of women. Its importance in that case is

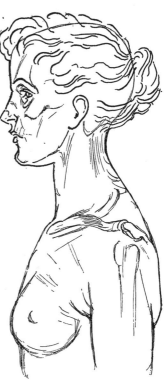

FIG. 180.—The Character of the Bones of the Neck in Woman.

due to its prominence, for the clavicles are lower, and it is consequently more exposed. The first ribs in woman slope down at a greater angle than in man, and the bulk of the thorax (bony basket of the chest) being less, the clavicles also droop toward the shoulder, which is con-

sequently rather lower. All this gives prominence to the upper part of the top ribs, which therefore gain in importance. Indeed, it is no exaggeration to call the top pair of ribs the inner base in the neck of a woman, for its influence on the form is unmistakable. It is they that help to support the necklaces. Let us notice that these ribs form with the inner or convex part of the clavicles a fairly continuous surface, as if, indeed, the clavicles did not pass to the shoulders at all.

We must now notice that the inner and outer bases are not in the same plane. The inner (the top ribs) slope downward, the outer (the clavicles and the spines of the scapulæ) slope backwards and downwards.

We must notice finally that the obliquity we have observed in the lower part of the neck in woman is extended also to the upper part. The back of a woman's skull slopes up somewhat, whereas that of a man is squarer. The result is that the neck of woman is lengthened both behind and before.

29. The Sterno-cleido-mastoideus.

THE muscle is seen in its completeness in the three-quarter view of the neck. The sternal head appears the more important, lying in a direction very suggestive of a lady's bonnet-string. Above, under the ear, it forms one mass with the clavicular head, and the section of the two together is that of a swollen ribbon-form, being at once fleshy and broad. The form of the mastoid process itself helps to govern the section, the mastoid resembling an inverted fir-cone, somewhat flattened. The sternal head descending becomes rounder in section, the widest part of

the whole muscle being at about the half-way down its course. The sternal head is concluded by a cord-like tendon running on to the breast-bone. This tendon is *in front* of the muscle, and hence even in well-fleshed women and children it shows in many poses as a sharp cord. Indeed sometimes when the borders of the various muscles are quite lost in one soft somewhat cylindrical

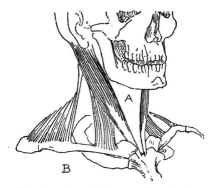

FIG. 181.—Sterno-cleido-mastoideus Muscle.

Attachments—Above, to the mastoid process of the temporal bone
 and backwards some distance along the superior curved line of
 the occipital—below, by the inner or sternal head to the front
 of the top of the sternum, and by the clavicular head to the
 innermost third of the upper border of the clavicle ; the head of
 that bone lying between the two attachments.

mass, these two tendons start up buttress-like from either side of the pit of the neck. (Fig. 182, B.)

One of the actions of this muscle is to turn the chin toward the contrary shoulder, when the tendon is seen as a very sharp cord, though perhaps at its sharpest in the action of raising the head from the ground, when the person is lying on the back. . Then the whole muscle, up to the mastoid, becomes cord-like.

The clavicular head is fairly broad and ribbon-like. It

assists in splaying the neck on to the shoulder. Between the two attachments is the head of the collar-bone, showing very prominently, while above it is a small triangular vacancy between the two "heads." The mistake must not be made of attaching the cord-like tendon to the head of the collar-bone.

In thin and muscular persons, particularly in men, the borders of the muscle show with considerable distinct-

FIG. 182.—Effect of the Sterno-cleido-mastoideus.

ness. The modelling is most voluminous at about the middle of the sternal head, swelling out under the angle of the jaw, and meeting the mass of the throat with considerable abruptness. (Fig. 182, D.) Immediately under the angle of the jaw there is a softening which is shown in the diagram (C), as if the inner border of the muscle turned sharply round to the jaw. The sterno-cleido-mastoideus, lying then as a diagonal cord-like projection, makes the outline in three-quarter and similar views. Its curve is almost always a full swelling curve returning sharply where

the tendon occurs. It is straightest when the chin is turned to the contrary side, and the neck is stiff; but sometimes with this action the line is considerably broken and angular.

30. The Throat.

BETWEEN the two sterno-mastoids, or bonnet-strings, is the triangular space of the throat. Its apex is at the pit of the neck, its base from angle to angle of the jaw. Another triangle extends from this same base to the chin, and the two together form the space now to be spoken of. At this common base lies the *hyoid* bone, or *U-shaped* bone of the tongue, generally omitted from the specimen skeletons to be seen in our schools. It lies fairly horizontally, with the tails of the U directed backwards, and is not too deep but that it may just be felt. This hyoid bone is the uppermost piece of the larynx, the swallowing and vocal apparatus, the other pieces being the thyroid and the cricoid cartilages. It is the thyroid cartilage which forms the mass of the Adam's apple. Upon it occurs a little extra projection coming close up to the skin. The thyroid cartilage is in shape a short piece of a tube, and beneath is the cricoid or ring cartilage, somewhat similar in front to the hyoid bone. These forms are all more distinctly seen in men than in women, for two reasons : first, because they are larger and lower, and second, because they are less masked by the *thyroid body*, a gland which is not only larger in women but more prominent also, supplying the graceful fulness before a woman's throat. (See Fig. 200.)

In drawing the neck front view, it will be found that the tubular mass, the thyroid cartilage, must first be expressed,

and will fill up very nearly the space between the sterno-
mastoids if these are well developed. Then the centre of
this mass must be peaked with the sharp projection before-
named, while below must be the second horizontal ridge,
the cricoid cartilage.

If the chin be held up, and the action of gasping be
performed, all the forms of the throat will be brought out,
and these amount for the draughtsman to two divergent
masses above the apple, and, say, four divergent masses
below it, while on either side is a soft, less formal mass
filling up the diamond of the throat. (Fig. 184, A.) The

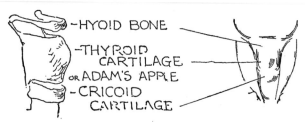

FIG. 183.—The Larynx.

divergent masses virtually meet on the hyoid bone. The
muscles which produce those forms are too numerous and
small for a detailed description to be much more valuable,
practically, to the draughtsman than what has already been
said. One only need be specified by name, the *omo-hyoid*.
(Fig. 184, B.) The importance of this little choking muscle
is due to its being the sole disturber of the emptiness of the
triangle on the other side of the sterno-mastoid. The omo-
hyoid runs from the upper border of the blade-bone to the
hyoid-bone. Although the blade-bone is most distinctly at
the back of the figure, yet the part above the spinous
process of it comes forward considerably. The omo-hyoid
is, moreover, a double muscle, having two fleshy bodies

continuous with one another, somewhat, may it be said, as two sausages, and joined together in somewhat similar fashion by an in-termediate tendon. This intermediate tendon passes under the sterno-mastoid, which appears to hold it down, and form a central at-tachment. From

FIG. 184.—The Throat. B, the Omo-Hyoid.

this position the muscle proceeds in a new direction, more vertical, up to the hyoid-bone. This upper part, in the throat, shows no more than the other small muscles of that region. The lower part is a little more in evidence, making a dull prominence along its course, though often hardly discernible.

31. Some Subordinate Muscles of the Neck.

AT the side of the neck will be seen three comparatively unimportant muscles. These are the *Scalenus*, the *Levator anguli scapulæ*, and the *Splenius capitis*. There are properly three Scaleni—anticus, medius, and posticus.

The Scaleni, divergent downwards, and standing upon the first and second ribs, form the spreading base of the neck. Very little of them reaches the surface, but this little forms an important mass at the side of the neck (Fig. 186, A), a mass which fills the apex of the external triangle of the neck. The line representing in a drawing the Scaleni radiates with the Cleido-mastoid from under the ear (B).

Splenius capitis and Levator anguli both show a little

of themselves against the Scaleni. Their position is, how-
ever, higher and further back. If they make any surface
lines they will be similar to the Cleido-mastoid and
Scaleni, radiating downward from behind the ear; but
while the Scaleni line is about vertical, these will run
backward a little (c).

Perhaps the Splenius and Levator are most useful for
their suggestiveness of form, rather than for their actually
providing any themselves, or alone. Thus Splenius capitis

FIG. 185.—Minor muscles of the neck.

A. Splenius capitis. Attachments—Occipital bone and mastoid
process of temporal—Spines of the vertebræ of the lower part of the
neck and upper part of the back, and the ligamentum nuchæ.

B. Levator anguli scapulæ. Attachments—Transverse processes of
first to fourth cervical vertebræ—Angle of the scapula.

c. Scalenus, anticus medius, and posticus. Attachments—Trans-
verse processes of certain of the cervical vertebræ, the anticus to the
third, fourth, fifth, and sixth, the medius to the second to the seventh,
the posticus to the fifth, sixth, and seventh—anticus to forepart of first
rib, medius to hinder part of first rib, posticus to hinder part of second
rib.

assists one to realize the upward divergent character of
the form of the neck, which is subtly interwoven with the
downward divergent as represented in the Scaleni and in

the Levator anguli scapulæ. Almost all of the Levator is hidden under the large muscle, the Trapezius, which has next to be noticed, but the form of the neck is much more readily suggested by the Levator because, as will be seen,

FIG. 186.—Mass produced by the Scaleni.

the Trapezius does not take the shape which seems most logical, considering its attachments, but is bound down till it takes its form from the muscle beneath, the Levator.

32. The Trapezius Muscle.

A TRAPEZIUM is a geometrical figure having four sides, a kind of elongated diamond. The four points of the muscle Trapezius are at the occipital bone of the skull, the spine of the last dorsal vertebra, and the two acromions. The muscle properly is in two triangles, with bases together at the spines of the vertebræ and apexes on the shoulders. Only the upper part of this muscle is concerned in the neck, and it must be noticed that instead of there being a direct line from the back of the head to the acromion, there is a double line following in the upper part, the Levator anguli, and in the lower seeming to connect the

acromion with the fifth or sixth cervical vertebra. Indeed there is a sort of cord-edge visible in the back passing in the direction described (Fig. 188, A.). The part above this, and forming the narrow back of the neck, passes to the front.

The cord-like edge forms the back line of the base of the

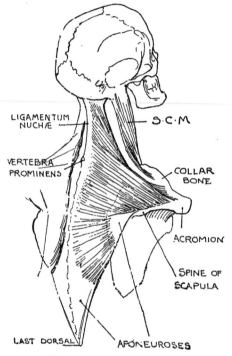

FIG. 187.—The Trapezius Muscle.

Attachments—Spines of all dorsal and last cervical vertebra, ligamentum nuchæ, from last cervical to occipital protuberance, and one-third of superior curved line of occiput—Outer third of hinder border of collar-bone, inner border of acromion, upper border of spinous process of scapula, all in continuity. There is an aponeurosis at the vertebral insertion, which expands around the vertebra prominens and also at the lower end, and there is a triangular aponeurosis, covering the root of the spine of the scapula.

neck and the upper limit of the trunk. From the cord-edge the muscle falls softly forward over the shoulder till it reaches its insertion on the outer third of the collar-bone, and thus completes the outer triangle or salt-box of the neck. (Fig. 188, B.) The border is hardly perceptible in the lower part upon the shoulder, melting gently into the

FIG. 188.—Effect of the Trapezius on the neck.

general mass, but the narrow part up the neck shows its edge pretty clearly (D).

33. Proportions of the Neck and Shoulders to the Head.

THE length of the neck in diagrammatic front view is from the chin to the heads of the collar-bones, three inches in man; in woman a little more. Or, finding an equal measurement up the face, it falls in man at the top of the wings of the nose; in woman at the middle of the nose, A and B, Fig. 189.

In profile it may be noticed that the length from the nose to the end of the chin is about equal to the neck from the corner under the chin to the hollow just above the head of the clavicle, C; while the horizontal under-side of the chin is less than, or is perhaps equal to, the distance from the chin to the top of the mouth, E.

As to the width of the neck, it may be taken as equal to

the width of the jaw at the angle, and the outlines may be commenced there, as is shown in the diagram. The length of the male neck to the bottom of the pit of the neck is $3\frac{1}{2}$ inches. The male collar-bone is 6 inches, the female $5\frac{1}{2}$ inches, in length. With an inch for acromion these measurements become 7 and $6\frac{1}{2}$. An exact rule for proportioning this to the head, or head and neck, seems impossible, but a tolerable guide is this—that the distances

FIG. 189.—Proportion of the Neck to the Head.

from the pit of the neck to the bridge of the nose, and to the end of the acromion, are equal, the limit being considered to fall lower down the nose in woman than in man.

34. The Form of the Neck.

THE neck is fairly cylindrical, especially in woman, and this cylindrical character is best seen when the shoulders are raised, as in Fig. 190, A. In man the greater prominence and apparent hardness of the muscular forms take away the smoothness, and render the term "cylindrical" less appropriate.

The lower part of the cylinder is hidden within the great

"buttresses" which the trapezius forms on either side. (Fig. 190, B.) These buttress masses are of the greatest importance, both in the necks of men and women. They slope down to the collar-bones. Although the "buttress"

A B

FIG. 190.

is separated from the sterno-mastoid by a hollow (Fig. 191), there is yet, in the necks of women, a degree of association between the two masses. This is due to the sterno-mastoid being fullest at its middle, shelving back down to the pit of the neck and the collar-bone, and retiring under the jaw and ear. The fulness is thus in proximity to the fulness of the buttress, and the form seems to pass from either side of the throat obliquely to the shoulders. This melting of the neck into the trunk is a great addition to the "charms" of woman.

Comparing the necks of man and woman in side view (Figs. 192 and 193), we see at once that that of the woman is incomparably the more graceful. It is longer, more supple, and consequently can bend more completely, its lines are more flowing, and continue further. The back of

the neck in man, instead of having the graceful hollow
curvature of woman, bulges out considerably, more than

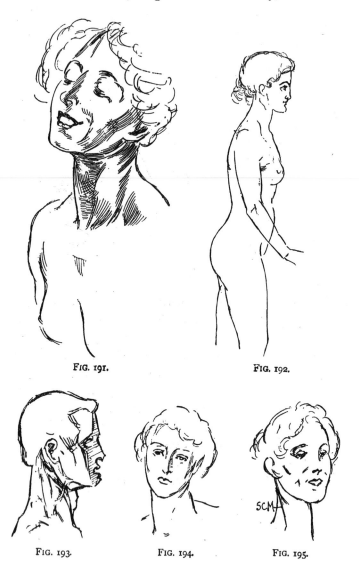

FIG. 191. FIG. 192.

FIG. 193. FIG. 194. FIG. 195.

the head above, sometimes, in the unidealized real man.
(Fig. 196.)

In the front of the neck there is a similar contrast. The
Adam's apple being higher and
smaller in woman, the throat is
looped up higher than in man ;
there is moreover a fatty fulness
below, which a man's neck has
not the advantage of. The
result is that the neck of woman
is narrower above than below
(Fig. 192), while the opposite is
true of the man's. (Fig. 193.)

The wrinkle in the side of
the neck is of great importance.
It should never be omitted.
It comes gracefully over from
the back, about an inch below
the skull, and passes forward
over the mastoid mass. (Figs
191, 194, 195, and 197.)

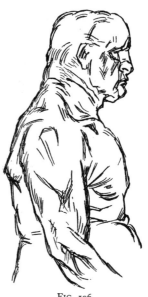

FIG. 196.

In Fig. 198 the planes of the neck are illustrated, and we
will run through them. 1 and 2 are two surfaces of the
sterno-mastoid, and the ridge between them is the highest
in that part of the neck ; 3 and 4 are two surfaces of the
trapezius, the ridge between them twisting round to the
back ; 5 and 6 are for the collar-bone ; 7 is part of trapezius
and splenius; 8 is part of sterno-cleido ; 9 is the side of the
jaw ; 10 is part of trapezius ; 11 and 12 are for the scaleni ;
13 and 14 for omo-hyoid. Note the channel between 7
and 10, and between 8 and 1. The nearest ridge to the
spectator is that between 3 and 4, then comes the ridge
between 1 and 2, surfaces 7, 10, 11, and 12 lying lower.

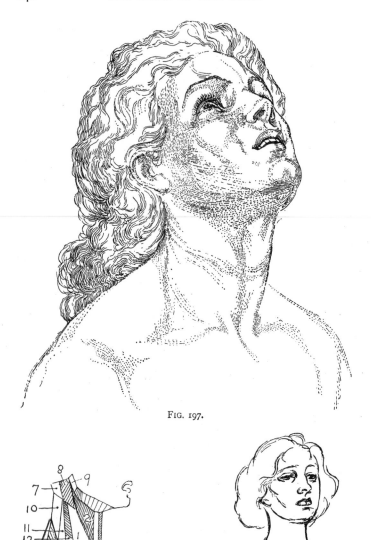

FIG. 197.

FIG. 198.

FIG. 199.

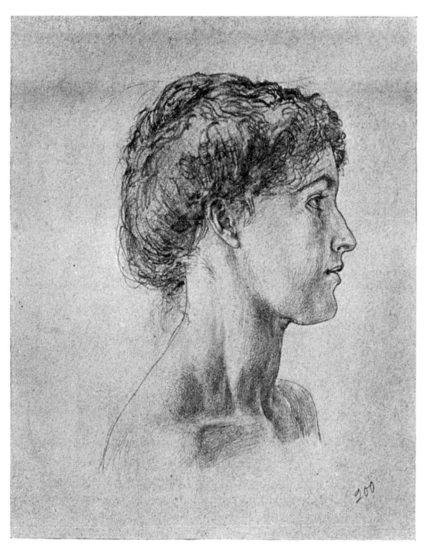

FIG. 200.

Often the neck in woman has definite curves for its two outlines, as in Fig. 199. We see also in that illustration that the back line begins close after the jaw. It is well indeed to commence the back line by drawing the sterno-cleido, putting the trapezius below it, as in Fig. 195, for the neck is thinner at the back, and the trapezius, in its upper part, is usually hidden.

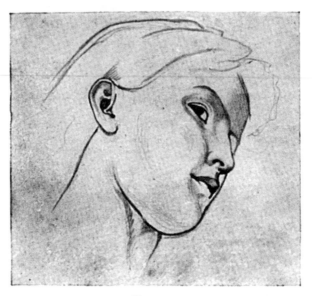

FIG. 201.

The various details are pretty well seen in Fig. 200. In Fig. 201 we notice the graceful fulness at the back of the neck, a fulness which, however, ceases close against the head, as in B, Fig. 203.

It need only be mentioned that the external *jugular vein* crosses the sterno-mastoid at about the middle of its course, coming from beneath the angle of the jaw. (Fig. 203, C.) It sometimes shows conspicuously for a

short distance, during exertion, beside the mass of the omo-hyoid.

The *Platysma Myoides* (D) is a skin muscle covering the whole of the front of the neck, and reaching up the face as high as the mouth and cheek. Its extent is remarkably similar to that of the camail, or capmail (E), worn in the fifteenth century. The fasciculi, or fibres of the muscle, radiate from the region of the mouth, some going almost immediately backward, and assist-

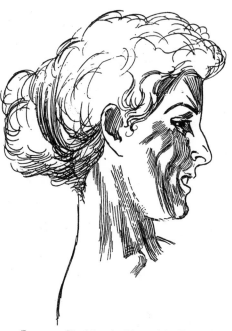

FIG. 202.—The Muscular Lines of the Neck, and the Folding of the Flesh of the Face.

ing in the expression of laughter, the rest spread out

FIG. 203.—Some Details of the Neck.

over the neck towards the collar-bone. It is a muscle of very little account, and possibly of most use in making

ugly faces, after the manner of a Chinese bogie, and in shivering.

35. The Head and Neck of a Child.

THE head of the child is remarkable for the relatively smaller face. The chin is well back, the angle of the jaw

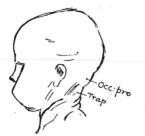

FIG. 204.—The Profile.

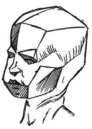

FIG. 204A.—The Planes.

FIG. 205.—The Form simplified.

FIG. 206.

is small, the zygoma is, however, of a good width. The forehead projects above and is somewhat pointed in front, vertically. This pointed character continues up the cranium, which rises high, very much as it does in woman. The back of the head slopes outward as it descends, so that the cranium has the effect of being placed obliquely, rising towards the back. The occipital protuberances are very marked

(Fig. 204), and the trapezius muscles start from them, apparently, in two cord-like forms. The neck is short, and the wrinkles in it very marked. The muscles of the neck, as the sterno-mastoid, show very sharply, as if they were unequal to the strain, and were stretched. The diagrams perhaps sufficiently explain the form, the planes, and the wrinkles, without further words.

THE TRUNK

36. Chief Characteristics.

THE first marks on one's paper in drawing a figure, are probably a slight stroke to fix the top of the head, another for the ground, a third for the centre of the figure, and two faint lines to indicate the position and obliquity of the shoulders and hips. Then it is perhaps best to indicate the bulk of the thorax and hips, as in Fig. 33, A, by a line at either side of each—four lines in all. These four lines allow not only the relative position of the two parts to be suggested, but the sex also. For a man, the chest must be wide and long, the hips narrow and short; for a woman the chest must be narrow and short, the hips long and wide. (Compare A and B, Fig. 207.)

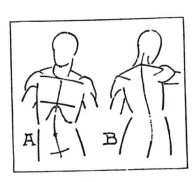

FIG. 207.

After the four lines just spoken of, the head and neck will be massed-in, if a front view is required; and then the

146

slanting lines of the shoulders, pointing to the chin ; then a line for the collar-bones. In a back view one would probably draw the slanting lines of the shoulders, as in B, before the head.

The shoulders, breasts, and thoracic arch will then be suggested as in the diagram, as well as the central line, which, though on the whole a flowing curve in most postures, must be kept fairly straight in the chest, and the chest-part of the back. Its extension in the gluteal crease is generally straight and at a slight angle with the line itself.

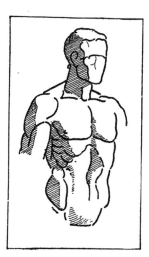

FIG. 208.

We will briefly examine a few typical positions, and remind ourselves of those matters which are of the greatest importance. Thus we shall briefly epitomize what is explained at length in succeeding paragraphs.

Fig. 208 is a male torso, three-quarter view. We notice how the chest diminishes downward to the waist, the outline of the back, seen under the arm, contributing very largely to the effect, and being itself a full convex curve.

The chest is square in section (see paragraph 37), but the squareness ceases with the ribs. The middle line lies in a slight trench of very unequal character. Often the edge of the ribs projects so prominently as to produce a receding surface, fairly flat, running down to the middle line as indicated by the shading. The middle line itself comes steadily forward from the pit of the neck to the

pit of the stomach, where the breast-bone ends, whence it
falls back to form the narrowness of the waist. From the
waist it rises again over the abdomen, but it must not be
continued far below the umbilicus. On the chest the bony
prominence of the breast-bone will break the simplicity of
the middle line there, as is shown in the diagram. In
women, the irregularity is much less prominent.

A few of the ribs may be suggested, as shown. They
must be nearly parallel. Above
them should be three or four
markings for the serratus, at a
different angle to the rib-bones,
and radiating more distinctly.
The uppermost, level with the
breast, will be about horizontal.
The lines for the collar-bones
will be short. The surfaces
above them, forming as it were
the top of the trunk, must be
remembered and expressed as
definite surfaces, at an angle
with the chest, and rising as
they recede. The mass of the
deltoid, capping the arm, must
encroach well upon both the top of the shoulder surface
and the chest.

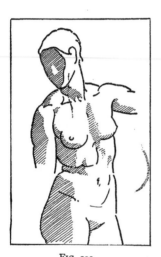

FIG. 209.

As regards this view we will here only note further that
the line of the *iliac crest*, ending the trunk below at the
side, is obliquely placed, not horizontally.

The same view of the female torso is given in Fig. 209.
The chest is smaller in bulk, the hips larger, the waist
longer and more mobile. The shape of the breast, dis-
tinctive as it is, is less important to the general appearance

of sex than the differences just pointed out, to which may be added the following. The shoulders are more sloping, and their connection with the arm more evident than in the male. The deltoid, although less marked in shape, is very full, particularly in its lower part, at the outer side of the arm. The muscular and fatty fold between the breast and the arm is important in a good figure. The muscular mass at the side of the abdomen, the *external oblique*, does not make so definite a fold; and the iliac crest although it should be represented must be as delicately shown as possible.

In the back view (Fig. 210, A and B) the blade-bones may be sug-

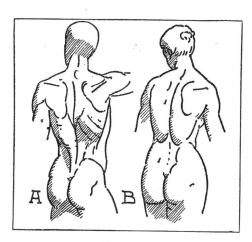

FIG. 210.

gested by a twice-curved line; a straightish line may represent the spine of the blade-bone running up to the outer end of the shoulder. Below, above, and between the blades are numerous minor masses of modelling, which are most clearly expressed when crushed by the blades against the middle line, or upward or downward. When the arm is raised the muscles are of course stretched out and allow the direction of the ribs beneath to show somewhat (A).

The chief characteristics of the form are, however, the

long lines from the arm-pits, which curve more and more backward as they descend, and then continue vertically to the iliac crest, or the ribs just above. The muscles to which these correspond are the *erector spinæ* and *latissimus dorsi.* In the male their vertical masses remain well-defined up to the middle line. In the female there is a broad, comparatively vacant, space in that region. The softness and simplification so characteristic of a woman's

figure is well seen in the back. The shoulders, or upper part of the back and lower part of the neck, are well rounded, and form part of an extensive surface, softly rounded, which reaches down to the waist. And again, from the waist downward over the loins and hips is another simplification of the same kind.

FIG. 211.

It is in such attitudes as Fig. 211 that the bony structure of the trunk asserts itself most palpably. The drawing would be commenced by a line at either side of the chest and hips, as in the cases above, but it is the line of the *thoracic arch* which indicates the foreshortening and consequently the pose of the figure. For the thoracic arch, or the lower part of it, is the *base* of the chest. Above, the collar-bones are able to exhibit their graceful curvature, and provide the outline. Below, the thighs appear spliced into the haunches; the abdomen coming down between them, and the mass

composed of the *external oblique*, the *iliac crest* and part
of the *gluteals* enclosing them at the outside.

37. The Bony Mass of the Chest—The Thorax.

THE thorax is generally described as a truncated cone,
more oval than round in plan. In studying the thorax
the male should perhaps be
taken, as the female is the.
same with the angles and
peculiarities softened. In dia-
gram 213 the two are placed
side by side.

In the male the first rib
drops at a considerable angle.
To this succeeds the "hilt,"
or upper part of the breast-
bone (sternum) F, leaving the
plane of the first rib at much
the same angle as that leaves
the horizontal. Then the
plane of the body of the
sternum (G) leaves the plane
of the hilt at much the same
angle; again, the plane of
the xiphoid appendage (H),
at the same angle, reaches the
vertical ; and it may even be
said that the slanting back-
ward of the ends of the eighth,
ninth, and tenth ribs is also
at the same angle (I). The lower end of the thorax is
horizontal, the two last ribs, the eleventh and twelfth, reach-

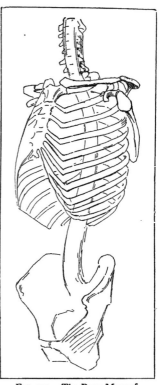

FIG. 212.—The Bony Mass of
the Trunk.

ing the limit as if they had been shorn of their extremities (J).
K shows the greater inclination of the first ribs in the female.
The measurement of the thorax in front is about twelve
inches. Of these, six inches belong to the bony part of the
breast-bone; that is, to the hilt and body of it, omitting
the cartilaginous extension below, the xiphoid appendage.
The lowest point of the front of the thorax is the cartilage
attaching to, and lengthening, the tenth rib. This point
is also the lower end of the *thoracic arch*, which is formed
by the costal cartilages. All the ribs are connected with

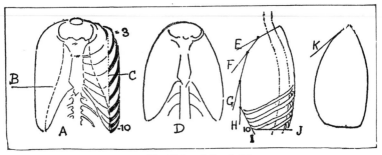

FIG. 213.—The Male and Female Thoraces.

the breast-bone by strips of cartilage similar to the ribs
in thickness; and these costal, or rib, cartilages are
short above and long below, and find their limits on a
graceful curve (Fig. 213, B), falling from the top of the
breast-bone to the corner provided by the tenth rib, the
lower extremity of the thoracic arch and the thorax itself
in front. The thoracic arch is roundest, or more truly
arch-like in the antique than in our modern models, while
in modern women it is generally said to be furthest
from the round arch. Undoubtedly the well-rounded
arch greatly improves the male figure.

There are seven *true* ribs, five false, of which two are

floating, the eleventh and twelfth. A true rib is one which
has a costal cartilage of its own, all the way to the breast-
bone. The three false ribs, the eighth, ninth, and tenth,
have costal cartilages, but they have to be content with
attachment to that of the seventh or last true rib. What
is important to notice in this region is that the cartilages
of the seventh, eighth, and ninth bulge outward somewhat,
and form a distinct elevation just above the thoracic arch,
almost as if the lip of the arch turned outward, as in

FIG. 214.

Fig. 214, A and B. Without this projection or bulging, the
torso, in this region, looks tame.

The greatest projection forward is at the cartilage of
the seventh rib.

There is considerable flatness both on the front and
sides of the thorax, flatness which is emphasized when,
the flesh being added, it can be called the chest. If in
a front view of the thorax a vertical line be drawn
upwards for the point of the ninth rib, this line will
represent the position of distinct bendings of the ribs
from the sides round on to the front (C). Indeed when the
Noah's-ark makers flatten Mr. Noah's chest, they suggest

an anatomical fact which the skeleton of the patriarchal original would have demonstrated. And again, the modern flat shirt-front is fairly harmonious with the bony facts beneath it, and the "Sailor's Knot" necktie not unlike the breast-bone which it covers.

If a section (D) of the thorax be taken, the flatness both of the front and sides will be distinctly shown, as also will the fact that the thorax is slightly wider than it is deep from front to back.

38. The Pectoral Muscles.

THE pectoralis minor is almost entirely hidden by the pectoralis major, and perhaps it only asserts itself when

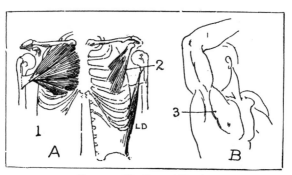

FIG. 215.—The Pectoral Muscles.

Pectoralis Major. Attachments—Aponeurosis of external oblique muscle of abdomen, front of body and hilt of sternum and adjacent costal cartilages, and inner half of collar-bone—bicipital groove of humerus.

Pectoralis Minor (2 and 3). Front of third, fourth, and fifth ribs—coracoid process of scapula.

the outward border of the latter is exposed, by thickening that border, and preventing any deep hollow behind it. (Fig. 215 (3).)

The form of the pectoralis major may be gathered from the diagram. Its arrangement in bundles affects external form, while the uppermost bundle barely touches the deltoid, so that there is a slight channel between them.

The twisting of the tendon, by which the muscle is attached to the arm-bone, is of great value artistically, as it does away with the horribly sharp angle which would be present did the lower fasciculi of the muscle proceed to the lower end of the insertion instead of to the upper. Let it be noted that the lower part of the muscle passes under the upper.

39. The Chest.

THE collar-bones when seen in front view make so straight a line that the student sometimes forgets how violently they are curved. The contrast is seen in Figs. 179 and 216. It is important therefore, at the very start, to show that the top of the chest is not flat from shoulder to shoulder. We must be careful to arch the collar-bones well, as in Fig. 367, keeping the middle out in front of the neck, and then boldly arching the form round as if it had nothing to do with the shoulder.

An examination of the relation between the collar-bone and the acromion process (Fig. 179) will present two facts which are of great value. First, the outline of the acromion continues the line of the collar-bone, but, secondly, the acromion is part of a bone almost at right angles to it. Now it is safer to think of the angular conjunction of these bony forms than of their continuance as one form.

And this is enforced by the fact that the two bones, though articulated together, are not rigidly connected.

The plane of the acromion is but rarely in the same plane
as the collar-bone. The movement of the arm, to the front,
to the back, or raised at the side, will cause the blade-bone
to glide about, and the relation of the acromion to the

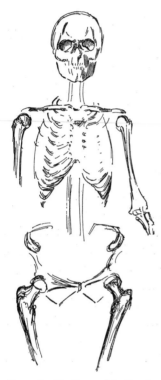

collar-bone to vary. The
collar-bone will itself rise,
fall, move backwards and for-
wards, and roll a little on its
axis, under the necessities of
action. The range of move-
ment is, however, not great,
and it is sufficient for the
artist to remember that it
"sympathizes" with the
actions of the arm.

The outer end of the collar-
bone often shows as a rugged
elevation; the acromion lying
rather behind and concealed,
with only its edge coming
forward. (Fig. 217.)

If we consider the form of
the collar-bone a little more
closely we may refer to Fig.
216. We see there four pro-
minences, or knobs. The two
acromions, at either end, and
the two heads of the clavicles,

FIG. 216.—The Bones of the Trunk
in Woman.

in the middle, separated by the notch at the pit of the
neck. Between these occur the shafts of the collar-bones,
and we notice that there is a smoothish part taking light,
succeeded, toward the shoulders, by a receding part which
takes shade. When we begin a drawing of the chest we

can start with a curved line for this light part, not because
it is in light, but because it is prominent and is sure to
be concerned in the development of the drawing.

In Fig. 217 the acromion is
rolled into view, the collar-bone
also is rolled and is raised as well.
We consequently see deeply into
the "salt-box," the very sensible
cavity walled round by the clavicle.
If the arm is brought to the side,
the palm being to the front, the
blade-bone will be drawn close
against the back, and the acromion
will be seen edge-ways, while the
collar-bone will be brought to
the straight, or even rolled a
little over toward the back. (Fig. 218.)

FIG. 217.—The Collar-bone
raised and rolled a little,
the Hands being on the
Hips.

As a rule the bone gives the form along the top of the
collar-bone and the acromion, for both those bones are
there close under the
skin. And below it
is often the bone that
we draw, but often
again it is the muscle
(Fig. 218), for the del-
toid and pectoral fre-
quently are so full in
form that we choose to
express them. In any

FIG. 218.

case, we do not draw longitudinal lines along under the
clavicles or acromions.

We must next notice that the deltoid muscle at the top
of the arm is situated under the acromion and under a

portion of the clavicle. Indeed it occupies almost half of the distance from the outside of the shoulder to the pit of the neck. (Figs. 217 and 218.)

We must now observe that in the man the collar-bone may be drawn with considerable roughness (Fig. 217), as if there were a corner projecting about half-way along where the curvature is greatest. We must note the little muscular "string," which is sometimes seen both above and below the bone there, and which is due to *platysma myoides* (page 143).

When the arm is raised the outer end of the collar-bone is lost amid the swelling masses of the deltoid and the trapezius (Fig. 218, A), and if the action is accompanied by pulling downward, or forward, the sharp, rope-like form of the clavicular portion of the great pectoral will come into evidence as much as it does in Fig. 219. The whole pectoral muscle does not rise, only the upper clavicular portion and the portion (similarly rope-like) bordering the arm-pit down to the breast.

The next matter to claim attention, in the chest, is the prominence of the breast-bone, where the hilt of it joins the blade. As has been observed before, there is a change of angle between the plane of the hilt and that of the blade. Often this change is so evident that the blade of the bone, between the breasts, seems sunken. This is, of course, largely due to the fact that the pectoral muscles, invading as they do the vertical margins of it, throw up elevations all down both sides, and so increase the hollowness of the breast-bone.

The cartilages by which the ribs are connected with the breast-bone supply some detail according to their shape, especially on either side of the prominence between the hilt and the blade.

The cartilages make a much more important addition to the form lower down, below the breasts. The cartilages of the 8th, 9th, and 10th ribs produce an elevation of the greatest importance. To shelve the form back from the bottom line of the breasts to the waist is one of the worst mistakes we can be guilty of. On the contrary, the form comes forward below the breasts, and returns again to the waist. The mounds for these prominences are given in Fig. 222, and their effect in Fig. 223.

40. The Breast.

THE Great Pectoral muscle is divided into portions, which, for the artist's sake, would be better called by different names. He would then not forget that the muscular form is such as arises from a number of muscles rather than from one. (Fig. 215.) Especially should that part of the muscle which arises from the collar-bone be marked off from the part which proceeds from the breast-bone, and this is the easier because the division points to the pit of the neck.

The pectoral muscle passes over to the arm, going under the edge of the deltoid of the shoulder. These two muscles (between which there is a decided gap, or division) are arranged together with much radial beauty, and the artist can hardly overdo the fan-like radiation of the bundles of these muscles, for the deltoid is sub-divided also.

A considerable bulk of the pectoral passes over the arm-pit, and this bulk becomes creased when the arm is down. The result is that there is a bulging mass both on the breast and on the arm, both really parts of the same thing, but divided by being folded. (*Vide* Fig. 225.)

We need only notice further that when the arms are extended in front, as in rowing (Fig. 219), the pectoral muscle becomes cord-like, chiefly in its upper part. In such actions the collar-bones are drawn forward, but still retain a bold curvature—for they never can be straightened out, and it is well to over-do rather than under-do the variety in their form.

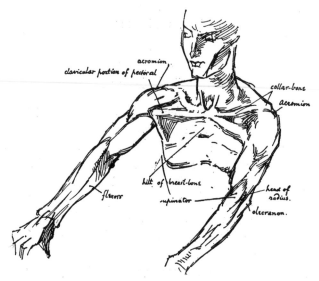

FIG. 219.—The Arms forward.

We see, then, that the muscles considerably affect the form of the breast, but it is the mammary gland which, even in man, gives the breast its peculiar shape.

It is most convenient to commence our study with the male form.

At the lower end of the breast-bone is the xiphoid appendage, a cartilaginous addition resembling costal cartilages which have got broken off, and to which no ribs are attached. We need only notice that this termina-

tion makes an irregular, sharp, curved depression, with its
concavity downwards.

Just outside this sharp depression is the inner lower

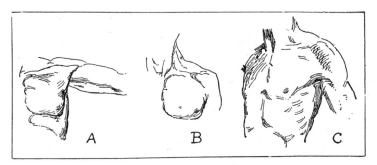

FIG. 220.—The Breast in Man.

angle of the breast. From this point the lower border
slopes downward at a slight angle, becoming fuller and
softer as it proceeds. This
mammary gland forms
the outer lower corner of
the breast (if so soft a form
can produce a corner), and
turns round up toward the
arm-pit.

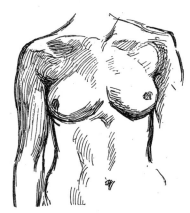

FIG. 221.—The Breast in Woman.

In men this gland is not
large, but is sufficiently
important not to be dis-
regarded. A little way in
from the outer corner is
the nipple, which would
be the centre of the
gland if the gland were not drooping down.

Perhaps the easiest way to describe the form is to say
that the gland seems to hang from the prominence between

the hilt and the blade of the breast-bone. This being so, there is a long slow rise, with increasing softness from this bony prominence to the nipple, and then from the nipple

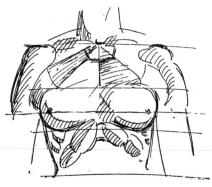

to the outer corner is a short, well-modelled, and very soft mass. The form toward the xiphoid appendage partakes rather of the character of the outer corner—it is very soft and rather well modelled. The border up toward

FIG. 222.—Planes of the Chest and Breast.

the arm-pit begins, round the nipple, soft and full, but very soon ceases altogether, and its place is taken by an even more prominent border supplied by the pectoral muscle, reinforced by the pectoralis minor beneath it. In a well-fleshed male breast there is a general squareness which gives a definite masculine character to the figure. In a thin model the form follows the meagre triangle to which the

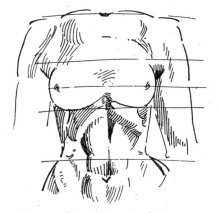

FIG. 223.—Proportions, and main masses.

muscle is reducible. The various characteristics are given in Fig. 220.

When we turn to consider the breast in woman, we find that we have much the same form as in man but with two very different conditions which produce considerable modifications. These two conditions are— the thorax is smaller above, so that there is more space between the trunk and the arm (*vide* Figs. 213 and 216), and, secondly, the mammary glands are much larger, or rather fuller; for it is well to keep the area small, because one generally thinks it is larger than it is.

It is not necessary to do more than refer the reader to the diagrams. He will notice the downward slope of the lower border of

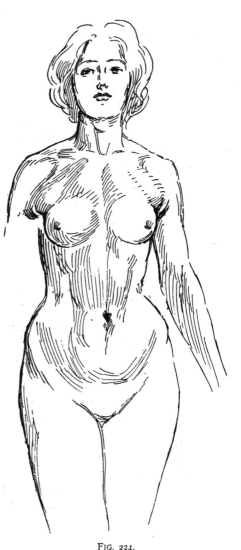

FIG. 224.

the breasts in Fig. 222, which he will find repeated in the others. He will notice, too, the hanging of the breast from

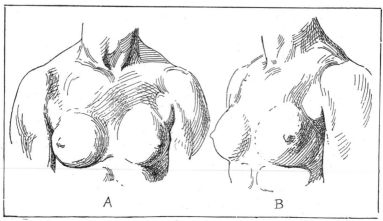

FIG. 225.

the prominence of the breast-bone, and the obliquity of form which results from it.

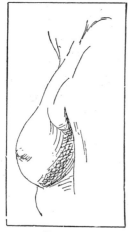

FIG. 226.

Nothing will assist the draughtsman more, in his expression of the breast in woman, than the observance of proportion. If he divides the space from the waist to the collar-bones into three parts (Fig. 223), he can give the middle one to the breasts themselves. Putting the fact another way, he must leave as much room above the breasts as they themselves occupy. The chief mistake of the incompetent is in carrying the breasts up too high.

Another mistake, always made by the vulgarest persons,

is that of placing the nipples in the centre of the breasts in the front view. They are really nearly at the side, against the outline, as in Fig. 224. The nipple of one

FIG. 227.

breast appears in the middle when the other breast is in profile, as shown in B, Fig. 225.

Further illustrations of the relation between the nipple and the outline are given in Figs. 226 and 227. By the latter illustration we see that the two breasts are at about 90 degrees to one another.

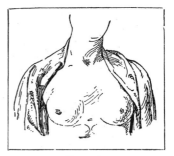

FIG. 228.

The hollow which has been pointed out as due to the distance between the head of the humerus and the thorax in the female, divides the bosom and breast from the shoulder and the mass of the trapezius. The shoulder and trapezius thus brood forward like the wing on a bird. Hence the bird-like appearance of protection in the bosom of a woman. In Fig. 228 this brooding shoulder-piece is clothed, and thus the masses are emphasized.

41. The Pose Based upon the Pelvis.

THERE can be little doubt that the pose is based upon the pelvis. The pelvis itself is a complicated bony basin, and is of such importance, as regards form, that its modelling cannot be too well known to the artist. To understand complicated things, however, a beginning must be made with the simpler aspects of them, and in the case of the

pelvis the simplest aspect happens to be of the greatest importance, for it is introduced in the front view of the figure.

The front view will always be largely used by artists because the head is then seen completely, and there is a symmetry, combined with a variety, in the lines of the figure which will always find favour. In the front view, then, we find our first exercise in posing. With the complicated form of the

FIG. 229.—The prominent parts of the Pelvis in Man, front view.

pelvis we have, however, only to deal to a small extent. The two iliac crests, the two trochanters, and the pubic symphysis between them are all that concern us. Properly speaking, the trochanters have nothing to do with the pelvis. They are the great projections on the thigh-bones; but while they belong to the thigh they also belong to the haunch, and he who separates them from it has not much feeling for the form of the figure.

There is also Poupart's ligament stretching from the iliac crests to the pubes. These details are shown in darker line in the diagram. (Fig. 230.)

When we begin our drawing we indicate these several bony details. We begin with them because they fix the form. If the figure be standing on one foot, the trochanter on that side of the figure will become the pivot on which the weight is hung. The opposite side will consequently fall down, and we thus draw the first indication of our pose by drawing a slanting line through the

FIG. 230.—The Pelvis in Woman.

two trochanters. We either draw that line or one above it through the iliac crests: both are drawn in Fig. 231.

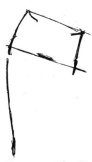

FIG. 231.—The First Lines drawn to fix the Pose.

We then put in little slanting lines for the iliac crests, and roundish strokes for the trochanters. Between the trochanters we mark the pubes, which, however, we do not place so much importance upon, because the pubes is of less consequence than the groin just above it, and because the forms hereabout do not cause us any great trouble. We add the outside line of the standing thigh, because it assists us in feeling the pose and keeping our work vigorous.

In fixing these first few strokes we can indicate the sex to some extent. For a woman's figure we must not place

the iliac crests so high above the trochanters as we do for a man's; we must indeed keep them low down, just as we should keep the line for the pubes high. The line of the groin thus, in a woman, becomes very shallow. In keeping the groin shallow the draughtsman will find he has divided the abdomen into two spaces of considerable size. Below there is a deep fold limited beneath by a V-like line.

42. The Pelvis.

THE pelvis is the bony basis of the haunches supporting the boneless fleshy mass of the abdomen. Each half of the pelvis is, in infancy, three bones—the ilium above, the ischium behind, and the pubes where the two sides meet in front. Behind, the two sides are connected by the sacrum, which is locked between them. It might be said that the inside of the pelvic basin belongs to the trunk, the outside to the thighs. The inside and outside are divided by a lip or edge, which thus marks the lower extremity of the trunk and the upper extremity of the thighs, and which we know as the crest of the ilium, or the iliac crest.

In side view the iliac crest approximates to two lines, one, towards the front of the figure, longer than the other, and containing between them a right angle placed vertically. (Fig. 232, B.) The end of the longer line is the *Superior Anterior Spinous Process*, or Spine, the end of the shorter the *Superior Posterior Spine*. The junction of the two lines is the highest point of the pelvis, but it is not the nearest to the spectator as he takes a side view. The nearest point would be some little distance down the longer line.

In plan each crest is a variation of the line "of beauty
and grace," the smaller curve of which, the hinder part,
fits against the sacrum. In the artificially articulated
skeleton the crests are joined to the sacrum by a bolt.
This mechanical contrivance very well illustrates the
rapidity of the return curve.

The *sacrum* is the *immovable* part of the vertebral
column, and is an agglomeration of five vertebræ. It

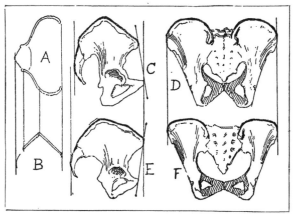

FIG. 232.—The Pelvis showing the iliac crest. C and D male, E and F female.
A, plan, and B, elevation of iliac crest.

is leaf-shaped. (Fig. 232, D and F.) Down the middle
of its hinder surface are the remains of spinous processes,
and below it are two or three small bones, vertebral
in origin, called together the coccyx. The side lines
upward from the coccyx form the continuation of the
iliac crest now being traced, and hence the surface of the
sacrum belongs to the trunk, and, behind, the trunk
has somewhat the cut of an Eton school-boy's jacket.
(Fig. 233, A.)

The iliac crest is continued in front by *Poupart's*

ligament from the sup. ant. spine to the symphysis pubis
(or meeting of the public portions of the pelvis), thus
forming the *groin* of the abdomen, and completing the
lower limit of the trunk. (Fig. 233, B.)

The diagrams include the forms both of the male and
female. The difference between the two in the pelvis
is very marked, and may be summed up as follows. The
female pelvis is deeper from front to back. The measure-
ment from side to side is the same in both ; but considering

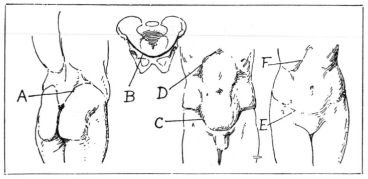

FIG. 233.—The Line of Division between the trunk and the thighs. A, post. sap.
spine. B, Poupart's ligament. D and F, thoracic arches. C and E, groins.

the shorter stature of the female, the pelvis in that sex
becomes relatively the wider. The remarkable manner
in which the male pelvis falls backward, and the female
forward, is illustrated by the oblique lines C and E, Fig.
232. In the same diagram the crests are drawn in
darker lines, and it will be seen that the male is in side
view more angular, and in the back view rounder than
the female, which approaches the horizontal, particularly
in the back view. In Fig. 233 the groins of the abdomen
may be compared. The female is shallower, and does not
reach so far down. The groins may also be compared

with the thoracic arches above. Thus in the male, C and D are similar, though inversely placed; in the female there is no similarity between the shallow E and the angular F. Further, the female sacrum is broader, so that the superior posterior spines (A) are further apart. The sacrum itself is also flatter, less disturbed by the muscles upon it; less overhung by the iliac crests, and consequently nearer the surface, which it renders smoother; and is set at a greater inclination from the vertical. It thus increases the apparent size of the loins by associating itself more with them than with the back.

43. The External Oblique and Rectus Abdominis Muscles.

THESE muscles complete the wall of the abdomen, and are concerned in drawing the thorax down to the pelvis, or bending the back forward, and in twisting the trunk upon itself.

The rectus is not only divided vertically into two symmetrical halves, but is also divided transversely by three or four similar aponeurotic lines, one at the umbilicus, two above it, and sometimes a rudimentary one below it, the fleshy masses bounded by them being very distinctly seen.

The rectus is enclosed within and covered by an aponeurotic sheet, which at its lateral borders gives attachment to the external oblique, the shape or outline of which muscle is consequently given by the conjunction of its fleshy fibres and the aponeurosis.

If a front view of the trunk be taken, the two great muscles of the chest will be seen forming by their lower

borders a somewhat horizontal line, at the level of the end of the breast-bone, the pit of the stomach. From this horizontal line the rectus falls vertically down to the pubes. Its borders occupy about the quarter positions across the whole trunk, but do not run as distinct lines right up to the pectoral. Their forms first become distinct at the

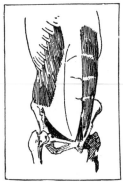

FIG. 234.—Rectus Abdominis, and Obliquus Externus.

Rectus abdominis. Attachments—Pubic crest and symphysis—fifth rib, fifth, sixth, and seventh costal cartilages, and xiphoid appendage.

Obliquus externus. Attachments—By digitations, which interdigitate with those of the latissimus dorsi and the serratus magnus, to lowest eight ribs—anterior half of iliac crest and the abdominal aponeurosis.

edge of the thoracic arch. From this point the border of the rectus falls in a graceful curve to the pubes, while the border of the fleshy mass of the external oblique, starting with it, diverges tangentially from it, and finally describes an arc of considerable rapidity, and arrives at the superior anterior spine of the iliac crest. (Fig. 235, A.)

In the back view a medial mass, similar to that of the rectus before, is observable. (Fig. 235, B.) This mass

consists of the erector spinæ and sacro-lumbalis, with the latissimus dorsi upon them, as explained in paragraphs 50 and 51. The long fleshy thong of the latissimus passes from the arm-pit down to the posterior end of the iliac crest, where it outlines this medial mass. The iliac crest is seen as a voluminous curve upon which the external oblique fits, forming the side of the abdomen, its digitations above making a series of little mounds on the ribs similar to those of the serratus magnus, and lying be-

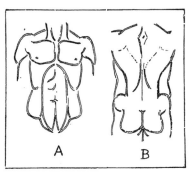

FIG. 235.—Lines of the Front and Back of the Trunk.

tween them and the prominent edge of the thoracic arch.

In the antique the external oblique always appears well developed, hanging somewhat over the iliac crest. (Fig. 236, A.) In most models, as every one knows, it is disappointingly meagre, the crests not infrequently making the greatest projection in this region. Even when it is tolerably well developed, and shows a convex curve, the crest is evident (irregularly) be-

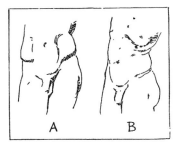

FIG. 236.—Effect of the External Oblique.

neath it. It is well to always express this bony ridge, letting it get lost as the form of the overlapping muscle is developed upon it.

In some poses, when the figure stands upon one leg,

and rolls the trunk over that leg, the oblique assumes a
volume similar to that which is in so many antiques the
normal mass. The other oblique is at the time stretched,
and the crest asserts itself.

The central division of the rectus is replaced at its
lower end by a small muscle, pyramidalis, which, arising
from the pubic bones, stretches some distance up the
aponeurotic "linea alba," or white line, which forms the
central division. This little muscular addition greatly
improves the lower part of the abdomen by neutralizing
the slight furrow made by the white line. (Fig. 237.)

44. The Abdomen.

IF a section be taken of the trunk, say, through the
pectoral, at 1, Fig. 237, it will be somewhat as shown in
the diagram. It will be more or less oblong, square in
front, since the thorax itself approaches this shape, as has
been shown in paragraph 37, and since the volume of
the pectoral assists by providing more corner to the square.
The back corners are swollen out by the latissimus dorsi;
so that the section is, broadly speaking, a modified oblong.
The section of the abdomen (2) is quite as deep from front
to back, in the male, in proportion to its width, as the chest.

When the torso is bent upon itself the transverse
divisions of the rectus assert themselves as creases
between the muscular masses; the thoracic arch also
comes into evidence, expressing itself by the wavy line
of the costal cartilages of the eighth, ninth, and tenth
ribs, the floating eleventh helping to carry the line
round towards the back. The external oblique bulges
up boldly, taking probably an undulating curve where it

borders against the abdomen. Below the umbilicus the abdomen is generally clear, but the skin sometimes creases; the groin will lie between the mass of the abdomen above and the last fold below, as a dull depression.

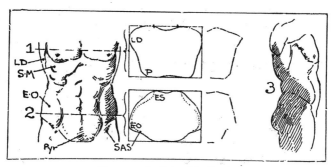

FIG. 237.—Sections of the Trunk.

In some cases the abdomen appears to have a section somewhat square presenting three surfaces, two of which appear in Fig. 238, B. The abdominal mass thus indi-

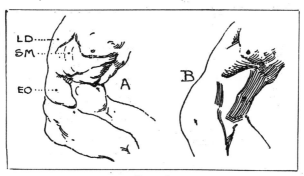

FIG. 238.

cated is limited by the border of the thoracic arch and the external oblique.

The detailed characteristics of the abdomen are considered in the next paragraph.

45. The Abdomen in Woman.

IN its modelling the abdomen, in woman, presents, in the first place, a broad, somewhat flat expanse. The relative flatness is caused by the projection forwards of the front ends of the iliac crests. These points (superior anterior spinous processes) are in actual fact further forward than the pubes, but the pubes is fleshily clothed, while they are more exposed, and so, from one iliac across to the other, there is a fairly flat surface, or horizontal path. (Fig. 239.) Above this flat path rises the projection of the abdomen, in three divisions. There is the central part, or abdomen proper, and on either side there are the muscular (for such they appear) masses of the flanks. The word "belly" is an ugly word, and it does not suggest either a graceful or even normal formation of the body. The word has become impolite, and sounds now to mean an abdomen exhibiting some fulness or distention. When dealing with ideal or noble subjects, artists avoid any suggestion of that gorged appearance which that ugly word very well describes. But even with this refined treatment there must be a degree of fulness such as the figure must have, if it is to be natural at all. Where then is the fulness, and

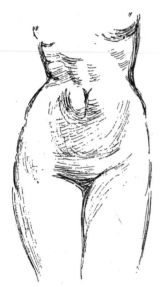

FIG. 239.—The Flat Expanse of the Abdomen.

what care have we to take? There are two fulnesses on
the abdomen proper; there is a broad fulness below the
umbilicus extending down to, and encroaching upon, the
flat path from iliac to iliac. This lower fulness is some-
what square in form, for it is bounded below by the groin,
and on either side by the edge of the rectus abdominis
muscle, which indeed governs it, lying, as it does, all down
the front of the body like a broad strap. The upper
fulness is beside the umbilicus, on
either side of it. It is narrower
than the lower, and more sharply
defined. The reader will have
observed that these fulnesses are
double, and occur symmetrically
on either side of the middle line.
The middle line is formed by
the aponeurotic linea alba which
divides the rectus muscle into two
halves.

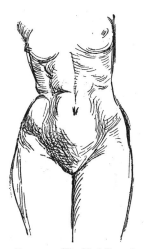

It is important to observe that
the modelling of the lower ful-
nesses rather coalesce below; the
division is there very delicate, and
must be tenderly rendered. Further,

FIG. 240.—The Modelling of
the Abdomen.

the modelling of these fulnesses runs on down beyond the
groin, and affects the mound below, as if the abdomen
came to a point. This is shown in Fig. 240. Moreover,
there is another muscle, pyramidalis, which further carries
the fulness down below the groin.

If this extension of the modelling be carried at all too
far, and become a convention, it is less desirable than the
opposite treatment, which is shown in Fig. 247, and which
is more often seen in work of an ideal tendency.

On either side of the central abdominal mass are the
muscular mounds of the flanks. They stretch from the waist
above to the iliac crests below. Of course the forms which
occur on the outlines are not always at the front, and we have
here a case in point. The upper part of this mass is further
back. The mass does not always show so clearly as it does
in Fig. 240, where there is considerable muscular effort, but
some such modulation of form will always be present. In

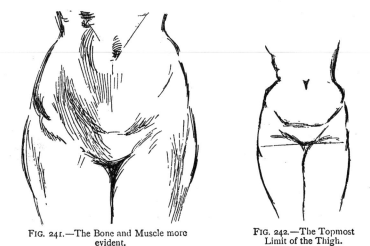

FIG. 241.—The Bone and Muscle more
evident.

FIG. 242.—The Topmost
Limit of the Thigh.

particular the form at the top of the thigh, at the front of
the iliac crest, must be noted. From the front end of the
iliac crest depend two muscles (tensor fasciæ and sar-
torius), as can be seen in Fig. 244. They follow divergent
courses, and there is consequently a depression between
them. It could be not inappropriately said that the thigh
begins at this hollow, as in Fig. 242, for the great muscles
of the thigh do not pass up so far as the iliac crest. Indeed,
it is a great mistake to carry the legs up beyond the middle
of the figure, for at that point begins the haunch.

If we epitomize the modelling of the abdomen in woman, we find the greatest fulness forms a zone below the waist and above the groin (Fig. 245), and we shall find the bold shadow line thus produced of great service in adequately representing the proper bulk. From this shadow line down to the top of the thigh is a rather twisted surface, with a valley running obliquely down its course somewhat in continuation of the V-shaped end of the trunk. And

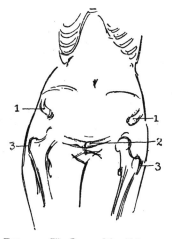

FIG. 243.—The Bones of the Abdomen.

1. The Anterior Superior Spinous Process of the Iliac Crest.
2. The Pubes.
3. The greater Trochanter of the Thigh-bone.

the same sort of modelling we see in some of the old drawings, as, for instance, in Fig. 246, which is of the early sixteenth century, and whatever it may lack in grace it certainly has in truth.

It is necessary to use three lines for the side of the abdomen, for the haunch. They are: one from the waist, **passing outward and downward, and then sharply turning**

round the iliac crest ; a short curve below this, connecting
the iliac with the trochanter; and, lastly, one round the
trochanter itself. The second corresponds to the tensor
muscle.

Let it not be forgotten that the course of a muscle does
not always result in a projection of form. Because, for
instance, the tensor fasciæ stretches from the iliac crest to

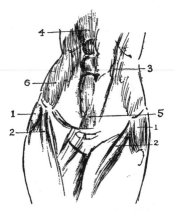

FIG. 244. —The Muscles of the Abdomen.

1. Tensor Fasciæ.
2. Sartorius.
3. Outer border of Rectus Abdominis.
4. Uppermost of the four portions of Rectus Abdominis.
5. Pyramidalis.
6. Obliquus Externus. (Note that this muscle, like Rectus, extends
 from the groin right up on to the ribs.)

the trochanter, it does not prevent any depression occurring
above the trochanter.

The abdomen ends below in a V-like line, which is
sometimes said to be made up of lines sometimes slightly
concave, sometimes slightly convex. This V-like line
presents an angle of sixty or ninety degrees or even more.
Indeed it is sometimes drawn extremely obtuse, as in Fig.

248. This obtuseness is seen in the nobler conceptions of the form. It is due largely to a convention proper to outline-work. An outline trickling round the form does not always very well express it, because there is shading, in many cases, which should be taken into account, and because an outline tends to pull the part it represents forwards, as if it were high in modelling. Hence in the present case one does not adopt a form which would not

FIG. 245.—The Masses of the Abdomen, in Woman.

FIG. 246.—From Alciat's Emblems, Augsburg, A.D. 1531.

FIG. 247.—The Planes of the Abdomen.

suggest the proper modelling. The shading will reduce the point of the V. Indeed, a drooping line and not an angle would more truly follow the effect of the shading, but a drooping line suggests a rather festoon-like form, and that is objectionable. The obtuseness is due also to a fulness of the upper inner side of the thigh, as is seen in such a pose as that of Fig. 248 B.

Above the shallow groin there is, in woman, a deep and expansive abdomen. The umbilicus is high up, very near

the waist. And not only is the abdomen deep, it is also wide, but this great expanse does not result in coarseness or obsceneness, because there is throughout the most refined modelling.

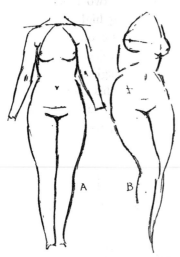

The forms in the waist of woman dovetail into one another. Some of the mounds seem therefore to belong to the thorax, some to the abdomen. The little mounds of the rectus, just above the umbilicus, belong to the abdomen, and their top border makes the line of the waist, but the upper mounds of the same muscle, filling up the thoracic arch, belong to the thorax. These upper ones certainly domin-

FIG. 248.—A. The Lower Limit of the Trunk, in Woman, represented by a Shallow Angle. B. The Lowest Line of the Trunk rendered Shallow by the Fulness of the Thigh.

ate the smaller one just below them. We see in Fig. 249 how they overhang. They are there marked A; we note that they are not drawn with a round curve, but with one somewhat flattish, or rather double. Above them, again, are other mounds due to the bulging of the cartilages of the ribs. To the outside of these mounds of the rectus there rises up a soft mass of the abdomen. It is as if there were two "hard" portions—the

FIG. 249.

rectus down the middle, and the partly muscular, partly bony, flank, or outer border of the abdomen. We might

say that Vulcan, or whoever forged the human kind,
pinched the abdomen at the sides and drove up hard
ridges on the flanks, and above gave two more pinches
leaving the ridge of the ribs projecting high. (Fig. 250.)
Or shall we imagine our demiurge giving one bold pinch,
and at once making thoracic arch, projection of rectus,
hard narrow flank, and the wider, though still hard, root
of the thigh? (Fig. 251.) Note that this thumb-mark is
not a mere oval, in outline. Above there is a notch in its
dark border; this is for the tenth rib, its end, for there

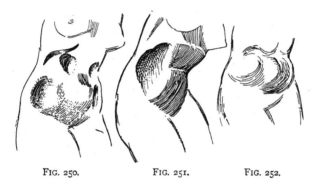

FIG. 250. FIG. 251. FIG. 252.

the bony basket is abruptly turning backward. Below
another notch is where the iliac crest, coming forward,
ends in its superior spinous process. The border below
this notch stands for the groin, or, if we like, for Poupart's
ligament (for which refer to Fig. 233). The inner border
will serve for the confines of the rectus.

If the god left humanity thus scooped out, some kinder
divinity filled the hollow, especially in the lower part—
filled it with that soft fulness of which we have spoken
above. This forms the outer fulness of the abdomen, so
that there are three fulnesses, one middle and two outer.
Of these the middle one is the greater, but is refined by

its division down the centre, and by the little mounds just
below the umbilicus. (Fig. 252.) The outer fulnesses melt
almost imperceptibly into the middle one.

46. The Whole Trunk in Woman. Front View.

WE have in other paragraphs dealt with the detailed
form of the abdomen and of the chest, and we here con-
cern ourselves with the relation which these two main
parts bear to one another. It is a matter of proportion,
and of general line and general modelling, or of planes.

If we are constructing the figure from the pelvis, and
building it upwards, we shall find it well to get to the
umbilicus as a point indicative of proportion. Although
in this matter one rule is as good as another, it seems to
me that the safest way to proceed is to first draw the long
line through the trochanters. This gives us practically
the widest extent of the figure (it is generally a little fuller
just below), and at the same time it gives us the slant
of the pelvis, and consequently determines which is the
standing leg.

We have to be careful, however, to bear well in mind
where this line through the trochanters actually is placed,
whether, that is, it is below, or through, the last fold of the
body. In practice we sketch our line, and just as chance
brings it high or low, so do we assume it to be in the one
or the other position.

There has been given, on an earlier page, a rule of pro-
portion for the trunk. By that rule we observe three
equal measurements from the top of the head to the end
of the trunk. The intermediate points upon which the
measurements fall are the shoulders and the waist, and no

parts of the trunk are so important, in the matter of proportion, as these.

Now supposing that we commence with a line through the trochanters, and quite at the end of the trunk, after we have fixed its length, we shall place upon it a V-like form for the limit of the abdomen. Assuming that we have not drawn either the waist or the shoulders, we shall experience some difficulty in finding their positions. We can, of course, take the chances of a speculative attempt, but our present study is directed toward finding some more secure method than that. Perhaps the safest procedure, in this case, is to erect an equilateral triangle upon the line already drawn. Now the width across the trochanters, in woman, is about 14 inches, and the altitude of an equilateral triangle with 14-inch sides is barely 12 inches. The height

FIG. 253.—Planning out the Trunk. First Method.

of the waist above the base line should be about 11 inches, so that our triangle carries us too far. However, such a triangle is merely sketched as a guide, and the point very readily gets neglected. We can thus fix the waist, and as for its width, that can look after itself, for there does not appear any ready way of determining it.

We next place the umbilicus a little below the waist. Its distance above the base line is about 9 inches. The umbilicus fixed, we add a few strokes to the abdomen,

and then proceed up toward the shoulders. We find that the umbilicus and the two nipples of the breasts form a small triangle, and again that the nipples with the pit of the neck form another. Of the two triangles the upper is a little the shorter, and is equilateral. We are thus able to determine the position of the collar-bones. We

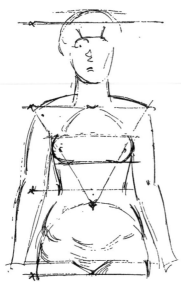

FIG. 254.—Planning out the Trunk. Second Method.

may, however, at the same time, note a few other facts. If we continue the line from the umbilicus through the nipples, it will give us the projection of the shoulder, and at the same time suggests the border of the chest. Curving round the nipple we draw the breast, carrying our line about equally above and below. It is well to cast across the figure two lines, which should slant according to the pose— one above, one below the breasts—taking care that the area of chest above the breasts is not less than that of the breasts themselves. There is an important valley line coming down from the pit of the neck to the outer side of the breast, and an important ridge line (gently hollowed though it be) between the pectorals, which is of further service in expressing the planes.

Another method of gaining the proportion from the line through the trochanters is that shown in Fig. 254,

in which a line is taken above the trochanters, or so as to have the V-like shape below it. Then with this as diameter we may draw a semicircle passing through the umbilicus.

Even if we com-
mence with the three
lines through the
shoulders, waist, and
hip, the umbilicus will
be useful, for it helps
us to the proportions
of breast and shoulder.

In Fig. 255 the
method which has been
recommended above is
put into practice, and
in Fig. 256 the same
figure has been de-
veloped.

It will not escape
attention that the waist
is, on the standing-leg
side, shown wrinkled
up, while on the other
it is stretched.

If one builds the
thorax upward upon
the waist, one places a
very tall curved cone,

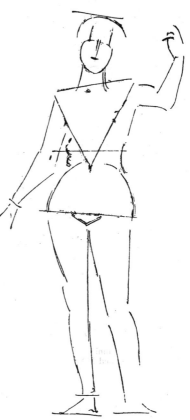

FIG. 255.—The Trunk planned out.

or beehive shape, which carries the form up to the pit of the neck, and upon which also one places the nipples. Note that this cone shape is much taller than the cone of the thorax, as we see it in the skeleton. (*Vide* Fig.

216.) This is shown in Fig. 257. The position of the blue vein of the elbow, and the ends of the bones of the forearm, will also not pass unnoticed; they are shown in the same diagram.

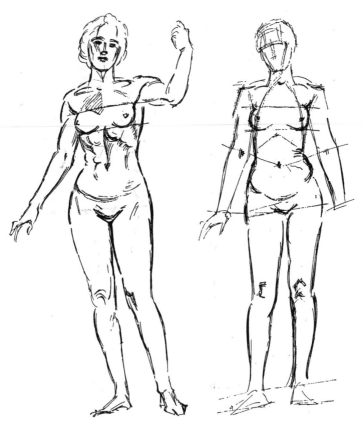

FIG. 256.—Figure Developed from the preceding Diagram.

FIG. 257.—The Proportions of the Trunk and Limbs.

47. The Whole Trunk in Man. Front View.

WE may set up our figure as in Fig. 258. The tro-
chanters give us the middle, and the body is divided into
three parts. These are not quite
equal, as they should be according
to our rule, for the middle one is
made larger, as it should be for a
man, and the lowest division is drawn
at the trochanters instead of lower
down. This is more convenient in
practice, and the draughtsman easily
gets to make the requisite allow-
ance. The most important matter
is that the iliac crests are drawn
immediately after the trochanters,
and that from them buttress-like
lines are carried up. Over these the
thorax is made to fit, as if it were
considerably wider.

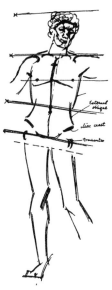

FIG. 258.—The Figure
set up.

By comparing Figs. 259 and 260
we see the great difference between

FIG. 259.—The Form in Man.

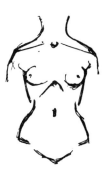

FIG. 260.—The Form in Woman.

the sexes. Other illustrations of the male form are given
in Figs. 261 to 264. In Fig. 263 we notice the cape-like
form made by the deltoids and pectorals—a peculiarity
repeated on the back of the figure, as in Fig. 277.

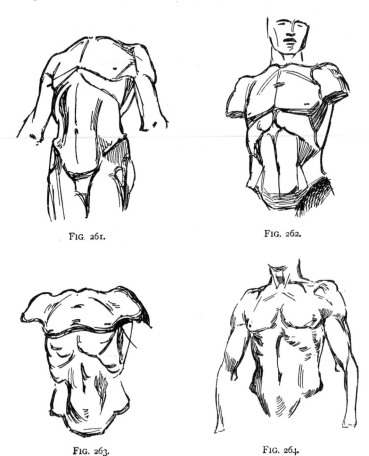

FIG. 261. FIG. 262.

FIG. 263. FIG. 264.

48. The Vertebral Column.

THE undulating shape is due to the constant attempt of the column to get beneath the masses, and thus ensure the erect position. The column must be situated somewhat at the rear of the thorax and the pelvis, in order to allow the internal organs sufficient space. But in both situations it is placed as far forward as possible. In the pelvis it is represented by its immovable portion, the sacrum, which is placed at a considerable inclination, and so reaches well forward at its upper part, leaves plenty of space before it, and yet is sufficiently high at the back not to produce a sinking or hollow between the adjacent iliac crests. Indeed it is not too much to say that across this part of the back there lies a surface smoothly curved in the direction indicated by the dotted lines in the diagram (Fig. 266, A), more particularly in the female. In the back itself there are two masses, one on

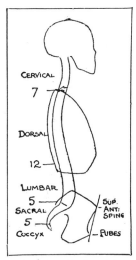

FIG. 265.—Outline of the Vertebral Column.

either side of the back-bone, and these two masses are produced by the ribs passing backward for some distance before they take their normal forward course. (Fig. 266, B.) Or, it may be said that the back-bone, to get well under the weight it has to support, holds a position as far forward in the thorax as possible, and thus, as it were, drags the ribs in some distance with it. There is therefore formed a

trough with the spines of the back-bone projecting from
its central depth. The point on the rib where its direction
changes from backward to forward is the *angle* of the rib,
and the angles together form almost vertical lines, which
become the crests or summits of the two large masses
originally mentioned. The trough between them is about
six inches wide, the inner borders of the blade-bones coming
to the edges.

In a side view of the skeleton the spines of the vertebral
column project slightly beyond the mass of the ribs, but

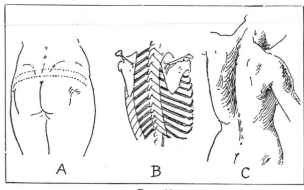

FIG. 266.

when the flesh is added the masses project beyond the
spines, for the spines are not covered by muscle.

Of all the spines the *vertebra prominens*, which is the
last vertebra of the neck, is the most prominent. Beneath
it one or two of the uppermost of the back also show;
then in the centre of the back none show, but those of the
lower part of the back gradually come into evidence, as
also do those of the lumbar vertebræ, of the loins.

The skin and the tendinous edges of the muscles are
held down by the extremities of the spines, and hence
when the back is bent forward the "buttons" show very

distinctly, but produce dimples when the back is bent backward, with the flesh between them bulging up. These remarks apply chiefly to the lumbar (loin) and lower dorsal (back) spines.

49. The Range of Movement in the Vertebral Column.

THE vertebral column may be regarded as a column of india-rubber; it does not move here and there only but throughout its whole length, except in the sacral portion, where the vertebræ are incorporated together into one rigid mass—the sacrum.

The movement is practically bending and twisting, and the artist is chiefly concerned with what the limits of movement are.

The range of movement is shown in the diagrams. In Fig. 267 it is shown that twisting will carry the shoulders round to a position at right angles with their former position A A is the direction of the feet, B B the original posi-

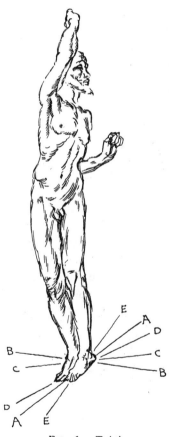

FIG. 267.—Twisting.

tion of both hips and shoulders, C C is the present position of the hips, and D D of the shoulders. The shoulders

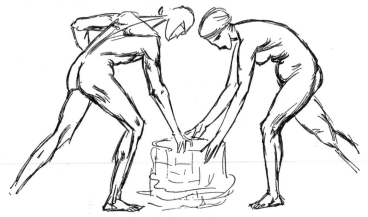

FIG. 268.—Bending Forward.

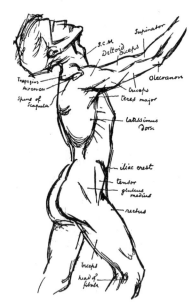

FIG. 269.—Bending Backward.

with difficulty could get round to E E. Of course, the ankle, knee, and hip joints are all assisting, for the column could not act alone—it is not secure enough.

Bending forward is performed in man with the lower, in woman with the upper part of the column, or rather those are the freer parts. (Fig. 268.)

In bending backwards the back participates only slightly, the loins considerably, the neck chiefly.

50. The Erector Spinæ and Sacro-lumbalis Muscles, and their Effect on the Sacrum.

THESE two muscles run from the sacrum and the adjacent end of the iliac crest, to the ribs, and are the representatives in the loins of a group of muscles passing from the lower extremity of the vertebral column up to the head. Their effect is to produce a muscular column on

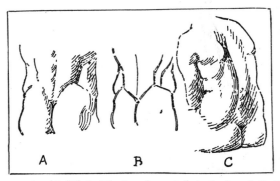

FIG. 270.—A and B, Effect of Erector spinæ. C, Lateral volume in the Female.

either side of the back-bone which greatly strengthens in appearance the region of the loins.

These muscles are deep, being covered by the *Latissimus dorsi* (see next paragraph); but they nevertheless provide the strong masses spoken of, which are chiefly evident when the back is bent backward.

It is important to notice that the attachment to the sacrum covers the whole bone, and therefore the surface of the sacrum becomes modelled into two masses with a hollow between, in accordance with all the muscular forms of the back; and this double modelling is observable in a figure standing in a normal attitude.

In women the sacrum is nearer the surface than in men, appearing as a broader, smoother mass. In men it is set deeper, the iliac crests slightly overshadow it, the gluteal masses further encroaching upon its size.

In a previous paragraph attention has been called to the smoothness of the surfaces passing over the sacrum from side to side. It may here be further noted that in the erect position, when the figure stands upon both feet equally, the strain of the gluteal muscles and of these now under special observation, interfere with the smoothness somewhat. But if the figure stand upon one foot only, the mass becomes very smooth, particularly in the female.

The student will not omit to recognize the dimples formed on either side of the sacrum, by the superior *posterior* spines of the iliac crests—two dimples which, with the noticeable hollow which commences the gluteal crease, form an almost equilateral triangle.

51. The Latissimus Dorsi Muscle.

THE muscle asserts itself in a variety of ways which will have to be studied separately. In the first place, its very extensive aponeurosis must be noticed. It may be said that where there is aponeurosis there is no muscle, and that the border of the muscle, artistically speaking, is the line dividing the muscular fibres from the aponeurosis which supports them, and provides their means of operation. Hence the curved line, rounding off the back, so frequently seen. (Fig. 272, A.) It will be noticed how gracefully this aponeurotic line continues into the iliac crest, and so into the outline of the thigh. The anatomical diagram shows a stouter and completely fleshy thong of the muscle at its

outer edge. This thong is one of four or five forming the anterior part of the muscle, the others attaching to ribs (G). The posterior part is, as has been shown, flat and sheet-like ; the anterior part consists of a number of fingers or thongs, and operates most directly in such actions as chopping. The thong which reaches the iliac crest is most frequently in evidence (B, C, D and E), being particularly

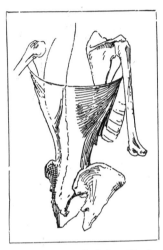

FIG. 271.—The Latissimus Dorsi.

Attachments—By an aponeurosis to all the spines of the back-bone
and sacrum, down from the sixth of the back (from the middle of
the back), also to the posterior third, or more, of the iliac crest,
and lowest three or four ribs—bicipital groove of the humerus.

strongly marked when the arms are held forward, not that it assists at all in that operation, but because it is stretched forward and makes a very noticeable fold. In the Greek vase paintings, the side view of the arm, if held forward, is generally continued above by a line representing the inner border of the trapezius, and below by a line representing the longest thong of the great dorsal (C). In this action

the long thong wraps over the shorter ones and hides them. If, however, the arm be held out sideways, and pull downward, these others will be exposed, fitting in with similar digitations from the external oblique muscle which arises from the iliac crest below (G).

It must not be thought that the long thong of the dorsal

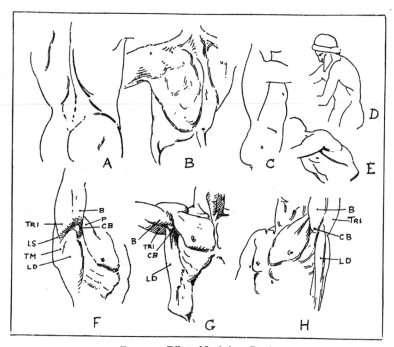

FIG. 272.—Effect of Latissimus Dorsi.

finds its insertion on the iliac crest immediately under its attachment to the arm. If this were so, there would be a sharp fleshy angle formed by this thong, from the arm to the crest, whenever the arm was raised sideways or backwards. The thong's course is however twisted. Viewed from before one only sees its upper part, and it is indeed

safest to imagine that it concludes at the waist as the smaller thongs do.

This accords with the fact that the muscle is most voluminous just under the arm-pit, forming a mass which adds greatly to the quality of being well-fleshed and heroic in build—marked L D in diagram F.

The way in which the muscle attaches to the arm will be found treated in paragraph 59, p. 227.

52. The Shoulder-blade and Shoulder.

THE form of the blade- and collar-bones may be gathered from Figs. 178 and 179; the muscles upon and about them are given in the following diagrams.

Complicated as the shoulder is, there is perhaps little to be gained by a detailed description of it. We will merely note its chief and most obvious characteristics. And first, as to evidences of bone, the collar-bone and the spine of the scapula are virtually a continuous bony ridge, meeting on the summit of the shoulder in the *acromion* process. It will be seen, by reference to the diagrams, that this bony ridge gives attachment to two massive muscles, the trapezius and the deltoid ; the former above, the latter below ; and between them is a degree of the bony ridge, but much less in width on the spine than on the acromion or collar-bone. Indeed in well-fleshed persons, with the proper amount of fat beneath the skin, the spine should show as a gentle depression rather than as a ridge. It is suggested by straight lines in Fig. 210. In drawings further advanced it is sometimes suggested by the outlines of the trapezius and deltoid, as in Fig. 274, B.

The base of the scapula, its border parallel to the back-

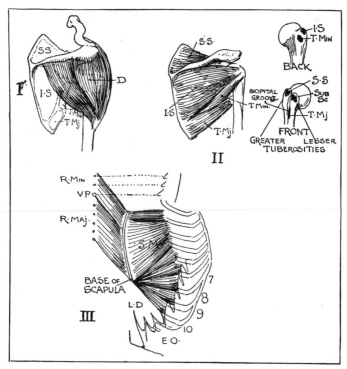

FIG. 273.—Muscles about the Scapula.

I. THE DELTOID MUSCLE.

Attachments—Under lip of spine of scapula, and outer third of clavicle
—deltoid impression on outside of humerus.

II. THE SCAPULAR MUSCLES.

Supra-spinatus.
> Attachments—Supra-spinous fossa of scapula—greater tuberosity
> of humerus.

Infra-spinatus.
> Attachments—Inner two-thirds of infra spinous fossa—greater
> tuberosity of humerus.

Teres minor.
> Attachments—At the outer side of the attachment of the infra-
> spinatus—greater tuberosity of humerus.

Teres major.
> Attachments—Below the attachments of the teres minor and infra-spinatus—bicipital groove of humerus.

III. THE RHOMBOIDS AND SERRATUS MAGNUS.

Serratus magnus.
> Attachments—Upper eight ribs—base of scapula.

Rhomboideus major.
> Attachments—Upper five dorsal spines—base of scapula from the root of the spine to the lower angle.

Rhomboideus minor.
> Attachments—Lowest three cervical spines—base of scapula above the insertion of the rhomboideus major.

bone that is, reveals itself usually as a double curve, as in Fig. 210, or Fig. 274, C, D and E. The lower curve bends round and forms the lower angle of the blade (B and D).

Under the arm-pit there are three radiating lines, shown in Fig. 274, B. The lowest, representing the *latissimus dorsi*, does not touch the blade, whereas the other two arise from it. They represent, the lower, teres major, the upper, teres minor, and what is specially remarkable about them is, that major goes to the front of the arm in close company with latissimus, while minor goes to the back. They are separated by the triceps muscle at the back of the arm. These lines of the teres will be seen to be slanting, or obliquely placed, with the result that the sharp angle which would otherwise occur under the arm when it is raised, or carried at all away from the body, is filled.

The *deltoid* should always be drawn with a double curve, and not left as a ball at the top of the arm. Its border against the pectoral, on the chest, is well marked, owing to a slight hollow between them. Its hinder border is too thin in its upper part to express itself strongly, except when it is in action and raising the arm backwards. Above the arm-pit the hinder border is more voluminous,

but preserves a depression between itself and the triceps of the arm.

The scapula is, as it were, slung over the shoulders by the collar-bone, which thus provides the only bony connection with the skeleton.

The articulation between the clavicle and sternum is so mobile as to possess all the movements of a ball-and-socket joint. It will allow slight circumduction, such as

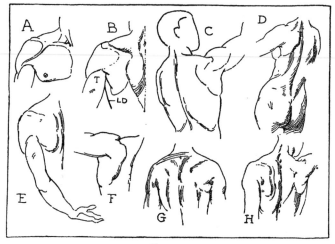

FIG. 274.

the point of one's pen makes in writing the letter O, slight rotation upon the axis of the bone, but chiefly a degree of movement up and down, and backwards and forwards.

The joint between the clavicle and scapula is in effect similar to that which connects the clavicle to the sternum. It allows a general mobility and accommodation to the actions of the arm, but its chief movements are upward, as in shrugging the shoulders or carrying weights upon

them ; and downward, and forward and backward, in which two latter the scapula glides over the thorax, arriving sometimes almost at the side of the trunk, and sometimes almost at the back-bone.

Then there is the movement of rotation, as if a pivot were passed through the centre of the blade, though the pivot shifts its position as the action proceeds. This movement is seen when the arm is raised above the shoulders, towards the head, and some degree of the contrary rotation when the arm is cast behind the body. (Fig. 274, C and E.)

But perhaps the most important fact concerning the movement of the blade-bone is the tendency of the inner, or vertical border, or base, to project outward, pushing the skin up. In strained actions of the arm ; when that limb is brought far forward ; and when the shoulders are thrown back, as in dumb-bell exercise, the scapula lies close and tight against the thorax, and the surrounding muscles assert themselves ; but in easy, or perhaps one should say lazy, positions, and when the hands are engaged in some light occupation, the base of the scapula, being loosened from muscular control, projects more or less. It generally appears as two mounds, one at the root of the spine, and one at the inferior angle.

The student of the history of art will have remarked how seldom the scapula is permitted to project in the manner here referred to ; it shows, but does not project. Pose has no doubt a great deal to do with this, and in this connection it is interesting to note how frequently in Greek works the position in which the shoulders are well back, with the elbows at the sides, and the hands held a little away, occurs.

The upper part of the back is of all the body the part

most liable to change, and it is virtually impossible to lay down rules governing the numerous details which come and go so readily. The spine and base of the blade-bone nestle among a number of subtly bulging masses sometimes very numerous, sometimes very few, and due chiefly to the muscles on the scapula, the rhomboids between it and the back-bone, and the trapezius. It will be when the arms are brought forward and the muscles at the back are stretched that the form will be simplest ; most complex when the arms and shoulders are thrown back. In Raphael's draw-

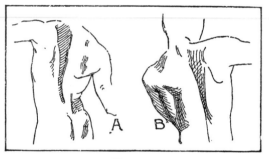

FIG. 275.

ings there are generally a great number of muscular "knots" on the back, and Michael Angelo and Cellini were equally fond of them. It must not be forgotten that the muscles consist of bundles of fibres, and these bundles often appear like separate muscles. The essentials of form are, however, those pointed out above.

Partly connected with the blade-bones is the modelling of the back, as shown in Fig. 275. The flat declivity from the blade to the back-bone is both characteristic and beautiful. Lower down, the back becomes divided, as in B, and as also in D and H, Fig. 274, into vertical masses, the outer of which are produced by the latissimus dorsi.

53. Some General Remarks upon the Back.

In Fig. 276 we see the muscles of the back displayed, much as they are in all books on anatomy ; and, as in all

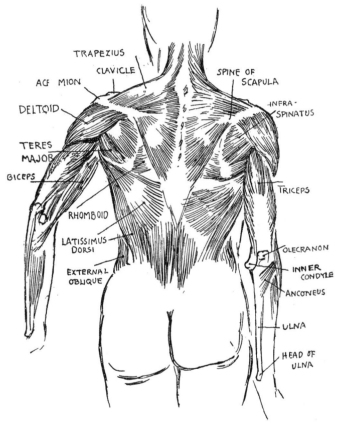

Fig. 276.—The Muscles of the Back.

those cases, the diagram affords a similar doubtful degree of assistance. This is because the edges of the muscles (which must of course be shown) do not correspond to

the modelling of the figure. Moreover, the muscles group themselves one way when considered anatomically, and another way when considered artistically. That is to say—muscles which have a similar origin or a similar function become grouped together when the anatomy is being considered, whereas there is quite a rearrangement when the modelling is being studied. Moreover, the outline shape of many of the muscles, as, for instance, trapezius, is very different from its modelled form, as we shall presently see. Furthermore, such a muscle becomes broken up into several parts and appears as several muscles. The mound A, in Fig. 277, owes its elevation in the first place to the rounded form of the thorax, for the ribs become smaller one above the other, and the flattish form of the back thus bends over to the lower

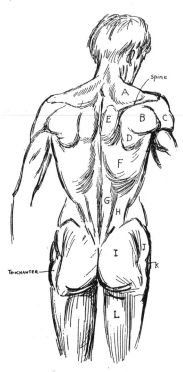

FIG. 277.—The Masses of the Back.

neck. But the trapezius muscle accounts also for a great deal of the fulness, though not for all, for it lies upon two muscles of the group round the shoulder-blade. These two are *levator anguli scapulæ* and *supra-spinatus*, which are illustrated in Figs. 185 and 273.

The mound B may be called the *infra-spinatus* mass.

It is separated from the mound A by the spinous process, or ridge, of the blade-bone, which stands up very markedly in thin persons (in children particularly). It is important

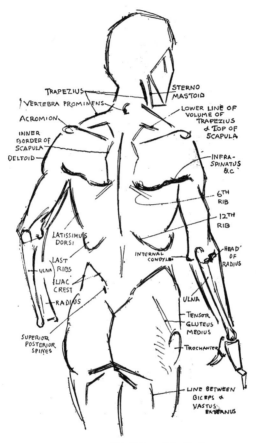

FIG. 278.—Chief Lines of the Back.

to note that this mound B, or *infra-spinatus* mass, passes over the arm-pit. Indeed, few hints about the figure are more useful than that. The mass C belongs to the deltoid muscle ; it interlocks with the mass B, C stretch-

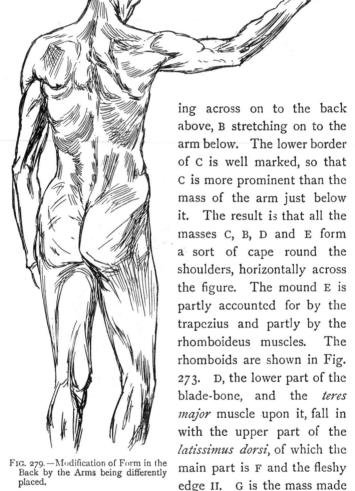

FIG. 279.—Modification of Form in the Back by the Arms being differently placed.

ing across on to the back above, B stretching on to the arm below. The lower border of C is well marked, so that C is more prominent than the mass of the arm just below it. The result is that all the masses C, B, D and E form a sort of cape round the shoulders, horizontally across the figure. The mound E is partly accounted for by the trapezius and partly by the rhomboideus muscles. The rhomboids are shown in Fig. 273. D, the lower part of the blade-bone, and the *teres major* muscle upon it, fall in with the upper part of the *latissimus dorsi*, of which the main part is F and the fleshy edge II. G is the mass made by the *erector spinæ*, lying beneath the aponeurotic portion of the *latissimus*, but very evident on the surface. I is

gluteus maximus, J *gluteus medius,* K *tensor,* and L the fleshy mass of biceps and *semi-tendinosus.*

From these details we deduce such a " commencement "

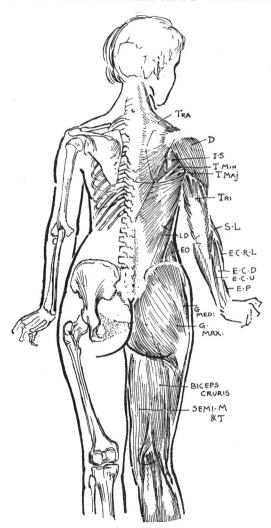

FIG. 280.—The Muscles of the Back, with the Bones.

as that shown in Fig. 278. The anatomical forms to
which the lines apply are stated on the drawing; but

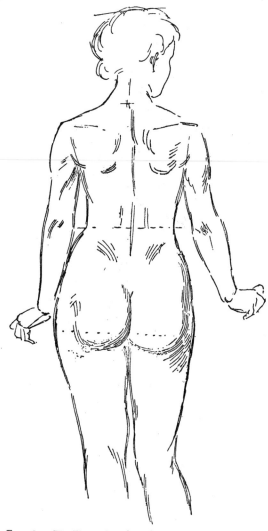

FIG. 281.—The Figure Complete, showing the Lines first drawn.

the lines are chosen not because they are anatomical, but because they help us to render the shape. A description could be given of each line—but the student will probably " read " the drawing as easily as any letterpress.

It is no great step from these illustrations to Fig. 279, which is what one might call a "scraggy" treatment, in which we knock the sleek anatomy about.

By comparing Fig. 281 with Fig. 278 we shall see the difference between the lines used to express a woman's form and a man's. The same diagram shows the position of the shoulders and waist, obtained by placing them at about the thirds between the top of the head and the gluteal fold.

We must note that

FIG. 282.—The Modelling of the Back.

the spine of the scapula does not show except in thin women.

The relative flatness and roundness of the several parts

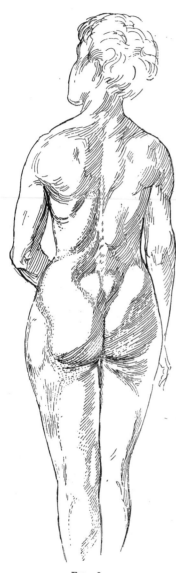

FIG. 283.

of the back are shown in Fig. 282, although that diagram is not drawn in planes. The blade-bones, right across on to the arms, form flattish surfaces, roughly four-sided; above them the "low" neck is in several triangular surfaces at angles with one another. Below the blade-bones the form is boldly modelled, for the back of the chest turns round to the side of the body, which cants off to the breast, obviously making the front of the body narrower than the back. A graceful line of shading passes from under the arm-pit to the middle of the figure behind, and is crossed by another from the middle of the back round in front of the iliac crest. These graceful lines indicate the flow of the form.

The form is again rendered in Fig. 283, where the full modelling of the hip, twisting about, is seen, and the roundness of the

shoulders also. Some similarity will be remarked between
the modelling at the back of the neck and at the back of
the waist; that is, there is a similar tying down of the
form round the prominences of the back-bone, and the
same swirling of the fleshy elevations.

54. The Proportions of the Trunk.

IT has before been said that the trunk (excluding the
head and neck) is divisible into two halves, at the lower
end of the thorax. In the female it is at the exact end,
but in the male it is rather at the end of the prominence
of the thorax before, at the cartilage of the tenth rib.
In the male these halves are each about 12 inches, in the
female about 11 inches. In the female the half of the
thorax gives the position of the nipples, in the male the
lower border of the pectorals.

In the back the following equal measurements (6 inches)
may be noted. From the top of the cranium to the
summit of the vertebral column, thence to the top of the
scapula, thence to lower angle of that bone, and then to
the end of the thorax. (Fig. 34.) In the female these
measurements are about $5\frac{1}{2}$ inches.

The scapula is virtually between the same horizontal
parallels as the collar-bone and nipples in both sexes.

Contrasting the measurements of the two sexes, it will
be seen that the width of the hips is the same in inches in
both, although the woman is in stature $63\frac{1}{2}$ inches, and
the man 67, if we adopt the customary average height.
The width of the thorax, bone only, is $11\frac{1}{2}$ inches in man,
9 in woman. Across the shoulders to the articulation
between the collar-bone and the acromion process is in

man 12 inches, in woman less. The acromion processes will add about an inch at each side.

The waist is 8 to 9½ inches in woman, 10 inches in man; the hips across the trochanters 13 inches in both. The female figure is also very wide across the ilia, being 12 inches to 11½ in the male. The greatest width of both figures is across the thighs a little below the trochanters. Taking the centre of the female figure as at the level of the trochanters, we see that from the centre down to the top of the patella, and also up to the breasts, are measurements equal to that across the trochanters. Again, the greatest width of the female is one-third the measurement from the ground to the waist.

In the male the width of the shoulders is supported by a very similar width in the chest and breast, but in the female the chest and breast are much narrower, permitting the arm to hang closer to the thorax, and so the width across the deltoids is in the female about 16 inches, against 18 inches in the male. It also accounts for the "brooding" of the shoulders of the woman spoken of on page 165.

The female thorax is not only narrower, it is slightly shorter. The female pelvis is slightly wider in actual measurement, but not so tall. Hence there is more space between the thorax and pelvis, than in the male.

There may be some little practical value in the diagrams of the proportion of the back, given also in Fig. 34. In the female there are four equal measurements of 12½ inches each; in the male the second is reduced to 10 inches, the others increased to 14 inches each.

THE UPPER LIMB

55. The First Lines in a Drawing of the Arm.

THE earliest sketch of the arm must include both the shoulder and the hand, particularly the hand, which most beginners seem to regard as something quite different from the arm, and which can be added at any time. That this is a great mistake any one who gives the least consideration to the construction will see at once.

The commencement of the drawing will consist of simple lines on either side of the limb. It is not wise to linger upon the details of form, till the whole arm is built up in simple fashion, and the proportion and action are determined by such means. But these first lines should be true to form, and the draughtsman must be continually trying to compass as much fact as possible into simple and rapidly-drawn lines.

Different views of the arm yield different outlines, and the variety is very great, but perhaps Fig. 284 summarizes the most frequent positions. The curves bounding the form on either side are generally somewhat parallel, but some positions require both outlines to curve outwards as F, Fig. 284. When the curves are parallel, as in the other examples in Fig. 284, the convexity is backward in the

side view, as A, C, D and H. In views approaching the front
and back, the parallel curves for the (upper) arm will have
their convexity toward the figure, as E and G. In these
examples will be noticed a slanting line from the arm to
the elbow, which corresponds to the massing of the bones
of the elbow, as shown in Fig. 286. In H, Fig. 284, the
whole arm is within lines convex backward. B is similar,
but while the upper line is single the lower is double,

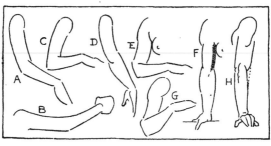

FIG. 284.

and thus expresses by the angle formed the projection of
the elbow.

The first lines of the hand will be as in A, C, D, E and G,
a straight line being placed for the back of the hand, and
a graceful curve for the index finger. Before proceeding
further with the practical drawing, it will be well to remind
ourselves of the bones and chief muscles of the arm.

56. The Bones of the Upper Limb.

THESE are shown in the accompanying diagrams, Nos.
285 to 287. A few characteristics will need to be pointed
out. The greater tuberosity of the humerus helps to form
the upper bulb of the mass of the deltoid muscle. The

shaft is tolerably straight, and ends in the articular surfaces for the hinge-joint of the elbow. Above that joint the bone is very thin, being hollowed before and behind, to accommodate the ole-cranon and coronoid processes of the ulna, when they, in the respective actions of extending and flexing the fore-arm upon the arm, come up against the humerus. Were that bone not hollowed to receive them, the actions would be so far further limited. The hollowing necessitates the provision of power-ful lateral support for the articular surface, and this is provided by the epicondyloid ridges. These ridges are very important to the artist; for one, the external, is the centre of a radiating set of muscles, and conse-quently of the lines

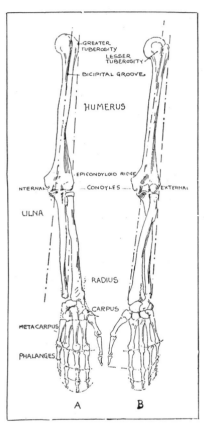

FIG. 285.—The Left Arm.
A, Supinate; B, Pronate.

which express them; while the other, the internal, is, generally speaking, always in evidence.

Turning to the side view, the lower end of the humerus will be seen to bend forward a little. The back of its

lower end is thus smoothly curved. In the skeleton this
smooth curve is suddenly broken by the olecranon process ;
but with the addition of the muscles and skin, the break
is considerably lessened.

Viewing the skeleton of the arm as a whole, the fact
that apparently the humerus and ulna form one distinct
part, and the radius and hand another, cannot be over-
looked. This oblique fitting together of the parts will
frequently be noted in a study of the figure, but nowhere
is it so palpable as in the arm.

FIG. 286.—The Elbow-joint (left arm).

A, Inner three-quarter view, pronate ; B, Inner three-quarter back view, pronate ;
C, Outer three-quarter back view.

The elbow-joint depends almost entirely upon the ulna,
the lower end of which will be seen to be very similar
to the upper end or head of the radius. These smaller
ends of the bones have lateral articular surfaces which are
concerned in the actions of pronation and supination,
which may be briefly described as follows. The head
of the radius remains in the same position throughout
the actions, but revolves. The lower end of the radius,
during this revolution of the head, works against the
lower end of the ulna, and is carried half-way round, or
over it. When the thumb is outside, the arm is in the

position of supination ; when it is turned in towards the thigh, it is in pronation.

The pronate arm is much more nearly straight than the supinate. This is due to the slight obliquity at which the ulna is placed to the humerus, an obliquity demonstrated by drawing a line level with the greater tuberosity of the head of the humerus and the external condyle ; it will touch the outer side of the lower end of

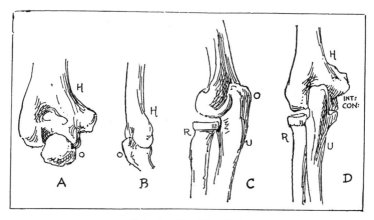

FIG. 287.—The Elbow-joint.

A, Back view of the left elbow, bent; B, Showing how the olecranon grips the humerus, and the curvature of the latter ; C, Outer view, left elbow, straightened ; D, Back view of same.

the ulna. (Fig. 285.) In supination the radius is to the outside of this line, and thus produces an obtuse angle with the humerus, the external epicondyloid ridge being in continuation with the line of the radius. The angle thus occurs at about a third of the length, upward, of the humerus. This is worth observing, as the final muscular form is suggested by it.

If a line be drawn as axis to the humerus, it will be seen in supination to be considerably to the inner side

of the wrist, but in pronation the wrist comes up to it.
Even in pronation, then, the axis of the fore-arm is not
quite in line with that of the arm, but deflected a little
to the outward.

Pronation is an auxiliary *rotation* of the arm. Rotation,
as the word implies, is a moving round upon the axis. If
the two bones of the fore-arm were rigid, the palm could
only be turned downward if the elbow-joint itself con-
tained the power of rotation. Such a change would entirely
destroy the strength of the limb. Pronation being a kind
of rotation is nearly always accompanied by rotation of
the humerus, which is of course easily performed at the
loose shoulder-joint. So that when the thumb is turned
over toward the body (pronated), the elbow projects at
the side, outward; and when the thumb is carried back
(supinated), the elbow is drawn in close to the trunk.

57. The Triceps Muscle.

THIS important muscle covers the whole of the back
of the arm, the details of which are the details of its
form and construction. Its office is to extend the fore-
arm, on the arm, and for this purpose it is attached to
the strong olecranon process of the ulna. Its attachment
also to the scapula gives it power of drawing the arm
towards and behind the trunk.

The form of the muscle may be gathered from the
accompanying illustration, and only a few words of
explanation will be necessary.

In the first place, the common tendon by which all
three heads are attached to the olecranon is of considerable
length, reaching nearly half-way between the olecranon

and the acromion, as shown in Fig. 289, A. Omitting the junction of this tendon with the olecranon, it has three sides, two very long and virtually parallel, expressing the length, while the third, which connects them at the top, is inclined downwards toward the outside. The depression due to this short slanting border is one of the most noticeable characteristics of the muscle.

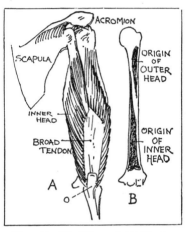

FIG. 288. —The Triceps Cubiti Muscle.

Attachments—Middle head, beneath the glenoid cavity on the neck of the scapula ; outer head, outer side of upper half of shaft of the humerus; inner head, inner side, and below, the back of the shaft of the humerus—upper border and sides of the olecranon. B shows the origins of the outer and inner heads on the humerus.

When the muscle is in repose it dies almost away, and is generally evident when the arm is in powerful action.

The tendon from this slanting " hollow" to the olecranon is nearly flat, being slightly bulged by part of the inner head beneath it. The tendon joins on to the olecranon,

with the result that the olecranon appears more a part of it than a part of the ulna bone, a deception which is assisted by a slight depression under the elbow. Nothing could be worse than to suggest in a drawing of a bent arm that the elbow projected backwards as in Fig. 289, C. Such is typical of lower animals, D.

A fringe of muscular fibres runs down either side of the tendon raising the borders, and thus rendering this lower part of the muscle somewhat flat, while at the same time

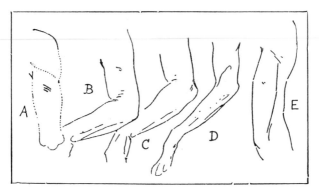

FIG. 289.—Effect of Triceps.

it makes three surfaces of modelling, one for each fringe and one for the tendon.

The *outer* head is the higher in position of the two which arise only from the bone. But this precedence is wrested from it by the middle head in conjunction with the inner. These form a mass which overshadows the outer, although it is the largest of the three. The mass thus formed, as soon as it emerges from under the deltoid, spreads out toward the trunk as if it had need of the space provided under the arm-pit. It will be wrong, therefore, to draw the internal line of the arm, representing

this mass, from the arm-pit to the condyle, as even a
tolerably straight line. It must press inward, almost as
if it were following the course of the latissimus dorsi.
Then it must as suddenly return, and with one or two
slight roundnesses arrive at the condyle. The outline of

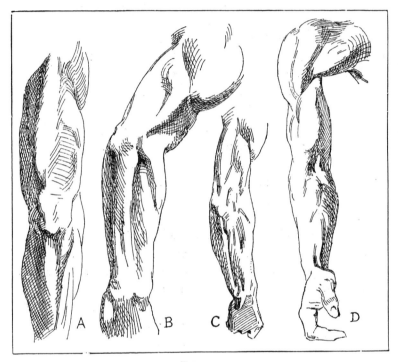

FIG. 290.

the outer head is very similar. Commencing lower, it
passes outward and then inward. And thus the triceps
take somewhat the form of a coffin (E).

The outer head and the inner mass can hardly be said
to commingle. Even when they seem to form one smooth
surface, it is evident that a degree of precedence attaches

to the inner part. In muscular men there is a distinct depression between them, and the inner mass is seen to grow into the middle head which carries it on up under the deltoid, which it sometimes slightly raises. The outer head, finishing, in fact, as well as in appearance, at the deltoid border, shelves down, and so accents the groove between it and that muscle.

The outer head, with the "hollow" beneath it, is perhaps the most noticeable of all the details of the triceps. It produces a bulging, *obliquely* placed, skirting the edge of the deltoid, and passing from the back to the front, or rather to the side, of the arm.

A muscular arm is in its section roughly triangular. One side of the triangle will face the trunk, being limited behind by the middle head, and before by the summit of the biceps ; one side will face somewhat backward, and extend from the middle head to the outer head, while the third side will extend from the outer head to the biceps. These three sides are shown in the diagrams, the one facing inwards in Fig. 292, the one backwards in Fig. 290, C, and the one forwards and sideways in Fig. 290, D. As regards the triceps, let it be noted that though it has a side to itself, the backward one, it yet extends some distance across the inward one. Thus it has two surfaces, divided by the middle head.

58. The Brachialis Anticus, Coraco-Brachialis, and Biceps Cubiti Muscles.

THE brachialis anticus, somewhat in shape like a *vesica piscis*, a pointed oval, lies beneath the biceps, but appears in what in the last paragraph are described

as the sides of the arm looking inward and forward-
sideways. Its form is not very distinctive, the biceps and
triceps, which it separates, having both more character.
Nevertheless, its volume is very important, as the lower
part of the biceps is seldom wide enough to cover it.

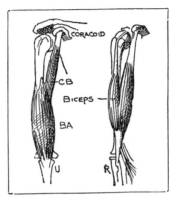

FIG. 291.

Brachialis anticus.
 Attachments—Lower half of anterior surface of the humerus—
 below coronoid process of ulna.
Coraco-brachialis.
 Attachments—Apex of coracoid process of scapula—inner side of
 the middle of the humerus, anterior surface.
Biceps cubiti.
 Attachments—Long head, above glenoid cavity, short head, apex
 of coracoid process of scapula—by a long tendon to back of
 bicipital tuberosity of radius, the tendon sending off a fibrous
 expansion which spreads out over the fascia of the flexor
 muscles of the fore-arm.

Reference to it will be found marked B A in Figs. 293
and 295.

In the living model the biceps does not show that it
has two "heads." When inactive it appears as a short,
fairly straight and stout cylinder with rounded ends, for
the muscle diminishes rapidly to tendon at both ends.

Across the centre of the cylinder is a very shallow depression which gives a slight wave to the outline. (See Fig. 293, D.)

It is well known how the biceps changes its form when acting as a flexor of the elbow. It runs up from its lower end and gathers into a mass in its upper part, more suggestive of a sphere than a cylinder. And whether the muscle is engaged in flexion, or, in company with other

FIG. 292.

muscles, flexors and extensors, is strained to render the arm rigid, the fibrous expansion over the flexors of the fore-arm is evident. (Figs. 292, B, and 293, E.)

The coraco-brachialis, which is a proper adductor of the arm, occupies a position between the biceps and triceps, and proceeds up to the arm-pit; and appears somewhat similar in mass to the inner edge of the brachialis anticus, which, like it, is between the triceps and biceps, but lower down. The coraco-brachialis may be seen in Figs. 292, A, and 293, D, E and F.

59. The Order of Arrangement of the Muscles about the Arm-pit.

THE way in which three muscles of the trunk approach and attach themselves to the arm requires special attention. These three are—teres major, latissimus dorsi, and pectoralis major. The teres comes from the back of the

FIG. 293.

scapula, the dorsal from the iliac crest, the pectoral from the chest, and they are all inserted into the humerus in a small area about the bicipital groove, a groove on the front of the bone in which the long head of the biceps plays, like a cord in a pulley. (Fig. 285.) The order in which these three muscles are attached is easily remembered if their initials be taken and made into the word PELT; that is to say, that reading the attachments on the humerus from the front, there is to the outside, first the pectoral, next the latissimus or dorsal, and last the teres.

Let it be further remembered that the latissimus and

teres are intimately associated at their insertion; and they thus form a party, as it were, from the back, as distinguished from the representative of the front of the body, the pectoral. Between these two masses pass the biceps and coraco-brachialis. In drawing the arm then, having placed the double outline for the deltoid, one follows, from the insertion, for a little distance, its ascending anterior border, and then takes up the axillary or arm-pit border of the pectoral, which carries one over to the trunk. Beneath this is the large bulk of the biceps, and close to it is the coraco-brachialis, for the short head of the biceps and that muscle have the same insertion. Next to the coraco, which passes down the arm, will come a mass for the latissimus and teres passing down the trunk, and last the triceps of the arm.

Looking at the matter of the order of arrangement of the muscles about the arm-pit in another way, and omitting the deltoid and the rotator muscles beneath it (supra-spinatus, infra-spinatus, and teres minor), it will be found that the first syllables read, commencing at the back and passing under the arm-pit, in this order—

TRI (triceps); TER (teres major); LAT (latissimus); COR (coraco-brachialis); BI (biceps); PEC (pectoral).

If punning be allowed, and the Scotch for crow (corbie) be imported, and little heed be paid to the sense of it, a sentence is formed—

Try to let corbie peck;
which may nevertheless be an aid to memory.

Both the latissimus and pectoral have short flat tendons twisted upon themselves. The effect of this twist, apart from its mechanical advantage, is to soften the connection with the arm, making an upward curve, as seen very prominently in the pectoral border of the arm-pit.

60. The Muscles of the Fore-arm.

THE muscles of the fore-arm may be roughly divided
into two groups, flexors and extensors, operating upon the
wrist and hand. There are muscles with other duties, but
they do not interfere with this general classification. In-
stead of the flexors occupying completely and only the
front of the fore-arm, and the extensors the back, each
group encroaches upon the other's territory. Thus in the
front view, part of the ex-
tensor group (the supinator
longus though not an ex-
tensor is by location part of
that group) is seen on the
outer, or thumb side, the
muscular division being a
graceful line. And in the
back view part of the flexor
group is seen on the inner
side, and is limited by a line
(B), representing the ulna
bone, not very unlike the other dividing line.

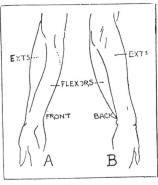

FIG. 294.

The details of the muscles are shown in Figs. 295 and
296.

The ulna forms an excellent basis upon which to
arrange the muscular marking of the extensor group.
A portion of it is subcutaneous, that is, close under
the skin, and thus gives a permanent line from the elbow
to the little knob which terminates the bone below, and
which is plainly to be seen on the little-finger side of the
wrist. The line which expresses this subcutaneous portion
is also the edge of the flexor mass. It is a slightly-curved

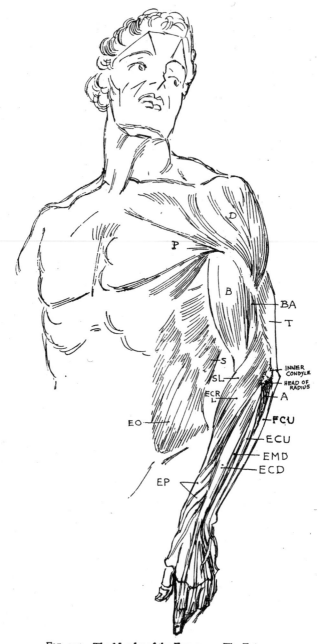

FIG. 295.—The Muscles of the Fore-arm. The Extensors.

EXTENSOR, OR BACK GROUP.

Supinator radii longus.

 Attachments—Upper part of epicondyloid ridge of humerus—base of styloid process of radius.

Extensor carpi radialis longior (longer extensor of wrist on radius side).

 Attachments—Lower part of epicondyloid ridge of humerus—base of metacarpal bone of first finger.

Extensor carpi radialis brevior (shorter extensor of wrist on radius side).

 Attachments—External condyle of humerus—base of metacarpal bone of second finger.

Extensores pollicis (extensors of the thumb, three in number).

 Attachments—Back of the ulna and radius—respectively to the bases of the three bones of the thumb.

Extensor communis digitorum (common extensor of fingers).

 Attachments—External condyle of humerus—by four tendons to the back of the bases of last two bones of the fingers.

Extensor minimi digiti (extensor of the little finger).

 Attachments—By the tendon common to the extensors of the fingers, to the external condyle—back of base of last two bones of little finger.

Extensor indicis (extensor of index finger).

 Does not appear on the surface.

Extensor carpi ulnaris (extensor of wrist on ulna side).

 Attachments—External condyle—back of base of fifth metacarpal bone.

Anconeus.

 Attachments—Back of the external condyle—outer side of ulna below the olecranon process.

line, and does not entirely follow the shape of the ulna, which is straighter. The next point to mark will be the external condyle, almost covered by muscle, and having immediately below it the head of the radius, which, although crossed by the tendons of the extensor muscles, sometimes shows as a slight knob-like projection. (See Fig. 308.) From the external condyle radiate five of the seven muscles which pass down the fore-arm from this region ; the other two, supinator longus and extensor carpi

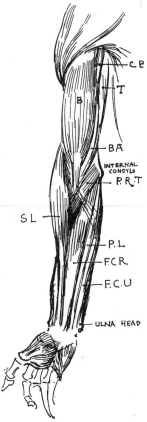

FIG. 296.—The Muscles of the Fore-arm. The Flexors.

THE FLEXOR, OR FRONT GROUP.

Pronator radii teres.

Inner condyloid ridge—middle of outer side of radius.

Flexor carpi radialis.

Inner condyle—base of second metacarpal bone.

Palmaris longus.

Inner condyle—fascia of the palm.

Flexor carpi ulnaris.

Inner condyle—pisiform bone of wrist and base of fifth metacarpal
bone.

Flexor digitorum sublimis (a deep muscle).

Inner condyle—sides of second phalanges of fingers.

radialis longior, coming from the epicondyloid ridge above. It is important to notice that these two are not arranged as longitudinally upon the limb as the others, but are placed obliquely, and thus pass from the back to the front of the arm, and constitute that portion of the extensor group which is found on the flexor side. Hence, in representing these muscular forms by lines, a proper difference must be made between those for the two and those for the five. It may be noted that the line of the extensor carpi radialis longior, the lower of the two, is almost symmetrically placed with the lower border of anconeus; the two borders making an angle into which the four straightest extensors fit. One of the three borders of anconeus comes upon the line indicating the ulna, which it supersedes for its short extent, Fig. 297, and renders angular.

FIG. 297.

61. General Characteristics of the Arm.

THE arm, roughly speaking, consists of two cylindrical masses, one, represented by the biceps forming the front; the other, represented by the triceps forming the back of the arm ; the fore-arm also consists of two masses tapering toward the wrist. These two masses of the fore-arm, represented, the outer one by the supinators, the

inner one by the flexors, are placed in a position contrary to that of those of the arm, having their flat side forward, while the arm has its flat side outward.

It happens then that when the fore-arm is seen at its widest, the arm is reduced almost solely to the width of the biceps ; and similarly, when the arm is seen at its widest, the fore-arm is at its narrowest.

The directions are not, however, exactly contrary, though very nearly so. When the greatest width of the fore-arm is directed forward, a little of the inner side of the upper arm is seen ; or, in other words, there is a slight suggestion of continuity between the biceps mass above, and the supinator, or outer mass, below.

FIG. 298.

In drawing any part of the figure, the first things to fix upon and locate will be such indications of bone as exist on the surface. By these also proportion is best secured. In the arm, the part above the elbow that is, there is very little bone exhibited. Above, the head of the humerus has to be thought of as just under the acromion, and contributing considerably to the upper bulb of the deltoid mass. Below, in all probability the olecranon, or one of the condyles, or all three, will be seen. If the fore-arm be bent, the condyles and olecranon will very likely show as a triple form not unlike an inverted trefoil. In most cases the internal condyle will be the landmark, limiting the internal line of the arm.

Just as this internal line happens to be long, extending from the arm-pit to the internal condyle, so the external line is short. For the deltoid reaches nearly half-way down the humerus, while the supinators of the fore-arm reach a third up it, so that between the deltoid and the supinators there is very little space at all.

In the fore-arm the ulna and radius both become evident, the ulna more completely than the radius. It is sub-cutaneous throughout its length. The student will probably already have noticed that the ulna takes one side of the wrist, the radius the other, and that the ulna belongs to the little finger, the radius to the thumb. The diagrammatic position of the arm has the *little finger* against the body, the palm being forward ; the position with the palm inward and the

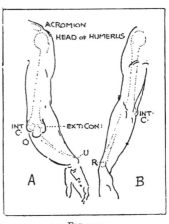

Fig. 299.

thumb against the thigh is, however, more natural. The two positions have already been described as respectively supination and pronation. Before proceeding with his drawing of the arm, the draughtsman has to determine whether it is to be pronated or supinated. This settled he can proceed, and he proceeds as follows. Supposing the arm to be in a simple natural position, pronated, the drawing will be commenced as in Fig. 284, A, and continued as in Fig. 300, A. The form of the elbow (O) will be placed, and then the other end of the ulna (U) at the wrist. Then the subcutaneous ulna itself will be

indicated by the line of *anconeus* (A), and the long line U. Beneath the line thus put together will be two curves (F) representing the *flexors*, and forming one of the outlines. Note that the upper of these lines does not commence at the projection of the olecranon (O), but a little below it, and also that the lower does not quite reach to the wrist. In the arms of women this lower line (F) must be fairly full, and must creep as low down to the wrist as possible. The

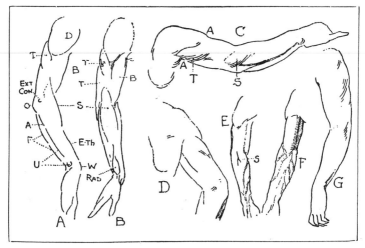

FIG. 300.

upper outline of the fore-arm is definitely divided into two parts, *at about the middle*. The upper part represents the supinator mass spanning the elbow-joint, and commencing about one-third up the arm. This mass is very important, and must be taken well up the arm. The lower part of the outline of the fore-arm consists chiefly of the lower end of the radius bone, but it is swollen by the extensors of the thumb (E Th.) which pass over it. The wrist must on this side have a curved outline (W), followed by a very slightly

convex line for the back of the hand, and that by a double line for the finger. Above, the deltoid (D) must first be indicated, and on one side the biceps (B) by a waved line, and on the other the triceps (T). The outer head of the triceps must show as a prominent and distinctly oblique mass; and the lower part of the muscle leading down to the elbow must be convex, and the elbow must only project beyond it very slightly—not at all if the arm is bent.

No. 10, Fig. 301, is a similar view of the arm, detailed further, and with the hand extended instead of flexed. In this it may be seen also how that the triceps continues down into the ulna of the fore-arm so that the whole left side in the diagram is connected. The wrinkle across the back of the wrist is valuable, as it helps to indicate at once the fact of the hand being extended.

An outer view of the arm, not pronated, will be as given in Figs. 300, B, and 301 (8), the latter being the more forcibly extended. Excepting at the elbow, and then only slightly, the ulna will not show; but the lower end of the radius will appear in its place at the wrist, the upper part of it shows sometimes just below the external condyle. The lower end of the radius appears longer and broader than the lower end of the ulna, being moreover tolerably sharp. Its form may be gathered from the diagrams. The outlines of the fore-arm are provided by the assemblage of muscles both at the front and back. The back outline is mainly due, however, to the ulna, the simple and hard shape of which it almost exactly repeats. The front outline has the fleshy bulging of the flexors, followed by a slight hollowing, succeeded again by the full roundness of the wrist. (Fig. 300, B.) The supinator mass is perhaps the chief detail of this view. The outline of the inner view of the

arm (Fig. 301 (9)) will be the same as an outer view (Fig. 300, A), excepting only that the internal lines will differ. The biceps virtually provides all the form—it has two

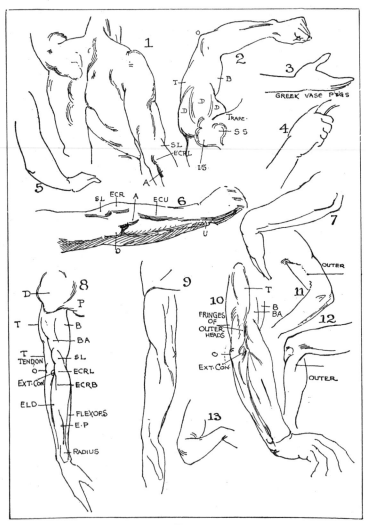

FIG. 301.

tendons at its lower end, or rather a tendon and an expansion. The tendon dives down between the two masses into which the fore-arm is roughly divisible, while the expansion spreads over the mass of the flexors. The lower end of the radius will be the only other clearly-marked detail of the fore-arm. In the upper arm *coraco-brachialis* will appear between the biceps and triceps under the arm-pit, while *brachialis anticus* will show as a slight mound between the same muscles, but just above the condyle.

The most remarkable details of the arm are certainly the masses of the *triceps* and *supinator* (T and S, Fig. 300, C). They are distinctly obliquely placed. The deltoid must always have a waved outline, as being double in character and not ball-like. In the female arm (G) the doubling of the deltoid is very noticeable, the lower part or mass of it being very full, and low down. The arm at the arm-pit must be kept somewhat narrow in the back view (A A, Fig. 300, C).

The female arm (G) is wide in the upper part, and its section throughout rounder than a man's. In the back of the wrist in both it is necessary to express the ulna line and knob, as in G, as if supporting the hand. The back view of the arm (Fig. 300, D) has the biceps continued on the fore-arm by the aponeurotic expansion, and a line parallel to the biceps separating it from the triceps.

The veins of the arm must not be overlooked. Their exact number and position is not important, and they are divisible, roughly, into two groups, an outer and an inner. Both groups commence in the upper arm as single veins running longitudinally down the limb. We have spoken above of the arm being in section triangular, with one surface flat against the trunk, and the other surfaces directed one backward and outward, the other sideways and for-

ward. The angle between the inner surface against the trunk, and the side, is formed by the front of the biceps muscle—a wide angle certainly. So that while the *front* of the biceps forms the angle, its sides become parts of the outer and inner sides of the arm. Now it is just at the junction of the outer side and front of the biceps that the outer vein occurs ; and its effect is to accent the surfaces spoken of. The inner vein is about midway across the inner surface of the arm ; in fact, between the biceps and triceps muscles. Having thus a natural hollow to lie in, it is not so evident as the outer vein which lies on the body of the muscle.

The inner vein becomes very prominent at the hollow of the elbow-joint, where for an inch or less it shows as massive in volume and blue in colour. In the hollow of the joint two branches are sent off from both the inner and outer systems, and make any distinct division impossible. Nevertheless, as an aid to memory, the following may be taken as the arrangement. The inner system follows the direction of the *aponeurotic expansion* of the biceps, falling round the mass of the flexors, as shown in Fig. 300, F. The outer group skirts the supinator mass (Fig. 300, E), as if to avoid climbing the ridge, and passing over the extensors of the thumb reaches the back of the wrist, where it descends to the back of the hand, keeping to the middle course. The arrangement is, however, very variable.

The complexity of these veins renders them difficult to introduce. Their effect is to break the flowing curves of the fore-arm, and to render polygonal its smooth surfaces.

The wrinkles, or creases, are always of great assistance. They help one to seize the conditions and facts of the pose. Those of the arm may be capitulated as follows—

When the arm is fully extended, there are a few creases

at the back of the elbow, above and below it; when it is flexed there are one or two before the elbow-joint. As the mass of the supinators crosses the joint, it becomes folded in flexion of the elbow, with a deep crease between two very voluminous masses, which so increase the bulk in that region as to seem to threaten the gracefulness of the fore-arm. And at the same time the bones project very prominently below. Both these peculiarities must be frankly accepted. (Fig. 301 (13).)

At the wrist-joint several creases appear in the action of flexion; in extension, the puckering of the skin hardly amounts to creasing. But in forced extension, a distinct crease appears at the end of the arm-bones. It at once indicates the force and character of the movement, and the flatness of the back of the wrist.

62. Some further Instances of Form in the Arm.

IN this diagram we have a somewhat back view, although the figure is a three-quarter one. The arm is rolled, and the elbow is coming toward us. We notice the wrinkling of the skin above and below the elbow. The lower part of the fore-arm appears flat and bony, the extensor muscles occupying the upper half.

In Fig. 303, where the hand is on the hip, and we see the blade-bone on the back, we notice particularly the sharp inner and cord-like edge of triceps, dividing the inner surface of the arm, and coming down on to the inner condyle of the humerus. It comes *on* to the condyle and leaves part of it exposed below. To this lower part, but not on to it, goes brachialis anticus, and biceps comes down and turns rapidly and gracefully on to the flexors.

The surface of the inner side of the arm is passing obliquely away from us, and the surface of the fore-arm is also going away from us, flatly.

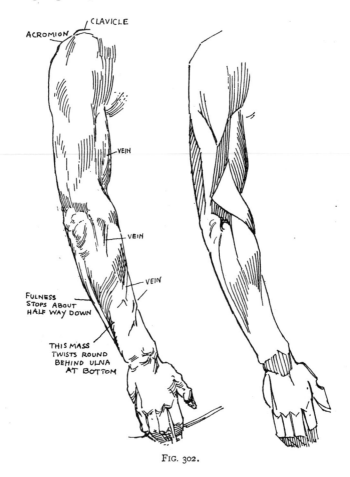

FIG. 302.

Fig. 304 is an arm of a woman corresponding to the previous diagram, which is a man's. The form is the same, but is masked in the softer character of the sex. The

deltoid is shown by a few strokes of shading higher than the triceps, as if there were a channel across from the angle

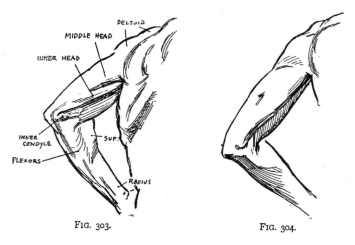

DELTOID

MIDDLE HEAD

INNER HEAD

INNER
CONDYLE

FLEXORS

SUP:

RADIUS

FIG. 303.

FIG. 304.

in the outline over to the arm-pit. Note, particularly, the point made by the olecranon in both illustrations. The shaft of the bone does not run as a straight line down to the wrist, but passes inward.

When the arm is bent the mass of the supinator is creased across, and the mass is thrown up full and large. To it suddenly succeed, on both sides of the fore-arm, the more strongly-marked masses of the extensors. (Fig. 305.)

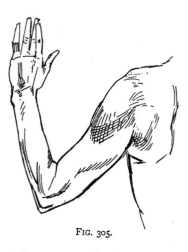

FIG. 305.

The slight sketch, Fig. 306, illustrates with what delicacy

the Greeks rendered the form in their easily-executed vase-paintings.

We see in Fig. 307 the lines of the flexors striating the fore-arm, the division between them (A) making a line continuous with the line of biceps above. The biceps line may sometimes (B) with advantage be carried above the line of the pectoral (C), for B is then following one of the radiating lines of the deltoid. Below, D is the depression just above

FIG. 306.—A Note from a Greek Vase-painting.

1, mass of deltoid; 2, depression between deltoid and outer head of triceps; 3, outer head showing full, and gliding into a flat bony continuation, 4; 5, bony line of ulna; 6, extensor; 7, lower part of ulna with muscle upon it, and here drawn rather too convex; 8, end of ulna; 9, back of hand; 10, knuckles; 11, fleshy mass of biceps; 12, wrinkle in profile; 13, wrinkle across supinator mass; 14, supinator mass; 15, flexors; 16, hollow where radius and tendons lead to wrist.

the end of the radius bone. E P is the extensors of the thumb (*pollex*), F the flexors, and S L the supinator longus —these three are the main elevations of the form, and the depressions between them correct the "turned wood" character which the fore-arm sometimes takes.

We note in Fig. 308 the line of the ulna—three different parts—then the head of the radius, close beneath the outer

condyle. It is covered by the tendon common to the extensors, which arises on the condyle above, but it is frequently visible.

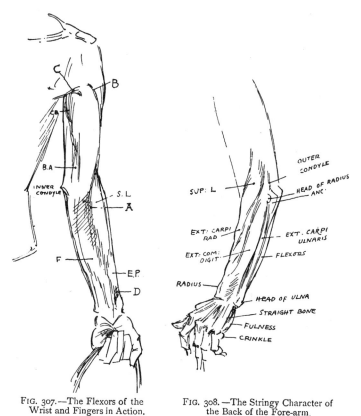

FIG. 307.—The Flexors of the Wrist and Fingers in Action.

FIG. 308.—The Stringy Character of the Back of the Fore-arm.

63. Movements of the Wrist and Hand.

THE wrist, like the flexor muscles of the fore-arm, is so full of detail that it becomes simplified by its very complexity.

The wrist proper consists of eight small bones arranged

in two rows, four in each. Between the two rows is a kind of ball-and-socket joint, the length of which is the width of the wrist, and the breadth its thickness ; or, since the bones are much of a size, it is four bones long and one wide. A similar joint is between the upper row and the end of the radius. By these joints a degree of all movements is possible, except rotation, which is pre-

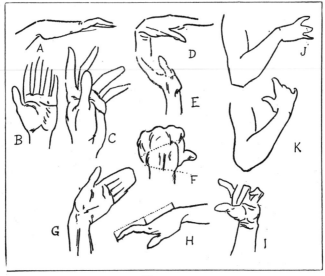

FIG. 309.

cluded by the length of the articulation in proportion to its width. The different bones of the carpus (wrist) also glide upon one another, so that the whole region is one of complete though limited mobility.

For the designer it is sufficient perhaps to specify only the following details of movement :—

The wrist may be bent sideways (adducted, Fig. 309, G) in the same plane as the fore-arm, to a considerable

angle, as illustrated, but it can scarcely be abducted (the thumb sent towards the arm) at all, if kept in the same plane as the arm. And in this matter of adduction and abduction of the wrist, the law of the association of flexion with *ad*duction and extension with *ab*duction holds good.

Extension with slight adduction is possible, and not inelegant. It is seen in the gesticulation which sometimes accompanies a declaration, and in some attitudes of pointing.

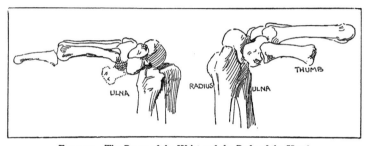

FIG. 310. The Bones of the Wrist and the Body of the Hand.

Abduction with flexion is virtually impossible, adduction being nearly always present.

In the attitude of the hand upon the breast, adduction, J, is certainly better than abduction, K, which looks strained. In these attitudes the hand is flexed upon the fore-arm.

The movements of flexion and extension of the wrist are illustrated in Fig. 309, D and E, where it will be seen that flexion goes as far as a right angle, extension only about 45 degrees.

It will not be expected that the fingers will follow the curve or direction of the wrist; they are often found contrasted with it, in accordance with that principle of

variety and alternation upon which grace depends. (Fig. 309, A and H.)

64. Details of the Form of the Wrist.

THE wrist has a front, a back, and two sides. Each side is flattened ; the thumb side by the somewhat trapeziform "side" of the thick end of the radius, the other by the ulna bone and the tendon of the flexor carpi ulnaris, a tendon which naturally shows most when the ulna side of the wrist is flexed. Between the tendon and the ulna is a shallow concave hollow, which runs back and gradually gets lost. The ulna plainly reveals its drum-stick end. This ulna side faces slightly downward.

The radius side is not so distinctly flat, the trapeziform side of the radius being itself somewhat rounded, and unsupported by such a tendon as that on the other side. The tendons of two of the extensors of the thumb more or less outline it, but they are only evident between it and the ball of the thumb (see Fig. 311, C), and do not therefore affect the wrist itself.

Another point of contrast between the two sides, and which has already been suggested, is the smallness, round-ness, and prominence of the end of the ulna compared with the longer and less generally prominent end of the radius. Alternation is also observable in the bones of this region. (Fig. 309, F.) The end of the radius commences higher up, and finishes lower down than the end of the ulna. Between these ends the back of the arm is flat, except when the wrist is bent, when it becomes somewhat rounded.

The wrist-bones form an arch, the hollow of which is at the front, and encloses, and is filled up by, the tendons

of the flexors of the wrist and hand. The rounded back
of the arch forms a noticeable roundness at the back of
the hand just below the wrist-joint.

The difficulty of joining the hand to the arm is con-
nected with the wrist. The best way to proceed is perhaps
as follows. In several diagrams (Figs. 264 and 278) the
arm is cut off at the wrist, the ulna and radius finishing
it. This is a useful way of getting a grip of the wrist;
but if we add the hand to. it, and even put the wrist

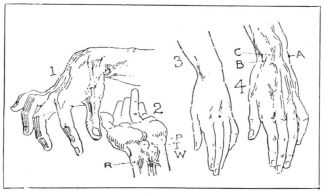

FIG. 311.

between (as we should), and yet do not observe a par-
ticular fact, we shall not fare well. The particular fact is
—that the wrist has (at the back) an elevation higher than
the end of the fore-arm and than the hand, and it overlaps
them both. We therefore have to put a buttress mass
(A in Fig. 312), by means of which we model the form
over. This is, of course, roundish, and the back of the
hand follows the same curvature. In fact the hand, and
particularly a woman's, which is thick if it is narrow, is
sure to look wrong if made too flat at the back.

We note that it is against the radius that the back

of the wrist makes the greatest fulness. This fulness is
continued up into the fore-arm by tendon, and on to the
hand by tendon also.

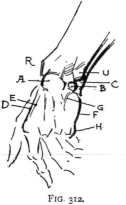

There are two other forms in the
wrist which cannot be overlooked,
B and C. B is small and knob-like,
C is fuller, larger, and seems more
a portion of the ulna underneath
the knobby head of that bone.
This is seen also in Fig. 313, where
the relation is perhaps better seen.
There also the pisiform bone, P,
comes into view. P is nearer the
spectator than U, U nearer than B.

FIG. 312.

When we attack the hand we
first draw the line for the metacarpal of the first finger,

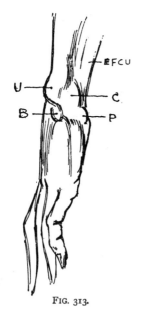

FIG. 313.

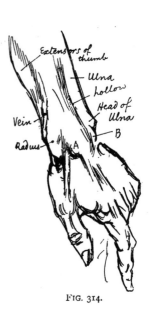

FIG. 314.

D, Fig. 312, and then E if we like, the tendon going to the mound A. The line D is rather false, for the bone is hidden and no actual line is there, but if we draw E first, we do not get the bulk of the

hand so well. On the other side of the hand the bone is so hidden that we may as well at once draw the curved flesh line, F, with its con-tinuation G, not, however, omitting the knuckles of *all* the bones.

FIG. 315.

The side of the wrist becomes of great importance as a connection between the arm and the hand, and it is

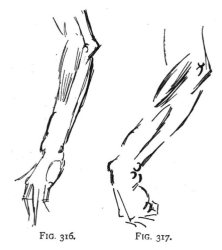

well to have so many little bones to apply, for it prevents that appearance of sudden junction which is so unnatural. There is danger, therefore, in so simple a method as Fig. 315, though one often begins and must begin with it. Figs. 316 and 317 are illustrations, roughly sketched and left, of

FIG. 316. FIG. 317.

the application of the above hints.

65. Tendons at the Wrist.

THE flexor muscles are chiefly evident through their tendons, which make up, in distinctness, what the fleshy parts lack. The most important of them is that of the flexor of the wrist on the ulna side (*flexor carpi ulnaris*). The effect of this tendon on the form is unusually great. It gives us that sharp line beneath the wrist, as shown in Fig. 319. This tendon passes to the pisiform bone of the wrist. The pisiform bone (Fig. 320) begins the palm of the hand on the little-finger side. It is not very evident, but is sufficiently clear to require remembering. It extends the palm down into a some-what pointed form, running it off into the tendon of the flexor, as in Fig. 321.

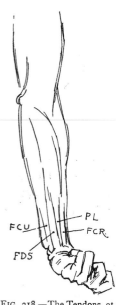

FIG. 318.—The Tendons at the Front of the Wrist.

The most prominent of the tendons

FIG. 319.

of the wrist is usually that of *palmaris longus*. Unlike all
the others this tendon is not bound down beneath the

band-like annular ligament
which encircles the wrist,
in a similar fashion to the
cords or straps, which
labourers tie round their
wrists in the same place.
The *palmaris longus* may
not be an important muscle;
indeed, since one cannot
always manage to make
the tendon prominent, one
might conclude that the
functions of the muscle
itself were limited. It shows
when the fingers are pinched
together, as in Fig. 322. It

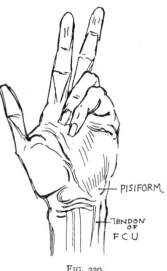

FIG. 320.

is evident, too, when the hand is used to flatten something,
as when the two palms are rubbed together. In fact, the

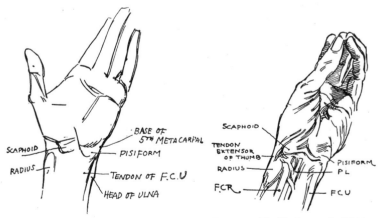

FIG. 321.—Several small bony Features. FIG. 322.—The Tendons at the Wrist.

tendon is at its tightest and is most pronounced when the hand is held stiff, in that action. It very frequently shows, however.

Another tendon which competes with that of *palmaris longus* for pre-eminence is that of *flexor carpi radialis.* It is close beside the other (*palmaris longus*), and the two are often evident together, while sometimes one, sometimes the other, is the more noticeable.

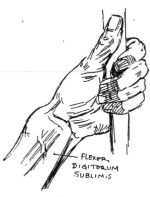

Another tendon which sometimes makes itself evident is that of the great flexor of the fingers, *flexor digitorum sublimis.* This muscle is deep, and spreads so completely throughout the fleshy mass of the flexors that it does not possess any marked characteristics, nor does it affect the detail form. But when the fingers, more particularly the little finger, are bent down into the palm, and the wrist is bent also, there is a prominent tendinous form produced between the tendons of *palmaris longus* and *flexor carpi ulnaris*, Fig. 323. If the wrist is bent but the fingers are not bent down this tendinous eminence is not formed, the flexors of the *wrist* only being then in action.

FIG. 323.

66. The Hand.

THE body of the hand presents four subjects for study—the palm, the back, the thumb-ball, and the little-finger ball.

The chief characteristics of the back are the convergent
tendons of *extensor communis digitorum*, which are sug-
gested on the backs of gloves, and which themselves suggest
the metacarpal bones beneath them, though the bones do not

FIG. 324.

converge so rapidly. Between and crossing these tendons
are several veins.

The palmar surface divides itself into three parts—a
base for the four fingers, the ball of the thumb, and
the ball of the little-finger side. (See Figs. 309, 321,
and 325.)

The ball of the thumb is defined by a crease, or line,

to which the thumb-seam of a glove corresponds. When the thumb is drawn over the palm, the ball becomes a thick mass, and a fold develops between the thumb and the palm. Thus crushed up, the ball presents an outline undulated, but approaching the straight.

The base upon which the fingers stand is partitioned off from the rest of the palm by two lines, one over the thumb-ball, the other under the three outer fingers.

This base, in accordance with the general arched character of the hand and wrist, is lower in the middle,

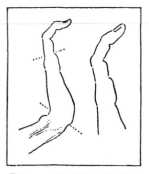

FIG. 325.—The Ball of the Little Finger.

so that, except when the palm is stretched wide open, the parts below the first and fourth fingers separate from the base, and form shapes somewhat square. These are not of course represented by rigid lines.

Nor is the ball of the little-finger side, but by a number of broken creases radiating from the narrow space between the thumb-ball and the finger-base. The two balls meet at the wrist by strongly-curved lines, which form a point running up into the palm. Beneath, and on the thumb side of this vertex, is a well-rounded, small, bony prominence, from which one of the prominent tendons of the wrist passes to the arm ; beside it another tendon comes from the region of the vertex itself. On either side of these tendons is a hollow bounded in both cases by a short display of tendons.

The side view of the little finger-ball is especially graceful, its straight lines contrasting well with the curved portions of the hand. In the annexed diagram the ball

occupies the space between the dotted lines. It is double in form, the upper part being the end of the base of the fingers as seen in the palm. The angularity of the outline of the ball must not escape attention (Fig. 324, D and J), but sometimes it is crushed into a rounded form as in C.

The hands in Fig. 324 are chiefly Gothic, and illustrate the conventional positions which constituted the stock-in-trade of the old artists—as regards hands. P Q R and S are Japanese. L and M are plump female hands. In L may be noticed the roundness of the wrist at the back, in M the roundness in front of it. In M also the back of the hand is puckered into two masses, as if the fingers had a fleshy " base " on the back of the hand as well as on the palm. N is an arrangement of lines to illustrate the different directions at which the fingers are placed. It shows that the fingers must not be drawn parallel, but becoming regularly more curved in accordance with the foreshortening shown. The application of this is shown in O, which is intended also to epitomize, in an exaggerated manner, the forms of the wrist and hand, and to illustrate the concave character of the several "joints" of the fingers.

The hand is further dealt with in paragraph 78.

67. The Form of the Fingers.

EACH of the fingers has three bones, phalanges, with also a metacarpal bone, which becomes part of the body of the hand. These four bones are all much alike, and appear as in regular succession. The shaft of the metacarpal is virtually round in section, while the shafts of

the phalanges are flattened underneath but retain their roundness above. (Fig. 326.) The metacarpal is straight, the phalanges bent downwards. The fingers are rarely, if ever, quite straight, being generally slightly flexed. The third phalanx turns up to support the nail, as though nature could not permit a curve to remain without alternation. This bending of the third phalanx is peculiarly graceful. (Fig. 324, M.)

The ends of the phalanges are wider than the shafts, emphasizing the tendency toward flatness suggested by the under side of the bones. They are also deeper than the shafts, and produce a double bony prominence. It is the top of the lower end that makes this prominence. The lower end of the metacarpal also dominates the form in its region. It is large, and approaches a ball-shape, and consequently shows on the knuckles as a single but rounder eminence. (Fig. 285.)

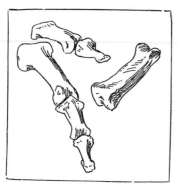

FIG. 326.—Phalanges of a Finger and Thumb.

In drawing a finger, one may first suggest the three "joints," as they are commonly called, as at B, Fig. 327, letting the last one turn up a little. Then at the top, one may add the large single mass for the end of the metacarpal, then at the two other joints, the double form of the ends of the phalanges, and finally the nail directed outward a very little.

If the reader will look attentively at the ends of the first and second phalanges of a finger, in Fig. 326, he will see

that the larger bone is there deeper but narrower than the smaller bone, which is wider, and has a triangular peak running up between the two "knuckles" of the other bone. Hence there are four prominences, two at the top somewhat separated, and two at the sides. These are shown at A, Fig. 327.

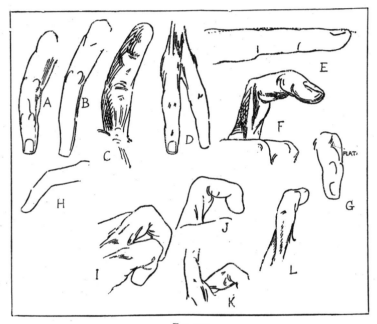

FIG. 327.

The fingers bear no muscles, giving attachments only to the tendons of the muscles which move them, and which are placed in the hand and arm. The clothing of the fingers is due then to the skin, and the fat and fascia beneath it.

The fatness increases the bulk of the shafts of the phalanges, not of the joints, and gives very much the

effect of a layer of muscle between the joints. Particularly in the fingers of women is this to be observed. Omitting this fattening, the finger appears widest at the joint between the first and second phalanges, and as if diminishing as it approaches the hand. This is because the upper end of the first phalanx is hidden against the large knuckle of the metacarpal, which seems to belong to the hand rather than to the finger.

The details of form supplied by the skin, with its thickening of fat and fascia, are as follows. Upon all the phalanges, at the back that is, there is a fleshy confirmation of the longitudinal curve, and transverse roundness of the bones. Over the joints the skin is thinner, and wrinkled with a number of small creases forming roughly an oval, transversely placed. These are, of course, chiefly seen when the fingers are straightened, and are more marked at the first joint than at the second.

Taking the finger straightened, and in side view, the outline becomes a succession of slow gentle curves over the shafts and rapid puckers over the creases at the first joint, and a suggestion of the same over the second (E).

On the under side the outline is roundest under the outer end of the first phalanx, has a suggestion of double curvature under the second, and is palpably double under the last. It is perhaps safe to be guided by the old French motto, "more than less," and let the form fluctuate more rather than less.

It must be noted that the creases which appear on the under side of the finger do not exactly correspond to the joints which produce them. They both occur under the second phalanx, thus lengthening the under side of the last, and tending to lengthen that of the first. The length of the first is considerably reduced by

the webbing of the hand reaching some distance up on the palmar side, and by the presence of another crease similar to those on the length of the fingers close against the palm. Thus, as any one may see by examining his own hand, the division of the fingers on the palmar side appear virtually equal, the last divisions of the third and fourth fingers being among the largest.

The under side is like the bones, flattened, though the outer end of the third and second phalanges is rounded considerably. The fingers may with advantage be considered square in section, so that even the tops are flattened. (See Fig. 311 (1).) With apex at the root of the finger, a triangular mass stretches up to the outside of the first joint, being hollowed and crinkled somewhat down its centre. (Fig. 327, C.) From the joint a similar broad triangular piece seems to start, but

FIG. 328.—Female Hand.

dies into a rounded mass before the second joint. Then again at the second joint a flatness commences, but soon gives way to the round forms, of which there are two.

In the bent finger, extended on the hand (F), the tri-

angular piece just spoken of appears strongly marked, and if the fingers on either side be flexed, it will be accentuated by a fold on either side. In all such positions these two forms will be seen, the triangular piece perhaps in profile, as at J, the crease by a softer diagonal line.

Some of the variations to which these creases are subject are illustrated in Fig. 327, and as every one's hands are available for experiment there is no need to enter into a description of the changes.

A very important fact concerning the back of the hand is seen when the fingers are close together. It is that the sharp creases which extend the spaces between the fingers up between the knuckles follow different directions. The second, or longest, finger seems to be a centre, and neither crease beside it goes over it. The crease between the first and second fingers curves over the *first*, the crease between the second and third curves over the *third*, and that between the third and fourth curves over the *fourth*. This fact is particularly valuable in drawing women's hands.

The tendons of the extensor communis digitorum show down the back of the hand, spreading out from a position on the wrist a little to the ulna side. They pass over the knuckles, and get lost on the first phalanx. They continue, however, to the third, splitting as they approach the first joint, and thus contribute a degree of the flatness observable below the first joint. These tendons appear to hold the fingers on, very much in the same way as the finger-stall of domestic surgery (D). The form of the finger-stall is also maintained in the way in which the finger continues up the back of the hand, the channels between the knuckles being very noticeable and much beloved by draughtsmen of "terror and wonder."

The tendon of the special extensor of the little finger

may readily be observed, close to the tendon for this finger from the extensor communis digitorum (L). The special one for the index finger is hardly perceptible.

The fingers are of different lengths, and set upon a curved border of the palm, which in some persons is less curved than in others, so that some persons' hands are square, and others ovoid.

68. The Thumb.

THE thumb consists of only two phalanges, which are similar to those of the fingers (Fig. 326). Calling the two

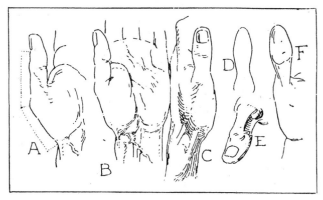

FIG. 329.

parts of the thumb "joints," we notice that the end joint is convex in outline, the first joint concave, so that D, Fig. 329, will epitomize the shape, if the basal joint be included as part of the thumb, as perhaps is best. The end joint on its palmar surface appears heart-shaped (F), while the first joint has the same triangular arrangement that was noticed in the first joint of the fingers. On the outer side (E)

the first joint appears square in section, the squareness being due to one of the extensor tendons which attaches to the base of the second phalanx, and shows very distinctly sometimes, as in Fig. 311 (1).

Viewed from above, the second joint has a somewhat ovoid form, succeeded in the first joint by contrasting concave lines. In side view the chief difference to note is that under the end phalanx the tip is not so bulky as the roll or mass behind it, which is both deeper and broader than in the fingers. The nail is directed upward a little more than in the fingers.

FIG. 330.

Two of the three tendons of the three extensors of the thumb generally show between the ball of the thumb and the end of the radius. The one towards the middle of the hand, the extensor secundus internodii pollicis, goes to the base of the second phalanx. It is, therefore, very plainly seen down as far as the thumb-joint, during strong extension.

The student will hardly need telling that the thumb is not placed in the same plane as the fingers. Its nail is directed almost exactly sideways; and the thumb and its ball are situated as much at the front as at the side of the hand; in the female they are much more distinctly in front.

In Fig. 330 we see that the skin-line from the thumb passes between the skin-lines from the palm and back of the hand, all going to the base of the index finger.

69. The Proportions of the Upper Limb.

THE lower end of the humerus falls to about the level
of the umbilicus in both sexes, while the lower end of the
radius reaches nearly to the level of the absolute end of
the trunk. The end of the fingers falls to about half-way
between the *trochanter* and the head of the *fibula*. The
wrist is considerably below the trochanter in man, but only
just below it in woman ; so that in relation to the trunk
and hip the female arm seems short compared with the
male. And undoubtedly in relation to the trunk and hip
the female arm *is* short, for the body in that sex is longer
in proportion to the total height than in the male. Taking
the measurement from the top of the shoulder to the lower
border of the trochanter, it is one-third of the whole height
in woman, but less than a third in man, being 21 inches in
man and nearly 21 in woman. And the fact that the
gluteal mass is lower in the female also renders the body
and hip, in that sex, longer ; so that as far as contrast goes
the female arm appears short.

If the hands are folded before the figure they will just
cover the centre of the body.

The proportions of the different parts of the arm to
one another are not easy to seize. The bone-lengths are
about 13 inches for the humerus, 9 for the radius, and
$7\frac{1}{2}$ for the wrist and hand. In the female about $11\frac{2}{3}$, $8\frac{1}{2}$,
and 7 inches. If an inch be added for the acromion,
it gives the upper part a measurement of 14 and 13
respectively. But these measurements are very variable.

The lengths of the female radius and wrist and hand
bear the same proportion to the whole figure as in the
male, but the female humerus is nearly half an inch shorter

than the male, apart from the diminution due to lesser stature. We have given the length of the radius as that of the fore-arm because the ulna overlaps the humerus somewhat. Its length is 10½ inches.

The head of the humerus being lost under the deltoid, the acromion process of the shoulder becomes the upper-most point of the arm. The lower end of the humerus is indicated on the outer side by the external condyle, or more exactly by the space between it and the head of the radius (Fig. 331), and on the inner by the inner condyle,

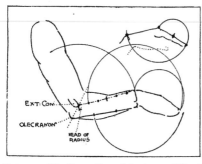

FIG. 331.—The Proportions of the Arm and Hand.

though its prominence is some little distance above the end of the bone (see Fig. 285). In the diagram above there will be seen a dotted line across the elbow. This dotted line runs from the olecranon behind, to the inner side of the joint, distinctly marked by a large blue vein ; and, more-over, is not at right angles to the direction of the humerus, but is higher in front even in the straight arm. On either side of this dotted line, on the outside, occurs the external condyle above, and the head of the radius below. From the measurements we may deduce the facts that the radius is in length about two-thirds of the upper arm (including the acromion) ; that the ulna is to the upper arm as 3 to 4 ; that the hand and wrist are to the radius as 5 to 6, or as 5 to 7 to the ulna.

As a practical rule, one may sometimes take the distance from the arm-pit to the elbow-joint as equal to the fore-

arm, then halving the fore-arm may find an approximate
limit for the supinator mass, and then the back of the
hand as nearly equal to one of these halves, and the fingers
as equal to it.

The hand and wrist, $7\frac{1}{2}$ inches, are well known as being
equal to the face. The whole index finger is about half
the hand and wrist together, and the two small joints of
that finger are together equal to the longest. The two
small joints are also equal in length to the nose, 2 inches.
The proportions must be taken with the fingers bent, as
the knuckles are counted with the parts on either side of
them. For the hand and wrist are not 8 inches long. In
the female the fingers are comparatively longer, the hand
narrower, and the wrist-bones smaller.

When the arm is hanging by the side the finger-tip
reaches half-way down the thigh in man, not so far in
woman. This difference is due to the greater length of
the female trunk, and also to the fact that the first bone
of both the upper and lower limbs is shorter in women
and children than in men. In both male and female
the middle of the fingers is half-way from the top of the
acromion to the ground, a distance of about 50 inches in
woman and 54 inches in man ; while the elbow-joint is at
about a quarter of the distance down. In the figure
standing at ease, not erect, the large knuckle or the tip
of the finger takes the central position, according as the
shoulder is down or up.

THE LOWER LIMB

70. The Bones of the Hip and Lower Limb.

THE reader may be reminded that the pelvis is the
bony basin supporting the trunk, and also providing the
sockets in which the thigh-bones, femurs, articulate. It
is made up of three bones, two innominate or unnamed,
and the sacrum, which is the immovable part of the
vertebral column. The innominate bone itself is made
up of three bones, which grow together, and form one
as the infant grows. These three are the Ilium, Ischium,
and Pubes, and the regions which represent them in
the amalgamated bone are the iliac, ischiatic, and pubic
portions.

The pelvis is illustrated in Fig. 232. The iliac portion
is that above the acetabulum, the ischiatic that which
proceeds downward from it, and the pubic that which
projects forward, or to the right in diagram C. In D the
back of the two pubes is seen shaded.

The ilium is in section a double curve, a " line of beauty
and grace." The convex outward portion spreads upward
from the acetabulum, the part behind being concave. The
upper border of the ilium, the iliac crest, is of great import-
ance as regards form. At each end of it is a spinous
process, that before being called anterior, and that behind

posterior. Beneath these are two other spines, so that there are inferior and superior spines, both before and behind.

The lower part of the pelvis, below the acetabula, consists of the lower halves of the innominate, and comprises the two pubes and the two ischia. These two halves, placed at an angle to one another, meet at the symphysis between the two pubes, while the ischia at their lowest points are some distance apart. These lowest points of the ischia are the bones upon which one sits.

Beside the iliac crests and the back of the sacrum, the only part of the pelvis evident on the surface, and then only in a very indirect way, is a part of the pubes on either side of the symphysis. To this Poupart's ligament from the superior anterior spines of the iliac, attaches, and forms the groin, giving the strong round curve which limits the abdomen below.

In the male the groin keeps well down to the pubes, but in the female it is considerably above, so that the last fold of the trunk in that sex is deep.

The femur, or thigh-bone, answers to the humerus of the arm. Its articular surface is a much more complete ball, and the acetabulum into which it fits is a much more complete socket. Thus embedded, its range of action is more limited than is that of the humerus, though in some degree to counteract this deficiency it has a longer *neck*, without which it would be virtually impossible for the thighs to be crossed.

At the part where the neck joins on to the shaft, there are two prominences, the greater and lesser trochanters, which correspond to the tuberosities of the humerus.

From the trochanters the shafts return to the middle of the figure, so that the knees are close together, and the

two thigh-bones form an inverted isosceles triangle, which in a good figure is almost entirely filled up by the adductor muscles of the thighs.

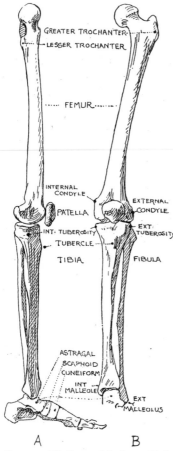

A draughtsman must certainly know the bones, and be able to draw them with considerable accuracy, from memory, especially if he has to work without a model.

Of the upper part of the femur only the *trochanter* reveals itself upon the surface, but its solitariness is balanced by its importance.

The lower end of the femur contributes very largely to the form of the knee, although it shows itself but rarely. Its shape may be gathered from Figs. 332 and 341.

The tibia has two broad ends connected by a shaft triangular in section. Of the three sides of the shaft, one is directed immediately backward, one to either side. There is thus a ridge in front, between the two

FIG. 332.—The Bones of the Lower Limb.

side surfaces, which is called the crest. It is remarkably sharp, and rising to the skin forms the easily felt, and damaged, shin.

Above and below, the crest expands into triangular surfaces, approaching the flat, and forming the front of the two ends.

Just where the crest expands to form the upper triangle is a rough eminence, the tubercle, to which the ligament of the patella, or one might almost say of the triceps of the thigh, is attached. Above the tubercle the surface becomes broader and fairly flat. The surfaces on either side of the crest follow its course up the sides of the triangle, to which they add bevelled sides, as it were, as if this upper end of the tibia were half a hexagon in section. But at the fibula, or outer side, is a definite flatness, while on the inner side the internal edge of the triangular shaft sends up a gracefully arched bracket, almost a true semi-circle in plan, and extending from the flat triangular surface on the front, to the middle of the back. This is the internal tuberosity, and is shown in Fig. 332, A.

Viewed from above, the upper end of the tibia appears kidney-shaped, the double curve of the outline being behind.

At its lower end the tibia is somewhat oblong in section. The triangular surface provided by the expanded crest forms one side, the internal surface of the shaft another, while the back and fibula side provide the remaining two.

The transverse axes of the two ends of the tibia are not in the same plane. The bone is twisted. If the upper end be directed immediately forward, the lower end will be directed outward somewhat, the foot turning out with it. So that with the heels and toes together, the knee is rolled inward. In the natural attitude the toes are apart, the angle between the feet being perhaps 45 degrees. Attitudes in which the heels and toes are together are not ungraceful if one knee folds before the other, but it is distinctly ugly if both legs are straight. Nor is an attitude necessarily

ungraceful if the feet, while some distance apart, are parallel, or even nearer together at the toes, and there are very many positions which are exceedingly graceful; but out-turning feet are the rule in standing positions. A seated figure does not turn the toes out so much. When a person is altering the direction in which he is going, as when turning to ascend steps, the toes are turned in and the heels out.

The fibula is a long narrow bone with enlarged ends, the lower of which forms the external ankle ; the upper receives the biceps muscle from the thigh.

Taken together, the tibia and fibula are narrowest about four or five inches up their shafts. As regards curvature, it may be noted that the internal surface of the tibia is very slightly convex above, concave below, while in profile the crest appears slightly concave below the tubercle, then convex, and concave again above the ankle. The bones of the foot are mentioned in paragraph 77.

71. The Muscles of the Lower Limb.

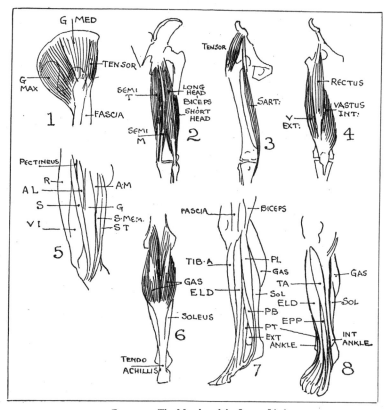

FIG. 333.—The Muscles of the Lower Limb.

I. THE GLUTEAL MUSCLES.

Gluteus maximus.

Attachments—Lower border of sacrum and coccyx and adjacent portion of ilium—Upper part, over the trochanter to the fascia of the thigh. Lower part, back of the thigh-bone below the trochanter

Gluteus medius.

 Attachments—Upper part of outer surface of ilium—outer surface of greater trochanter.

Gluteus minimus (concealed beneath the tensor and gluteus medius).

 Attachments—Lower part of outer surface of ilium—front of greater trochanter.

Tensor vaginæ femoris (tightener of sheath of thigh).

 Attachments—Superior anterior spine, and behind it,—fascia of the thigh.

II.

Semi-membranosus.

 Attachments—Back of tuberosity of ischium—back of internal tuberosity of tibia.

Semi-tendinosus.

 Attachments—Back of tuberosity of ischium—inner side of front of tibia.

Biceps cruris.

 Attachments—Long head, back of tuberosity of ischium—short head, lower two-thirds of back of shaft of femur down to the external condyle—head of the fibula.

III. SARTORIUS AND TENSOR.

Sartorius.

 Attachments—Superior anterior spine—Inner side of front of tibia.

IV. THE TRICEPS CRURIS.

 Attachments—Vastus externus—Outer side of back of femur—by the common tendon to the patella.

 Crureus—Upper part of front of femur by the common tendon to the patella.

 Vastus internus—Inner side of back of femur—by the common tendon to the patella.

 Rectus—By two tendons, to anterior *inferior* spine of pelvis, and above the acetabulum—by the common tendon to the patella.

V. THE ADDUCENT FLEXORS.

Pectineus.

 Attachments—Pubes and part of ilio-pectineal line above it— Behind lesser trochanter, on the shaft of the femur.

Adductor longus.

 Attachments—By a narrow tendon to pubes—middle third of back of shaft of femur.

Gracilis.

 Attachments—Pubes, on the part (ramus) descending to the ischium—Inner side of front of tibia.

Adductor magnus. Outer border of ischium—whole length of back of shaft of femur.

VI. Gastrocnemius and Soleus.

Gastrocnemius (double except in tendon).

 Attachments—By two heads to back of condyles of femur—back of os calcis by the tendo Achillis.

Soleus.

 Attachments—Back of head of fibula, and part of the upper fourth of both tibia and fibula—Back of os calcis.

VII. Outer View of Leg.

Peroneus longus.

 Attachments—Head and upper half of outer surface of fibula or peronē—Under side of base of metatarsal of great-toe.

Peroneus brevis.

 Attachments—Outer side of fibula below peroneus longus— Tuberosity of fifth metatarsal bone.

Peroneus tertius.

 Attachments—Lowest fourth inner surface of fibula, facing the tibia—Top of base of fifth metatarsal bone.

VIII. Front View of Leg.

Tibialis anticus.

 Attachments—Upper half of outer surface, facing fibula, of tibia, up to the external tuberosity—Under side of first cuneiform and first metatarsal.

Extensor proprius pollicis (proper extensor of great-toe).

 Attachments—Middle portion of inner surface of fibula—base of last phalanx of great-toe.

Extensor longus digitorum (long extensor of toes).

 Attachments—Upper part of inner surface of fibula and external tuberosity of tibia—last phalanges of four outer toes.

The following are hidden beneath the gastrocnemius and soleus. Their tendons pass behind the inner ankle. Of their bodies, a few inches of flexor digitorum, only, appear above the inner ankle between the tibia and the soleus, but greatly enriching the form.

Tibialis posticus.

 Attachments—Back of tibia, facing the fibula, and inner side of fibula—Tuberosity of scaphoid bone.

Flexor longus pollicis (long flexor of great-toe).

 Attachments—Back of fibula below soleus—under side of base of last phalanx of great-toe.

Flexor longus digitorum (long flexor of fingers). Back of tibia, below soleus—third phalanx of four outer toes.

72. Remarks upon the Muscles of the Lower Limb.

A CLOSE description of these muscles will not be necessary if the student will get to know the general character and position of them as they are given in the preceding paragraph, and will attend to the following remarks.

The *gluteal* group corresponds to the *deltoid* of the arm, but, unlike it, does not gather into a point upon the bone, but surrounds the trochanter, which consequently shows as an eminence.

The proper action of these muscles is abduction ; but connected with it is rotation inwards and flexion for that part of the mass which is before the trochanter, and rotation outwards and extension for that part which is behind. So that in turning the thigh to look at the heel, the tensor will be seen to swell up into a roundish mass, and similarly the maximus becomes more concentrated when the leg is held out, and behind, and particularly when the figure is standing upon one leg.

The *fascia lata* is a tendinous sheath enclosing the thigh, and chiefly evident on the outside. It is supported and tightened above, by its proper tensor and the gluteus maximus. Below, it becomes a tendinous strip, and passes over the knee-joint on the outside, looking very like the tendon of a muscle. (See Fig. 342.)

The *tensor fasciæ* arises from the superior anterior spine, as well as from behind it. At the spine it is in close connection with the sartorius muscle, which passes to the inner side of the thigh, and thus makes with the tensor an inverted V. (Fig. 338.) The two muscles present a very convenient start point for the study of the muscles of the thigh.

The *sartorius* forms an important and beautiful line dividing the extensor muscles on the front of the thigh from the adductors at the inner side of it. It shows most when in action, in drawing the heel up to the knee, its uppermost part appearing as a prominent strong cord, its middle and lower as a depression.

The *triceps* extensor of the thigh consists of rectus femoris, vastus externus, and vastus internus, the upper part of which, hidden under the rectus, is called crureus, and is sometimes considered as a separate fourth head.

The patella is a movable fulcrum by means of which the triceps gains greater power in its action upon the tibia, or leg-bone. The tendon that connects the patella with the tibia belongs then to the triceps, and it is better to consider the muscles as inserted into the tibia.

The tendons and aponeuroses of the triceps affect the form somewhat. Thus the vastus externus is attached to the femur by an extensive aponeurosis which covers its upper three-fourths, and renders the surface tight and stiff. The vastus internus, on the other hand, has no such aponeurosis upon it, and it is therefore more fleshy or flabby. The tendon of origin of the rectus also comes upon the front of the muscle, and helps to keep it down between the tensor and sartorius, than which it is originally placed lower by being attached to the inferior instead of the superior spine of the ilium.

Below, all these muscles meet upon a common tendon, taking, however, different sides of it. The internus crowds down upon the patella, the externus and rectus not reaching down so far, and in action retiring even further up.

It will probably be found that the superficial muscles from vastus internus round the inner side of the thigh to vastus externus, or the flexor-adductor mass, will be best remembered in their proper arrangement by classifying them according to their destinations. Thus there is a group coming round the inside of the knee, and somewhat to the front of the tibia below it ; another group find their insertions on the thigh-bone; and a third and last at the back of the knee.

The group that comes to the front of the knee comprises—

> Sartorius,
> Gracilis,
> Semi-Tendinosus,

—placing them in the order of their insertions from the knee downwards.

The group at the back of the knee-joint—

> Semi-membranosus,
> Biceps cruris,

—Biceps being at the outside.

Those attaching to the shaft of the femur are —

> Adductor magnus,
> ,, longus,
> ,, brevis,
> Pectineus,

—of which brevis is deep.

But while this classification may be of assistance in remembering the arrangement of the muscles, it is of little use artistically ; for the inner side and back of the

thigh are virtually one well-rounded fleshy mass, with hardly any, or only very subtle, features. Or rather there are two masses, the one just spoken of being the more important, and there being another formed by the lower parts of several muscles, and showing prominently at the back and inner side of the knee and thigh together. (See Fig. 340, 4.)

Of the tendons, it is needful only to specify the tendon of origin of the adductor longus against the pubes, which is narrow and shows clearly, and the tendons of insertion of the biceps, semi-membranosus, and semi-tendinosus. These are situated on the outside of the muscles, and therefore even in well-fleshed persons show as definite cords, very much in the same way as the tendons of the sterno-mastoids in the neck ; and then only when the knee is bent.

The adductor magnus is almost all concealed, while the semi-membranosus not only manages to hide itself for most of its course, but in spite of its tendon being placed further back than that of the semi-tendinosus, it allows that muscle to appear at the back of the thigh in close company with the biceps.

The division between the biceps and semi-tendinosus shows but very slightly indeed, and is virtually neutralized by the skin and fat above, so that it may be disregarded.

The muscles of the leg are perhaps the easiest of all to remember. They arrange themselves in groups of three each ; thus, counting the gastrocnemius as two, on account of its double character, there are three behind, the soleus being the third. There are three flexors (deep posterior group)—tibialis posticus, flexor digitorum, and flexor pollicis. Three outer or peroneal—peroneus longus,

brevis, and tertius ; and three extensors in front—tibialis anticus, extensor digitorum, and extensor pollicis.

Then just as the flexors in the fore-arm need not be considered in detail because of their not separately affecting form in any methodical manner, so the flexors of the leg may be overlooked because they are hidden under the gastrocnemius and soleus. Their three tendons pass round the internal malleolus, where they may possibly show, and where the flexor longus digitorum fills up the three or four inches between the soleus and the tibia bone.

The superficial posterior group consists of gastrocnemius and soleus. The shape of the former is well known, or rather the two masses of the calf are. It arises from above the knee in a rather remarkable manner. Two full fleshy strips, or one might say ropes, pass vertically over the knee-joint, and form the inner borders of the two bellies. There is no space between them, but at their upper extremities they part company somewhat in order to fit upon the massive condyles of the femur. At the outer side of each of these ropes is a long spreading aponeurosis which covers a large part of the mass proper of the muscle. These ropes and aponeuroses are very important. The aponeuroses lie down close, and harden the surface of the muscle, so far as they cover it ; so that each belly of the calf becomes triple in form, with an outer fleshy border, an aponeurosis, and an internal " rope."

The two bellies end upon a common tendon, which lower down becomes the *tendo Achillis*, to which also the *Soleus* muscle attaches itself. The soleus is a valuable addition to the form of the leg. Without it there is an appearance of scragginess. It is a great characteristic of the female leg, for the shortness of the tendons in that sex allows it

to creep down close upon the ankle. The tendon of the calf passing over the soleus renders it flatter in the middle, the lower part of the gastrocnemius, narrower than it, reveals its shape upon it, as in Fig. 339, C. The outer group, peroneus longus, brevius, and tertius, take their names from *perone*, the Greek for the fibula bone from which they arise. They occupy only a narrow strip on the outer side of the leg, corresponding in fact to the fibula bone. Their tendons sometimes give students a little trouble, because of the extraordinary course of that of peroneus longus. It passes behind the external ankle, and *under* the foot to the base of the metatarsal bone of the great-toe. But it is not difficult to remember which muscle does this, if it merely be noted that it must have a very long tendon indeed, and the name peroneus *longus* tells us at once.

Peroneus brevis and tertius are very similar, that is, they both go to the metatarsal bone of the little-toe, brevis passing behind the ankle, tertius coming down before.

Peroneus tertius is sometimes classed with the anterior group—tibialis anticus, extensor digitorum, and extensor pollicis. Of these the first two are very important, their forms show very distinctly, and their direction is oblique, from the outer side of the knee. The extensor pollicis comes out from between their lower ends.

Taking the two ankles as the limits of the front, there are between them four tendons, one on either side going to the tarsus, or metatarsus, not to the toes that is, while between them come down the tendons of the extensors of the smaller toes, and of the great-toe. The tendon for the smaller toes almost immediately splits into four. As to the order of arrangement, the peroneus tertius is

of course on the fibula side, and the extensor of the great-
toe on the inner side of that of the fingers, or smaller toes.

73. The Hip.

THE pelvis is the bony basin of the hip. It expresses
itself in external form only in the iliac crest and the
sacrum. The leaf-like sacrum is held between the two
ilia, the upper borders or crests of which are somewhat
in continuation with its sides, and form a bony line on
the back and sides of the figure, separating the trunk
from the thighs, and being in shape similar to a letter
M, drawn with the outer lines very slanting. It is
important to recognize this zigzag course of the bony
line. The lower part of the central or descending angle
of the M corresponds with the sacrum. Two dimples
(Fig. 334), representing the posterior spines, terminating
the crests behind, mark the lateral extent, as seen on the
surface, of the sacrum, and are further apart in the female.
The two upper angles of the M are provided by the iliac
crests (Fig. 232), but are in both sexes softened away
considerably, the crest having in the female only a low
and gentle curvature, with a degree of the angularity
here suggested.

Below the bony line just traced, and converging upon
the trochanter in a radial manner, are the several muscles
of the gluteal group, forming the most noticeable feature
of the back view. Above the bony line are the sacro-
lumbalis muscles upon the sacrum, and the external oblique,
or the mass which may be named from it, above the crest,
and stretching up to the waist.

The importance of the crests as details of form cannot

but be apparent; in male figures they are generally very evident, and seem to place an upward limit to the thigh unlikely to be lost. In female figures, on the contrary, the crests are often too subtly revealed to be drawn with precision, and the thigh and hip may be said to continue up to the waist. In a male figure our attention will fasten upon the crests and the trochanters beneath them, but in a female we shall probably draw a bold curve from the waist round to the knee. (Fig. 334, B.) But although the crest in the female is thus lost within the form, its

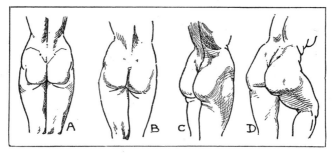

FIG. 334.

influence is very great. It is across the ilia that the female is so distinctly wider than the male. The measurement across the trochanters is slightly greater in a woman three or four inches shorter in stature than a man. Her greatest width is, however, lower than the trochanters, being below the horizontal gluteal crease (Fig. 334, A); in the male this augmentation of width is not so pronounced. But it is the great width at the ilia, followed just above by the rapid diminution to an equally narrow waist, that gives this region in women its distinctly feminine appearance. Indeed, one might say that the projecting ilium in the female makes a kind of shelf, and this description

is confirmed by the manner in which women carry things on their hips.

In the male the crest is generally well expressed by the modelling of the external oblique which runs backward round the flank in a somewhat upward direction (Fig. 335, A and B), but does not descend into the inner angle of the M. It borders upon the crest, but in the female the mass which may be regarded as similar, though owing much of its volume to fat, overlaps the crest, and suggests it

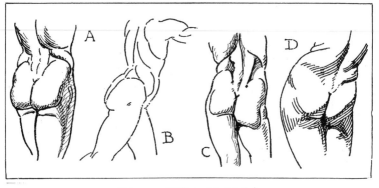

FIG. 335. (Of these, D is female.)

rather by showing that it is riding over some prominent substructure, than by stopping short against it. This may be followed in Figs. 334 and 335, D. In all these it will, however, be seen that it is not a simple arc that falls from the waist over into the hollow above the trochanter; it becomes hollowed or angular a little where it crosses the crest. In certain views an angularity is given to the outline, as if the descending line from the waist had to project outward considerably before turning downward. The effect may be seen in Figs. 334, C and D, and 337.

When the female figure is at all bent backward, as in

Figs. 334, C, and 335, D, the mass above the crest becomes bulged outward, and consequently the crest itself becomes suggested as a depression, or crease.

The sacrum is not flat, but slightly convex, from above downwards, and the muscular masses upon it express themselves throughout its length, with the slight channel between them, which continues right up to the head. In women these forms are more delicate than in men, although the sacrum is wider.

The flatness at the back of the female hips, extending up to the waist, produces a broad expanse, as seen in Fig. 282.

The lower part of the gluteal mass, provided by *gluteus maximus*, projects backward a little more than that part of the gluteals which ascends into the upper angle of the M. So that from the highest point of that angle down the whole extent of the mass is not a clear simple curve, but a double one, as shown in the profile. (Fig. 335, B.) It would be simplest in that of the free leg of Fig. 335, C, and most pronouncedly doubled in the standing leg of that diagram.

When the glutei are engaged in abducting, a deep sinking is noticeable above the trochanter, answering to the termination of their fleshy fibres, and the commencement of their tendon or aponeurosis. This sinking accents the flatness of the side of the hinder part of the mass. The hinder part is narrower from side to side than across the tensors which occupy the fore part. (Fig. 336.) Thus is completed that alternation spoken of on page 174, concerning the width of the trunk above and below. It was there said that above, the greater width in the region of the chest is at the back, and provided by the latissimus dorsi, while below it is in front. So that

descending a step lower to the hips the contrast is even
greater, the narrow part behind being palpably narrower,
while there is across the front of the middle of the figure
a flatness more nearly similar to that at the back of the
shoulders than that provided by the abdomen. This
flatness across the front of the middle is more pronounced
in women.

Then again, the rounded forms at the back must not be
drawn circular, but irregularly ovoid, sometimes squarish
as in Fig. 335, C, sometimes with a double line.

According to the position, so is this hinder part shorter
or longer. Thus, with the standing leg, it is generally

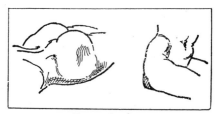

FIGS. 336 and 337.

short, square, and has a notable crease or two below it,
creases which indicate the biceps mass at the back of the
thigh, a mass which does not entirely extend across to
the outward. With the free leg the hinder mass is
generally longer, and more flabby. But if the free leg
is at all extended, or abducted, the glutei will gather
into a hard mass.

The muscles forming the gluteal group correspond to
the deltoid of the arm, and are *ab*ductors of the thigh.
Unlike the deltoid they do not mask the bone they operate
upon, but there is nevertheless considerable similarity in
form. The deltoid gathers its bundles together and plunges
down to the bone between the biceps and triceps. So

almost exactly does the gluteal group, for there is a biceps and triceps of the thigh, and it is between these that gluteus maximus reaches the bone. The outer corner of the prominent hinder mass, which is commonly regarded as very circular, creeps down then, as indicated in Fig. 339, B, and less emphatically in Fig. 335, C. The inner corner, too, must be kept rather square, for the two masses lie close together, as may be best seen in Figs. 334, B, and 335, C and D.

In Renaissance times these parts were generally drawn with full strong curves; but in the period when flabbiness was the fashion, and the flesh looks as if it would stay in any form into which it was pushed, the outline was much squarer, somewhat as in Fig. 338, D.

The mass produced by the projecting trochanter is stronger and more evident in women (Fig. 334, C and D) than in men. The trochanter generally shows as if divided vertically by a subtle depression, and not as a portion of a sphere.

We must not omit the little fold at the outer corner of the gluteal mass. This fold is caused by the gluteus continuing down the thigh-bone, and being folded up by the position of the limb.

74. The Thigh.

IF we epitomize the essential characteristics of a thigh they will appear as in A and B, Fig. 338. We have been speaking considerably, in the last paragraph, of the crest of the ilium. It appears now as supporting by its front end, or superior anterior spine, two muscles which are very important as regards the form of the thigh. These are

the Tensor fasciæ, T, and Sartorius, S. Tensor is one of
the gluteal group, and corresponds very fairly to part of
gluteus maximus, for they both attach to, and tighten, the
tendinous sheath of the thigh. It runs to the region of
the trochanter. Sartorius is very long, extending down
as far as the tibia, or leg-bone, and its course may be
traced in Fig. 338, B, by its being the uppermost muscle
of the mass there illustrated. When in action most of its
length buries itself in the thigh and makes a depression,
but its upper part remains isolated, and becomes thus a
fitting companion to the short tensor with which it is here

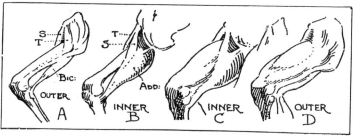

FIG. 338.

associated. The importance of these muscles lies in the
fact that they are inserted higher than the muscles on the
front of the thigh, and that consequently their form and
the space between them are often well seen. Compare the
other illustrations in this paragraph. Behind these muscles
are shown the glutei.

In Fig. 338, A, the biceps is also represented, with its
ham-string tendon, and although it is not here shown in
its proper bulk, it will perhaps all the more forcibly express
that character which a thigh has of being bone before and
tendon behind. Biceps is on the outer side of the thigh,
and is edged by a longitudinal channel of slight depression

marking the division between it and the triceps of the front. The ham-string character thus exhibited is repeated on the inner side, B, where other tendons come down in much the same manner. (See Fig. 339, B and C.)

Our next characteristic form is the adductor mass as epitomized in Fig. 338 B. It consists of adductors, adducent-flexors, and flexors, but the subdivision into separate muscles

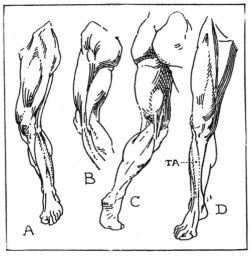

FIG. 339.

is so indefinite as to smoothen all of them together into a fairly full mass, which is nearly always round in section in its hinder part, but square-sectioned in its front portion when *adductor longus* is at all evident, as in Fig. 339, D. The tendon of this muscle is the only one that shows itself at the upper part against the pubes, and is suggested in the diagrams.

The mass of the adductors, as given in Fig. 338, B, is diagrammatic, and not completely accurate. The

adductors themselves are inserted into the femur, whereas in the diagram an insertion into the tibia only is shown. There are three muscles inserted side by side on the tibia. Their names, reading downwards from the knee, are Sartorius, Gracilis, and Semi-Tendinosus.

What is particularly important to notice is that there is a convex curve around the main body of the adductors, then a concavity, and then another convexity which wraps round the knee and includes the inner side of the head of the tibia in the thigh. And this outline runs on down the tibia bone to the inner ankle.

Sartorius, adductor longus and Gracilis are well seen in Fig. 345, a sketch from a model by Michael Angelo.

If we turn to a back view of a standing leg we shall see a similar duplication of form in the modelling. Fig. 340, No. 4, will illustrate the matter. On the inner side above the knee is a prominent mass of modelling, with a larger mass placed obliquely above it, formed of the upper part of the adductors and flexors fused with the biceps.

The front of the thigh is covered by the triceps, the details of which are the details also of the appearance of the limb.

A comparison of the front and back of the thigh will show that the extensors of the front are placed at a different inclination from the flexors at the back. The extensors pass from the outside of the figure to the knee ; the flexors, from the inside, as if, as in truth is the fact, the gluteal mass had to over-cap their origins.

The thigh is seen at its widest when it is rotated outward a little, and the mass of the adductors combines with the extensors of the front in one broad, rather flat, surface. This is particularly to be seen in the free leg when the two are crossed ; the standing leg

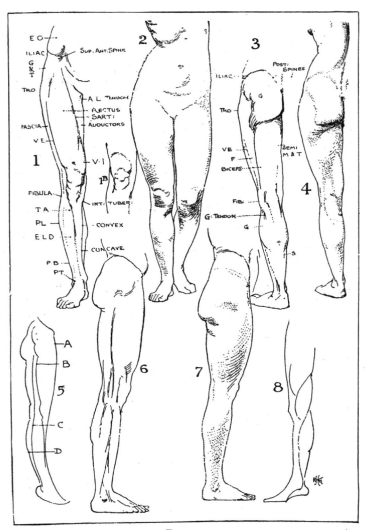

FIG. 340.

appearing drawn and tightened, with the adductor mass
raised, bulged, and apparently small, the line of the sar-

torius tightened, as well as the side of the thigh, where the fascia lata and aponeurosis of the vastus externus readily produce that effect. In this position also it may be noted how broad the knee of the free leg appears, while that of the standing leg appears narrow, and tightened above.

The inner line of the thigh must be expressive of the softness of that side; compared with it, the outer line is rigid and stiff.

The front view of the thigh may be represented by three lines—the outer, the sartorial, and the inner, which may be followed in No. 1, Fig. 340. The outer, commencing from the iliac crest, presses in the least degree beneath that bony ridge; then it describes a slow curve over the gluteus medius or the tensor; then in thin persons it possibly dips slightly before it passes over the trochanter, after which it describes a long, slow, hard curve for the fascia and vastus externus, followed by a convex curve over the knee-joint produced either by the tendon of the biceps, or of the fascia.

The sartorial line, after a slight suggestion of the superior spine, pursues a course beside the rectus and vastus internus.

The inner line commences by a short straight line passing outwards, followed by a curve for the adductor mass, to which succeeds a concavity followed by another curve which passes round the knee-joint, and arrives upon the front of the tibia. The curves are not arcs of circles, and a great deal of angularity or squareness becomes evident when the muscles are in action.

Turning to the back of the thigh, there are to be noticed one or two creases beneath the gluteus. These creases limit also a small surface better seen in the side view,

and which is much more prominent in women. It widens, but becomes lost, as it passes outward ; the creases take a downward direction from the middle line.

It not unfrequently happens in the body that forms will appear on the surface of muscles exactly the opposite of the direction of the muscles themselves. This is due to transverse massing of their fleshy parts, and to transverse creasing. The longitudinal position of the biceps and semi-tendinosus at the back of the thigh is very evident on the external form, as also is the fact that their origin is towards the inner side under the gluteus ; but there nevertheless appears a transverse mass, fleshy, well-rounded, and having no trace of the vertical division between the biceps and semi-tendinosus. It is more evident in women, and may be suggested by well-rounded curves, as in the diagram. Indeed one notable distinction between the male and female figures, is that the former has generally *longitudinal* muscular markings, the latter transverse modelling, as shown in Fig. 340.

The tendons of the biceps and semi-membranosus occurring on the outside of the muscles show as sharp cords, similar to that of the sterno-mastoid of the neck. And similar to those of the neck, they often glide into the fleshy mass of the thigh with as little breaking of the smooth surface.

75. The Knee.

THE patella is the most noticeable detail (A, Fig. 342). It is connected below by a tendon (B) to the tubercle of the tibia, which also shows, and forms the lowest part of the knee. On either side of the tendon the tuberosities of the tibia appear ; that on the inner side

(D) presenting a broad curved surface continuing down-
wards into the shin, and above blended with the internal
condyle (E) of the femur by the tendons of the sartorius
gracilis and semi-tendinosus muscles, which pass over
them. The outer tuberosity (F) appears as a small roundish
prominence, not dissimilar from the head of the fibula
(G) behind, and slightly below it. Between these two
comes down the tendon of the fascia of the thigh (H) over
the joint, which, it may be noticed, seems to hold up

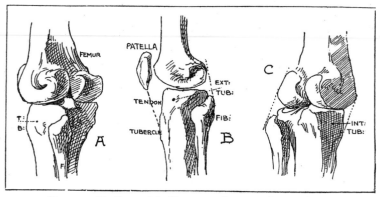

FIG. 341.—The Bones of the Knee. A and B, outer views; C, inner.

the muscular forms of the leg (J), while, on to the fibula,
comes down the tendon of the biceps muscle (I). From
below the tuberosity (F), the tibialis anticus and extensor
longus digitorium pedis (J) start down the leg in an oblique
direction.

Above the patella is the tendon (K) of the triceps,
short on its inner side, often appearing very long in its
outer, throwing, as it were, the mass of the vastus ex-
ternus (L) high up. Vastus internus (M) crowds down
upon the patella.

Very important are the fatty masses (N and O) due to

the synovial membrane, and appearing above and beneath the patella on either side of the tendons, which, however, become embedded within them and obscured. Their bulk is increased by the skin; and in women the fatness of this region in the standing figure is very noticeable, while even the bent knee in that sex is soft and smooth. The female knee is, in fact, wider and much less bony

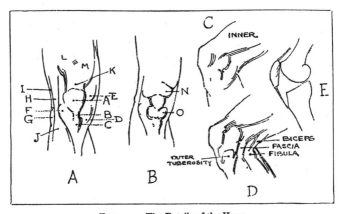

FIG. 342.—The Details of the Knee.

than the male, and behind, the masses at the lower end of the thigh are remarkably prominent, terminating abruptly as shown in Fig. 334, A. This prominence is probably due to the muscular fibres creeping further down the tendons in the female.

The fatty masses, evident in the straightened limb, disappear with extension. (Compare Nos. I and I B, Fig. 340.)

76. Drawing the Leg.

JUST as in the fore-arm the ulna has a subcutaneous portion which provides the draughtsman with a first line, so does the tibia in the leg. Its subcutaneous portion is its inner surface, facing the other leg that is, and becomes below, the internal malleolus or ankle. Above, this subcutaneous portion is limited by the insertion of the sartorius, gracilis, and semi-tendinosus, which, however, do not break the flow of its surface, but continue it up into the thigh. On its inner side it is bounded sharply by the gastrocnemius and soleus, and on its outer almost as sharply by the tibialis anticus, which comes from very near the head of the fibula. (Fig. 340, No. 1.)

It must be remembered that the subcutaneous portion is slightly convex in its upper half, concave in the lower. It is therefore wrong to make the whole line concave, as the designer is often tempted to do, especially after using the long flowing line A of No. 5, Fig. 340, true as that is in a general sense.

The internal ankle must project boldly, so that the shaft of the tibia seems set back behind the knee and ankle.

It has been said above that the muscles of the leg were divisible into four groups of three each. (See page 279.) As regards form we may think of them as constituting only two groups, and this arrangement corresponds to that of the fore-arm. Our two groups are the muscles of the calf, and those on the outer side of the front.

The reader will remember how in the fore-arm there is a group of extensor muscles radiating from the head of

the radius, or the external condyle just above it. The outer group in the leg is precisely similar. On the outer side of the knee is the external tuberosity of the tibia, and behind and slightly below it is the head of the fibula. (Fig. 343.) These are the bony prominences from which the muscles radiate. One cannot omit to notice how the external tuberosity seems, button-like, to hold back the tendinous forms descending from the thigh. From this position three long muscles come down—tibialis anticus, extensor longus digitorum, and peroneus longus. The obliquity of the first two is very important. In Fig. 339, D, it is seen to be fairly parallel to the oblique sartorius of the thigh.

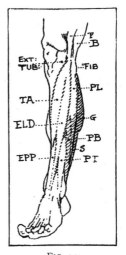

FIG. 343.

Below, three shorter muscles are spliced up into these long ones, and may be readily followed in the diagram. Of them peroneus tertius is the most important, because it corrects that insipid curvature which would otherwise be suggested, and which is associated with chair legs. The tendons of tibialis anticus and extensor digitorum show very prominently when in action, particularly when the foot is flexed on the leg, bent up, that is, as when one stamps the heel on the ground.

As to the modelling of the leg, the section at the widest part is roughly triangular. The outer surface comprises the muscles just spoken of, and ends upon the outer belly of the gastrocnemius. The peronei occupy a long narrow strip over the fibula, and are readily remembered as suggesting the stripe on a soldier's trousers.

The posterior surface consists of the back of the gastrocnemius, with the soleus beneath it. The gastrocnemius being two-bellied is consequently rather flat behind. The flattening is, however, emphasized by the aponeuroses at the back of these bellies, as in Fig. 339, C. In the centre, between these aponeuroses, and passing over the back of the knee, are two "ropes" of muscle.

The mass of the soleus is flattened in its upper part by the tendon of the gastrocnemius passing over it. These

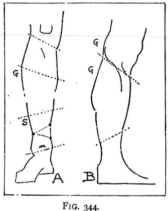

FIG. 344.

details of form are of course seen in extension of the foot; in the normal positions they are softened almost away. (See Figs. 339, C, and 340, No. 3.)

The internal surface, consisting of the smooth subcutaneous portion of the tibia, the well-rounded border of the gastrocnemius, and the side of the soleus, is the most heavily modelled of the three. (Fig. 339, D.)

The two sides of the leg are not symmetrical with one another. In the accompanying diagram (Fig. 344, A) the slanting lines indicate that the knee comes lower down on the inner side, that the inner head of the calf is lower, that of what is seen of the soleus the inner curve is smaller but higher, and that the inner ankle is the higher.

As regards the curves, those on the inner side are rounder than those on the outer, but the first part of the calf on both sides is rather flat.

A similar flatness on the calf is seen in the side view, B,

and behind the knee in the same the central roll provided by the two gastrocnemii, and which forms a feature of the back view of the knee when extended (G).

By the side view also it may be seen how the knee

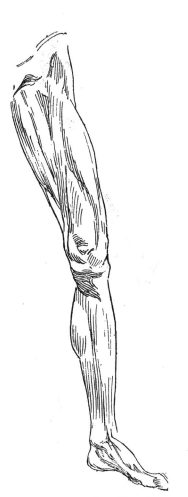

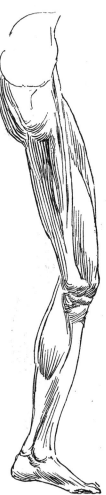

FIG. 345.—Inner Front View of a Model by Michael Angelo.

FIG. 346.—Inner View of a Model by Michael Angelo.

descends much lower before than behind, and how the
curve up from the foot over the ankle comes higher up
the shin than does the one from the heel up the back

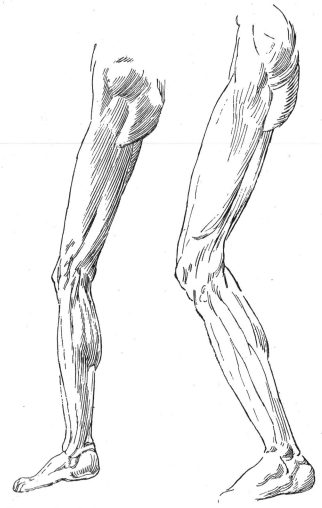

FIG. 347.—Outer Back View of a
Model by Michael Angelo.

FIG. 348.—Outer View of a
Model by Michael Angelo.

of the leg. Between these, on the front is the convex curve of the crest of the tibia between its two concavities above and below. It is interesting to note that the slanting lines in this diagram correspond to the limits of the breeches and boots of the Romans.

The knee must always be expressed by convex curves of its own, and not regarded as merely the junction between the thigh and leg.

Annexed are four drawings of a wax model by Michael Angelo in the South Kensington Museum. That they will prove of interest and assistance there can be no doubt. The junction of thigh and knee should particularly be noticed—it is seen in Figs. 345 and 346, also the back of the knee in Fig. 347, and the tendon of biceps going behind it in Fig. 348. The lines of the feet are very valuable.

77. The Ankle and Foot.

THE skeleton of the foot shows it to be composed of two parts or systems, one belonging to the heel and ground, the other to the ankle and leg. The one seems to imply the stationary and the other the active position. The heel-bone, os calcis, supports both systems, and both are arches, though the horizontal or ground system on the little-toe side is much less arched than the other.

It is perhaps best to consider the os calcis as situated on the little-toe, or outer, side, although it supports both. Its support of the inner arch is by means of the astragalus, the bone which makes the ankle-joint, and which it supports chiefly by a bracket. From behind, the heel is distinctly seen to be on the outer side. (Fig. 349, C.)

The body of the os calcis coming directly forward

articulates with the cuboid bone of the tarsus, and the cuboid supports the two outermost toes.

The bracket of the os calcis supports the astragalus or talus, which, projecting forward, supports the scaphoid, which itself articulates with the three cuneiform, each forming a base for one of the first metatarsal bones.

But while these two systems are very complete in themselves, they harmonize with one another and articulate where they meet.

Transverse sections before the ankle yield the facts

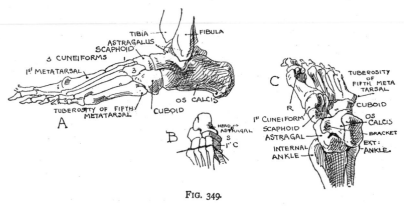

FIG. 349.

that the two systems do not form one clear surface till the cuboid and cuneiform bones are reached. Of these, the middle cuneiform is the highest, the surface falling slowly by a gentle curve over the third cuneiform and the cuboid, and toward the great-toe side by a very much more precipitous course over the first cuneiform, which presents a rather deep face. Indeed it is no exaggeration of fact to say the surfaces declining either way from the middle cuneiform are at right angles to each other. (Fig. 349, B.)

Between this row of cuneiforms and cuboid and the

ankle, the harmony of surface is not continued, the outer
system lying low compared with the inner, which con-
tinues to rise. The bone behind the cuneiforms is the
scaphoid. From above it appears as a parallelopiped, a
brick-shape, with the end declined outward according to
the declivity seen in the other bones, while its long side
agrees with the first cuneiform and points inward. Behind
the scaphoid is the head or forward part of the astragalus.

FIG. 350.

The effect of these particulars is to confine the rising
arch of the instep to the inner border; the foot must
therefore be kept depressed a little in front of the external
ankle.

The forward portion of the foot is characterized by the
great strength of the great-toe, and its metatarsal bone,
by the smallness of the phalanges of the four outer toes,
and by the great protuberance at the base of the fifth
metatarsal. Taking this great protuberance into con-

sideration, the five toes make, with their metatarsal bones,
a fairly parallel mass, when seen from above. In the side
view there is a degree of convergence toward the toes,
owing to the height of the instep, but even then the
parallel characters of the two borders is not wholly lost
and although rather gruesome and unpleasant, is frequently
to be seen in Michael Angelo's drawings. Fig. 350, J, will
illustrate the matter, as well as another peculiarity of some
of the master's drawings. This is the hollow in the ankle,
at the top of the instep. (Compare Fig. 349, A.)

The under side of the foot shows distinctly the two
systems spoken of above. There thus appears a hollow
or valley between them (see Fig. 349); the one system,
including the great and two adjoining toes, makes its
way down toward and dies into the tibia; the other,
including the two outer toes and the heel, is rendered
more distinct by a muscle, abductor minimi digiti pedis,
which passes from the os calcis to the base of the little-
toe. A similar muscle, abductor pollicis pedis, passes from
the os calcis to the base of the first phalanx of the great-
toe, thus bridging the valley in the sole, and rendering the
two sides much more alike.

This muscle is perhaps the only one that need be
mentioned, and it only because it fills up to some extent
what would otherwise be a very deep hollow under the
inner ankle.

Beside the tendons which come down from the leg
there are no others that assert themselves, excepting
perhaps the tendons of extensor brevis digitorum. This
muscle arises under the external ankle, and sends forward
four tendons which arrive at the bases of the great and
next three toes beside, and connecting with the tendons
of the long extensor, which comes down from the leg.

The tendons of the short extensor thus make a small angle with those of the long extensor.

Viewed from above, the inner border of the skeleton of the foot appears as two convex curves, each occupying about one-half the length. The hinder curve represents the tarsus and heel, the fore the great-toe and its metatarsal bone. Thus the ball of the great-toe, at the junction of the metatarsal and first phalanx, is thrown outward. The pinching together of the toes in modern boots makes it project even more.

The constriction of the outer side occurs further back, just behind the tuberosity of the fifth metatarsal.

Both the internal and external ankles are longer, vertically, than wide, and in shape something between an oval and a diamond with its upper point greatly elongated. The reader will hardly need reminding that the inner is much the higher in position.

In considering the drawing of the foot we will take the inner and outer views (Fig. 350, B and D) as the most frequently used. We have seen that the bones of the foot are arranged in two systems, one inner, connecting the great and second toes with the tibia; the other, outer, connecting the three last toes with the heel.

The most diagrammatic form of the foot in these positions is triangular, as at H and I. The heel should be kept well pointed behind, not because it is more beautiful if more projecting, for the contrary is the fact, but because it is generally neglected by students. If the foot is to be seen in outer view an extra triangle is added on the lower line for the little-toe (H); if in inner view, a triangle must be added above, on the upper line, for the little-toe and the parts about it (I). Then the ankles will differ. In the outer view (H) the joint will fall down toward the heel,

the outer ankle being low, the inner very high; in the inner view the joint will be almost in line with the upper outline, and the low outer ankle will be hardly seen.

We shall next place the instep before the ankle, but it keeps upon the inner border of the foot as it is formed by the system or arch connecting the great-toe with the tibia. In the inner view this connection will be very plainly seen (B and C), there being a palpable vacancy under the arch of the instep. The under line will come suddenly down to the ground behind the ball of the great-toe, and may then come forward along the ground as a straight line, as in C. The far side of the instep in this view will be well rounded, and will die away in front of the smaller toes.

In the outer view the instep will fit, somewhat buttress-like, down upon the horizontal system of the foot. The heel occupies about one-third of the total length, ceasing a little before the external ankle. If we draw a line down from the ankle to this point it marks an important division, for on both sides of it the border diverges outward, so that the heel and the little-toe-ball enclose a very large angle, and the heel of D is thus turning outward to face the spectator. Below the ankle in this diagram is a small stroke corresponding in position to the tendon of *peroneus brevis*. On the front is *peroneus tertius*.

Having drawn the heel, squarely, and marked the division spoken of, a full curve may be drawn all round the ball of the little-toe, and the small toes, massing them together.

The ball of the little-toe must bulge out softly, and must be of sufficient volume to suggest a sixth toe, not yet fully developed. In N it is given in an exaggerated form, and

as if squashed from under the foot by the pressure upon it. Its outline is a subtle, but not a single, curve, and the little-toe occurs high upon it, the ball intervening somewhat between it and the ground. In such views as M the ball will make the outline not the little-toe, and care must be taken never to let the little-toe, or little-finger, make a straight line with the outer border.

The proportions of the inner side of the foot are shown in L; one-third is occupied by the heel, the arch, and the great-toe with its ball.

A view, such as K, is generally massed as in O, but care must be taken not to fall into the error of filling all the angle on the right with toes. They should not project further into it than the dotted line. In early Gothic drawings the toes are shorn off, as it were, at an angle, as in M.

If the designer is at a loss for a model for a foot, he may take a shoe or boot which has undergone some wear, and he will find it some assistance.

Drawings of feet in stockings are useful, as they give the general shape of the foot.

The bones of the middle toes appear in the articulated skeleton projecting straight forward in continuation of the line of their metatarsals. In most cases in life, however, they are more or less flexed, bent so that their joints project upwards. One needs to know the bones of the toes just as much as those of the fingers, to which they are similar. The second and third phalanges are comparatively much shorter and wider. The first phalanx being nearly always turned upward a little, the extensor tendon on the top is evident, and becomes part of the toe-form, and the outline generally begins with the tendon. These extensor tendons attach to the base of the *second*

phalanx, and thus the length of the first phalanx becomes very much diminished.

The three middle toes, therefore, present each three upper surfaces, separated by two knuckles. Very often, however, the two last joints are almost straight with one another, and so only the upper knuckle projects. This yields such forms as are used in Fig. 350, B, D, and K. The little-toe, although also of three bones, shows its construction less clearly, and very often appears as merely an

FIG. 351.

ovoid mass, pebble-like, with a slight projecting nail before, and a concave tendon behind.

The smaller toes like the fingers have their pulpy parts at the outer ends of the last phalanges, although the greatest thickness is not quite at the end. In the great-toe as in the thumb the mass is driven further back, and is very much larger. The under side of the great-toe is even more heart-shaped than the under side of the thumb. As in the thumb, the first phalanx becomes a mere neck between the ball and the large mass of the second phalanx. The ball is deep, being enlarged by two sesamoid bones under the anterior end of the metatarsal.

The little-toe corresponds in two particulars to the little-finger—it is drawn back, bent somewhat more than the other toes, and it is more obliquely placed ; that is, it tends to show its inner border. At the side of it, as, to some extent, an extension of the fleshy mass which covers its metatarsal at the outside, is a fatty prominence, which looks like a sixth toe not yet endowed with a separate existence.

Considered together, the four smaller toes resemble the fingers in their knuckles being separated, and their tips together, and they contrast with the great-toe in making a convex mass forward, while it makes a concave.

The four smaller toes are separated, one from another, by divisions which are placed with regularity on an oblique line. These toes seem thus to be all of much the same length, to be set back one behind the other, and to arise from a portion of the foot common to the four. Between the second toe and the great-toe, however, there is a space rather than a mere division—a space sufficiently deep to separate the great-toe from the other toes, and which, furthermore, running into the foot to a point about level with the division between the third and fourth toes, makes the second and third toes appear connected together, and as if arising from a separate and common base.

The foot of a woman is much straighter than that of a man, and more like a hand. The great-toe is more like a thumb; that is to say, the last joint is not swollen out so much to a heart-shape as in a man's.

In sketching in the foot, it will be well to always give the smaller toes a different direction from that of the great-toe, letting the latter proceed straight forward, and the smaller toes proceed outward, as shown in Fig. 350, M.

78. General Remarks upon the Lower Limb.

A FEW words may be said epitomizing the sexual differences in the lower limb, the most remarkable peculiarities of form and movement, and the proportions.

The difference between the male and female forms is very considerable. In both the limb tapers, but in the female so much more decidedly that we may regard its form as tapering, the male as maintaining its width.

Allowing that the female limb is about three inches shorter than the male, the thigh, front view, is yet wider than the male; and the knee is also wider than the male, but the calf is less, and the foot is less. In the side view we notice that across the widest part, including *gluteus maximus*, the female is wider; at the lower extremity of the same mass, where the thigh properly begins, the female is wider; but at the middle of the thigh it is narrower; the knee is perhaps wider in the female, but the calf is again narrower; so that the upper part of the thigh is greater in woman, but the calf is greater in man. Then the tapering in the female is assisted by the greater width of knee, which equals that of the calf. This width of the knee is not produced by greater bone, for the female knee-bones are smaller than the male, but to an extra fatness of this region, coupled with that fact concerning the muscular forms of women which has been alluded to more than once. This is the shortness of the female tendons, or the creeping of the muscular fibres down the tendons. To the same cause is due the fattening of the lower part of the female leg, close down upon the ankle. The fatness of the female knee is evident even in the sitting figure. In the male both the knee and ankle are bony, and the

tendons more exposed and inclined to stringiness. The male knee is less in width than the calf.

The diagram here given will assist the comparison of the two sexes. The most remarkable differences are the following. The shapes of D and E and the relation between them, the length of F, and how in the female it makes an obtuse angle with G, so that in the male. F and G are almost one, but distinctly separate in the female.

FIG. 352.

The back of the knee (H) must be convex in both. The calf-forms (J and K) must be more zigzag in the male, (O) more prominent in the female, and (Q) convex in both.

The creases in the limb are very useful in expressing the direction forwards towards the spectator, or backwards away from him, just as transverse stripes, like those on the stockings of football players, are. The creases below the glutei at the back, and those behind the ankle and in the sole, are in this way very helpful.

Reference has been before made to the joining by an oblique line of one part of the leg with another. The

connection between the thigh and leg requires, however, another word or two. The thigh overhangs the leg; or, in other words, the leg comes from the hinder part of the thigh. One might go so far as to say that a line down the middle of the thigh will give the front outline of the leg. Compare Fig. 352, R, U, V, W, and notice how in U, which is a very frequently used view of the limb, the inner calf and ankle occur as projections upon this medial line. The rule applies less to the front view (W), but even there is of value. Note the obliquity of the knee in all these examples.

We have seen before how the thigh includes the knee. The inclusion is very palpable in the inner view (S). The connection of the upper part of the tibia and the knee with the thigh is also very important (T), the knee being spliced down into the leg. The student cannot fail to notice how in both the knee and elbow the bone projects, as it were, through the flesh, as if, fleshily speaking, the figure were always out at elbows.

The tibia is twisted upon itself, so that in the normal standing position, the heels being together, the toes are some distance apart. The feet are thus not parallel to one another, but at an angle of about 45 degrees. If the toes and heels are placed together, the thigh will be rotated inward a little.

In the seated figure the angle between the feet is much less, and the toes and heels may be together, or the toes may be even closer together than the heels, without any discomfort. This correction of the permanent out-turning of the foot is due to rotation inwards of the tibia, an action only possible when the knee is bent.

The knee-joint is a hinge of great range backward, flexion, but very slight range forward, extension. This

extreme extension is best, or perhaps only seen in the standing leg of a figure standing at ease.

The ankle-joint, including the joints between the larger bones of the foot, is a hinge-joint, combined with various subtle movements, of which the most palpable are the turning inward and outward of the sole. The outer and inner borders of the foot can thus be placed upon the ground without the leg or thigh being changed in position. In stretching the legs and feet out to their greatest extent the feet tend to cross, and the soles become inverted, or turned toward one another.

The female foot is proportionally smaller than the male, after allowing for difference of stature.

The knee-joint occurs at just about the half of the length of the lower limb from the top of the head of the femur to the ground. The head of the fibula is at a quarter the height of the figure.

The top of the foot is about half the length from the front of the ankle-joint to the tubercle of the tibia, in the female (Fig. 352, R) ; in the male twice the foot-front may reach as high as the knee-cap.

In the female the thigh-bones are not only shorter but more obliquely placed, being separated above by a wider pelvis. The angle they make with the tibias is therefore more definite than in the male.

We can gain considerably in our knowledge of the foot if we compare it with the hand. The similarity between the two is very great, and of great assistance to the draughtsman.

One has at the outset to remark that the actions of extension and flexion are contrarily named. To curl the fingers and toes up is to flex them ; to straighten them out, and if possible bend them back, is to extend them. Now,

in the case of the wrist a continuation of the action of the curling up of the fingers is called flexion, but in the case of the ankle it is called extension. The reason apparently is that the limb loses length in the one instance and gains it in the other. There is no need, however, for the artist to limit himself to the language of anatomists; and his own purpose will be better served if he regards the calf muscles at the back of the leg as the flexors of the foot, just as the flexors of the fore-arm perform the same action upon the hand. The flexors of the toes lie beneath the gasterocnemius and soleus, in the calf, but the gasterocnemius and soleus are regarded as extensors.

When consequently we press the finger-tips down firmly on a table we find the flexor muscles of the arm (a swelling fleshy mass) become more solid, and, similarly, when we press the toe on the ground the calf muscles behave in the same way. Again, when we raise the index finger, and bend the hand back, the extensor muscles harden and show their stringy lines on the back of the arm, and the muscles of the shin do the same when we raise the toes and foot.

The bones correspond, too, although there is apparently a great difference in the relations of ulna and radius to tibia and fibula. With the palm of the hand down, as in walking on the hands, the lower end of the radius occupies the same position as, and resembles, the lower end of the tibia. The lower end of the ulna and the lower end of the fibula both correspond also, and are on the little-finger side.

Both above and below the two bones are in the relation of big and little. Below, the radius in the arm and the tibia in the leg are the big bones, and the ulna and fibula are the little bones. Above, the ulna, in the arm, becomes the big bone, while in the leg, the tibia remains the larger.

It is useless, though interesting, to speculate upon the question whether there properly should be one stout bone and one thin bone as in the leg, or whether the bones should " change ends " as in the arm. Is the leg a modified arm, or the arm a modified leg ?

If we examine the bones of the palm of both hand and foot we find that the fingers and toes have each a stout bone, similar to their own "joints," which connects them with the wrist or ankle, and which forms the body of the

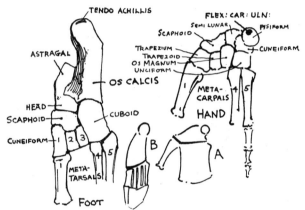

FIG. 353.—Comparison of Bones of Hand and Foot.

hand or foot. These are the metacarpal bones in the hand, the metatarsal bones in the foot. Both in hand and foot we notice these " meta " bones are supported by four small cube-like bones. In the wrist they are, reading from the thumb-side—trapezium, trapezoid, os magnum and unciform ; in the foot—cuneiform I, II and III, and cuboid. We note in the diagram (Fig. 353) the joint-line made by these bones against the " meta " bones, and we observe that in both cases the two last " meta " bones are supported by one bone only. We see next that there is a second row of bones, particularly in the wrist, where they

are scaphoid, lunar, cuneiform and pisiform. In the foot
there are only scaphoid, astragal and os calcis, but a closer
examination reveals the similarity, and it is these particular
bones which serve the artist. Thus pisiform of the wrist is
a little bone making cuneiform higher, and as it were
beginning the hand on the little-finger side. Moreover, to

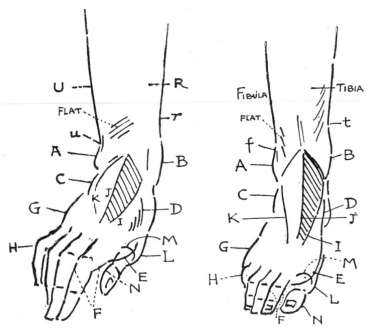

FIG. 354.—Lines of the Hand and Foot.

pisiform comes the flexor carpi ulnaris, one of the great
flexors on the fore-arm, and which should correspond to
something among (what I call) the flexors on the leg—the
calf muscles. As a matter of fact, the great tendo Achillis
of the calf comes down and attaches to the great projection
of the os calcis, so that one concludes that pisiform of the
wrist and the projection of os calcis in the foot are the

same. This leaves the front part of os calcis to do duty for the cuneiform of the wrist.

On the other side there is, in both wrist and foot, the

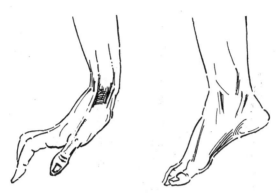

FIG. 355.—The Hand and Foot compared.

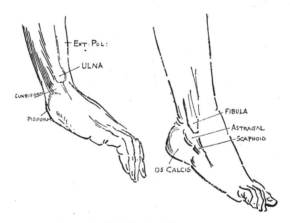

FIG. 356.—The Hand and Foot compared.

scaphoid, and either on or beside it is inserted the other flexors of the hand and foot (flexor carpi radialis in the hand, tibialis posticus in the foot).

Nos. A and B, Fig. 353, show the relation of pisiform in

both hand, A, and foot, B, to the joint between these various small bones and the "meta" bones. We see that in the hand this joint is broken, or deflected, so that the thumb is

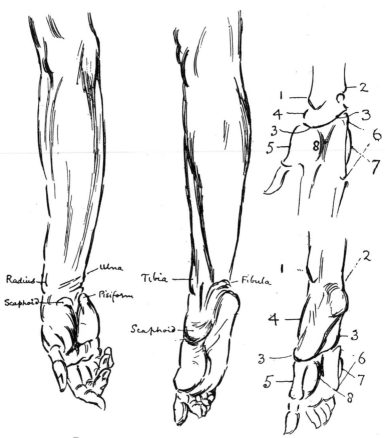

FIG. 357.—The Palmar Surface of Hand and Foot compared.

projecting outward ; we see that in the hand the pisiform elevation is very near the joint, in the foot it is distant ; we observe that of the two lines from the pisiform to the joint one is convex, and the other concave, in both.

If now we put into practice what we have observed, we make the following comparisons :—

In Fig. 354, U (ulna) corresponds to F (fibula), and in both should be kept fleshy and full, for there are muscles enriching the form very considerably here. A is the end

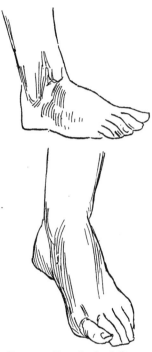

of the ulna or of the fibula ; B is the end of the radius or of the tibia. We note that in both cases A is knob-like : it may, however, be more knob-like in the hand than in the foot when the tendons and muscles coming down it fill up the hollow above it. We observe that B is lower than A in the hand, higher than A in the foot, and that the form is similar in both cases. Next we come to the line C in both. This is for that hard bony prominence which has been sufficiently dealt with before when the wrist was specially considered (page 250). It is of the greatest importance. In the foot it is considerably longer than in the hand. D is

FIG. 358.—Feet of a Greek Bronze Statuette in the British Museum.

a somewhat similar line on the other side, a little lower down. It follows into E, one of the most important lines. It should be kept well rounded, and drawn at first without any thought of the great-toe or of the thumb. It supports the first finger or first small toe. G is a similar line on the other side supporting H, the little-finger. To manage a

hand or a foot well, however, one must be careful to model the mass I J K. In both cases the ridge J is nearer the thumb-side, but decidedly so, and with a curve, in the foot. Notice how this mass fits against the arm or leg above. The ball of the thumb, or great-toe, is next put on with the line L, then the joint M is useful, and then N, the *inside* of the thumb and *outside* of the great-toe.

Much could of course be said of the comparisons illustrated in Figs. 355, 356, and 357, but it must suffice to say that the similarity is seen in almost every line of the upper and lower limb. The diagrammatic illustrations in Fig. 357 follow those of Fig. 353, and form a link between the anatomical facts and the artistic renderings.

79. The Effect of Gravitation on the Flesh.

THE falling of the flesh in response to the law of gravitation is most noticeable in the lower limb, if raised when the figure is lying down. The tibia or shin-bone shows up very distinctly, as also does the knee.

In a person seated on a low seat with the knees high, the bones would similarly show. In a figure seated on a seat of ordinary height, which by the way is about eighteen inches, that part of the thigh before the seat droops considerably, especially in the female. In the arm, too, the triceps, or biceps, sink as they happen to be underneath, the part above flattening somewhat by falling down the sides.

In old people, whose skin loses its elasticity, there is more drooping observable than in young people. But flabbiness reaches its climax in the drunken Silenus and the infant Bacchus.

FIG. 359.—Amorini or Loves. (From engravings after Piazzetta, Venice, 1752.)

In historic art, the falling of the lower parts of the body was admirably represented in the Greek sculpture of the fifth century B.C., the best period. It is excellently shown in the Theseus and Illysus in the British Museum. In the Theseus, in the falling of the flesh beneath the leg and thigh ; in the Illysus, in the falling of the abdomen, and consequent accentuation of the thoracic arch. On the Roman stuccoes also the fact is well expressed. It is likewise respected in the Early Renaissance, but from about the time of Raphael the flesh appears more solid and statuesque than formerly, the well-known muscular forms being often added without much regard to change under varying conditions. It is of course only in the work of second-rate men that this peculiarity occurs. In all periods the great men have found truth, the mediocre only form mannerisms. The tightly-drawn flesh of the Renaissance gradually slackened till it became more and more flabby, and as soon as Le Brun had finished his grandiose labours at Versailles, it assumed a looseness unparalleled in art history. Boucher and Fragonard may stand as typical masters of this flabby school. There was of course some good in this loose treatment. It looked soft and fleshy, and these are qualities by no means to be despised, but it was carried too far. With the French Revolution came David, with his revival of the antique, and then there is a return to rigidity, and an almost cast-iron hardness in the early part of this century.

In the drawing of the period when flabbiness was most cultivated (1750), the forms are generally expressed with a sort of wavy line, whereas in the hard times of the Renaissance and early nineteenth century, the curves are almost pure arcs of circles. The happy medium is, I suppose, the best.

FIG. 360.—Amorini or Loves. (From engravings after Piazzetta, 1762.)

80. Obliquity of Certain Details of Form.

THERE are innumerable instances in the figure of variety and alternation, and these are exemplified in the direction of the different parts, as well as in the character of their curvature or modelling. The architectural lines, the

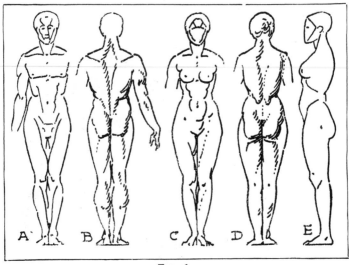

FIG. 361.

vertical and horizontal, only occur definitely, once each: the vertical in the middle line, the horizontal in the collar-bones. The symmetry of the figure also suggests the horizontal, but does not express it; while even the lower line of the male breast ascends slightly towards the middle line.

In the front view (Fig. 361, A) the number of lines converging downwards is very great. The eminences of the forehead, the cheeks, the neck, the sides of the chest,

the abdomen, the outline of the thighs, the sartorial line on the front of the thigh, the outer line of the leg, and the line of the tibialis upon it, all approach the centre line as they descend. In the female (C) the same may be noticed.

The back view presents a more alternating arrangement. The masses converging downwards are those of the back, and of the loins and gluteals. Divergent downwards are the masses of the neck, and of the muscles at the back of the thigh. The male and female may be compared in B and D. The female side view (E) shows how continually the vertical and horizontal directions are avoided. The obliquity of the line of the iliac crest is very important.

81. Pose and Gesture.

IN securing the pose, attention must be given to the large masses of the body falling properly over the point of support. If the figure stands on one leg, it will be found that the hip on the other side sinks, while to balance the loins upon the standing foot, the standing hip will be thrown out. Then, to bring the mass of the chest also over the standing foot, the loins will bend somewhat, while a reverse curve will frequently be upon the neck, to bring the head into the line of gravitation. The slope of the shoulders and hips is therefore contrary. (Fig. 20.) Any arrangement of the limbs, which disturbs this equilibrium, has to be counterbalanced by some other alteration. The change is most noticeable when something heavy is held in one hand. If it be held in the hand on the side of the standing leg, the tendency to pull the figure over on that side will be counteracted by throwing the free leg

further out. If, however, the weight be held on the free-
leg side, the standing hip will be thrown further out. In
holding a weight before, the back is bent backward so as to
bring the total weight as centrally over the feet as possible.
In looking through a window, one leg is generally thrown
back to counteract the increased value, as weight, of the
upper part of the body, which is thrown forward.

The different angles at which the
various sections of the body are
placed, must be particularly noted,
as is illustrated in Fig. 362.

In all posing, the simplest and
most natural attitudes must be
selected; no regard for the grace of
the figure must be allowed to in-
terfere with the probable aspect of
the action. Nor may a figure be
placed in any position without some
apparent intention in the figure's
mind to perform some action, for all
posing is simply the arranging of
the body in the attitude most suit-
able for the performance of some
action. It will therefore be found,
for instance, that when a person looks at an object, he turns
his head towards it, and does not merely roll his eyes
in its direction. Such only is done when the person
wishes to observe without betraying what he is doing
by his gesture. Again, when a person uses his hands,
except on trivial actions, such as pushing aside a curtain,
the body is to be turned towards the action. It is ex-
ceedingly ridiculous how often figures are represented
writing upon blocks, or reading heavy books—to mention

FIG. 362.

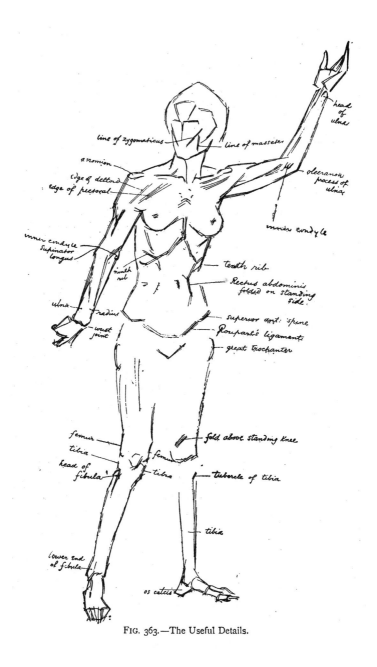

line of zygomaticus

line of masseter

head of ulna

acromion

edge of deltoid

edge of pectoral

olecranon process of ulna

inner condyle

inner condyle Supinator longus

tenth rib

ninth rib

Rectus abdominis folded on standing side.

ulna

radius

superior ant: spine

Poupart's ligament

wrist joint

great trochanter

femur

fold above standing knee

tibia

femur

head of fibula

tibia

tubercle of tibia

tibia

lower end of fibula

os calcis

FIG. 363.—The Useful Details.

two only of the most frequent examples—in the most
twisted and tortuous positions. Generally there is no
reason for them either to read or write ; these are occupa-
tions given them merely to fill up the space. A designer
should never attempt a figure unless he is really interested
in people, and takes delight in portraying their habits.

FIG. 364.—The Near Side Drawn
First.

It is rather a sign of a de-
signer's inability when in draw-
ing a composition he puts in the
features early ; this is chiefly
because expression must first
come by gesture. If the gesture
of the figure does not express
the part the figure is playing in
the subject, and even its character
and disposition, whether of pride,
humility, hypocrisy, or any other
quality, it is little use relying
upon the features ; the effect will
only be a wax-work. Further,
the designer should try to let the
whole drama of his subject be
explained by the gestures of the
figures and composition of the
whole. It would be a very good
thing if at exhibitions of pictures
no titles were declared.

To attack the whole figure we need to be in command
of such anatomical details, or details of form, as are shown
in Fig. 363, and in order to pose it easily we must work
somewhat after the manner of Fig. 364. In that drawing,
after the simplest commencement the near side of each
part is drawn. Thus, the near side of the chest is on our

right, and that is drawn before the left side. The near
side of the head is however on the left; and in the neck
the near side is on the left, above, and on the right, below.
This plan works well, because there is always a tendency
to enlarge the details as one draws them, and so, if one
draws those on the more distant side first, one is in danger
of extending them too far.

82. The Gracefulness of Woman.

THERE can be no doubt that the distinguishing charac-
teristic of the woman's figure is its gracefulness. The lines
always tend toward easy curvature, for the flesh so mounts
up between the joints that what is an angular arrangement
of lines in the skeleton becomes rounded in the living
subject. We see this particularity in the limbs; the knee
and the elbow seem so small in bone as to retire within the
form, and so to assist the expanding flesh to produce the
full, rounded, and yet delicate and not loaded, modelling
for which the woman's figure has always been famous.

The old dancing-masters, and most likely those of to-
day, too, told their fair young pupils to curve their arms,
for a woman's arm was always a perfect curve. Serious
students are apt in their dread of sugary elegance to pay
too little attention to this quality in the form of women's
figures, and permit their heroines to appear the awkward,
raw girls whose beauties were developed by the professors
of the art of Terpsichore.

The first effect of the softening of the form by the
fulness of the flesh and the smallness of the joints, is the
tapering of the limbs. We can see this in Fig. 365,
wherein the one arm is raised above the head. The arm

tapers there from the shoulder down to the wrist, and the
lower limb, in the same way, diminishes gently from the

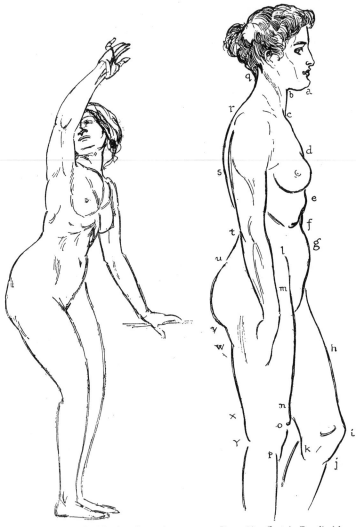

FIG. 365.—The Flowing Curves in
Woman.

FIG. 366.—Certain Peculiarities
of the Woman's Form.

top of the thigh to the ankle. We note particularly how nearly the outlines of arm and leg approach pure curves. As the knees are bent somewhat the curve behind cannot be a simple curve, but it also is not in the erect figure, and contrasts with the front line in being a succession of convex forms, while the front line always tends to be a graceful flowing curve. The front lines in Fig. 365 are not an exaggeration of the grace in the real subject, so nearly is the form built up to a form lacking angles.

But the diminution is not confined to the limbs, it pervades the female figure throughout. The haunch and abdomen certainly melt into the thighs and legs—the form is continuous throughout all, indeed the beauty of a woman's form depends, not a little, on this continuation of the form up to the waist, for her legs are relatively shorter, and thighs thicker, than a man's.

Some of the characteristics which produce the gracefulness in woman are illustrated in Fig. 366. Between A and B is a fulness beneath the jaw, carrying the form of the face round to the throat. There is a convex curve between A and B, and another between B and C—the pit of the neck. This second curve is fuller below than above, and thus with Q R at the back of the neck produces a form spreading as it descends. Just below C is the bold form for the collar-bone. One does not increase the gracefulness of a woman's neck by diminishing the projection of the collar-bone, for the sudden spread forms a most charming base for the head and neck, and a happy transition to the greater volume of the trunk. This bold projection of the collar-bones, and the spreading of the neck down on to them, is seen in Fig. 367.

Continuing the analysis of Fig. 366, we note the projection D and particularly that at E. The breast is not

the most prominent part of the front of the body, except in an accidental sense : it is an excrescence.

The letters upon the diagram will call attention to the several fragments into which the figure is broken, and there is need only to refer to the more important. There

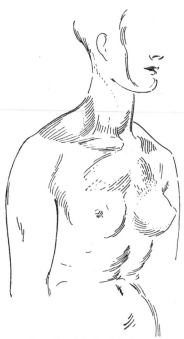

is a great fulness at the back of the arm, there is a graceful curve down the back from Q to S. The curve between U and V is not very bold, because below it the line V W struts out the thigh. This line V W is considerably greater in woman than in man. Another remarkable difference is that, in woman, the fulness behind the knee X Y is greater.

In such an attitude as that in Fig. 368 several of those instances in which the grace of a woman seems to lie are evident. The beautiful curve of the neck follows

FIG. 367.—The Neck fitting on to the Trunk.

down the back of the arm, and would pass as gracefully down the back itself if it were visible. Let us note that in the neck there is first a fairly straight piece from the head to the vertebra prominens, and then another from that point to the top of the blade-bone. As for the arm it is very full behind, but also full in the front where the biceps is. There is a sudden contraction at the elbow, and a puffing

out at the side—the mass of the supinator. And full as is the lower arm, it is comparatively small, and exhibits a subtle play of the bony and fleshy, in alternation.

The wrists and hands seem too small, as do the feet. The chin touches the breast below the collar-bone. The projection of the abdomen is perhaps one of the most important details, because one so hesitates to make the abdomen prominent that one is apt to err on the other side and make it too slight. The arm when held as in this attitude divides the figure into two parts, upper and lower. The lower is decidedly the greater, beginning above with the great masses of the haunch and abdomen, to which succeed, by a beautiful gradation, the full thighs, the slender legs, and the small feet.

The fulnesses on the lower limb are—on the front of the thigh, on the back of the thigh, a little fulness between the last and the projecting gluteus, above the knee, and behind the knee, on the calf and on the soleus below it, and two tender fulnesses on the front of the leg, on the shin, opposite the fulnesses behind.

FIG. 368.

In Fig. 369 we note the following peculiarities—the
collar-bones full and forward before the neck, the lack of
lumpiness down the back of the arm, and the great fulness
before it—a fulness expressed in a graceful curve, not in a
mere convex line. The
abdomen stands up
prominently as if it did
not pass below the
thighs, as if, that is, the
fulness of the abdomen
and haunch ceased
there and did not en-
croach upon the space
allotted to the limbs
below.

FIG. 369.

We must not forget
that in women and in
children the muscular
fibres creep lower down the tendons than they do in
man, so that in all those cases where the muscle is
attached by means of a cord-like tendon, the tendon is
shorter, and the flesh of the muscle fuller, than in a man.
This gives us great fulness at the lower end of the thigh,
at the wrist, and at the ankle.

83. The Hair.

IN old drawings, when the hair is represented by lines,
they nearly always follow the direction of the hair them-
selves. In our own day the lines are frequently nothing
more than a means of producing a tone, and the direction
of the individual hairs is not expressed. What needs to
be noticed in drawing the hair constructively is, that all

the hairs do not keep to the locks, but stray about, and though five or six·follow one even direction, they will be crossed at an angle, slight or great, by another hair, or by hairs.

In the engravings from which Fig. 359 is reproduced, the hairs are all drawn separately by double lines, and the tone is got by thickening the lines, and consequently narrowing the space between them. Great attention is paid to the stray hairs, and the effect is very good and not at all wiry. Fig. 86 also is in this manner.

DRAPERY

84. Points and Surfaces of Support.

IT is necessary first to fix the points of support, and these will be found to be of two kinds, principal and secondary. A principal support is one from which the

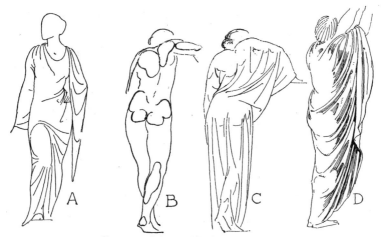

FIG. 370.—Points and Surfaces of Suspension.

drapery definitely hangs, as a shoulder ; a secondary support is one produced by an eminence of the body rising so far as to push the drapery out a little.

There is reason to believe that the Gothic artists defined
the areas of support by encircling them, as is done in B.
Any surface which asserts itself among the drapery,
whether as a primary or a secondary support, should be
outlined in this way. The areas thus defined become the

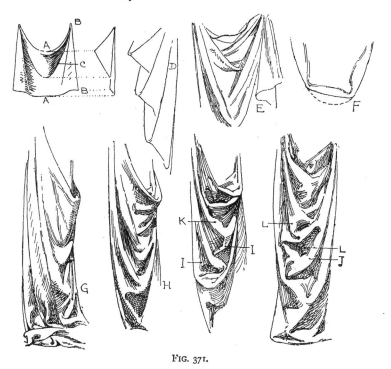

FIG. 371.

only parts of the figure which show ; the other limbs may
be thin wires for all the difference they make to the effect
of the drapery.

If the drapery is drawn upward, instead of being allowed
to fall, the surfaces of support will of course be on the
under sides of the masses of the figure (as D, Fig. 370).

The number of the folds depends upon the method of

arrangement, the kind of supports, but chiefly upon the texture of the fabric. A stiff or thick cloth will of course give broader masses, and duller and fewer folds, than a light silk or cotton.

The following details of folds must now be noted. In Fig. 371 it will be seen that the depth A A is less than the depth B B, although they are actually equal when the cloth is spread out. The weight of the festooned part compels it to fold upon itself, and so the edge (A in the example) comes forward, making a cone-like piece running backward and downward, till it meets another uplifting surface of the cloth (C). Thus there is a zigzag arrangement formed, which becomes less angular as it descends, while the folds become deeper, and more ovoid or pointed (D).

All folds, except those at the edges of the material have an upper or concave piece, and a lower or convex piece, connected in front by a cord-like edge. The upper piece has the same bulk as the lower, but less space, and therefore is obliged to crinkle, or fold upon itself. Often this subordinate folding affects the lower part of the fold, making it also angular, as F, Fig. 371.

More frequently, instead of the folds being continuous from one point of support to the other, there are two distinct arrangements, one from each point, and the folds of one meet their opponents at an angle (E, Fig. 371), dying away as they do so, or rapidly terminating, and not ascending beneath the other folds to the contrary point. When the drapery is full, however, the opposing systems intermingle, as is illustrated in G, H, I, and J. In G is a system from the left. In H the right corner is placed higher, and the right system begins to assert itself, and to diminish the predominance of the left system of G. In I

the process is carried further, till in J the right has more prominence than the left. As folds commence to come or die away, they suggest the directions which they are about to, or did formerly, take. Thus the premonitory elevations I I become the fold J, while the fold K is divided into L L.

85. The Summits or Cords of the Drapery.

MOST of the present illustrations will show that the folds have an edge, or summit, which generally receives light. In the simplest drapery of all, the folds radiate like

FIG. 372.

cords from the points of suspension, and die away upon the masses of the figure. Between the cords the surface sinks down into more or less of a concavity, and can be represented by shading (as in Fig. 370, D).

There will, however, generally be more cords on the broad part of the figure than at the termination of the folds on the point of support. What is one fold there, will divide into two or three as it descends, because it is pushed up by a secondary support. They may be managed thus: Let the two lines in, say, a pen-drawing, representing the two sides of a cord, diverge as they descend. (Fig. 372, A A.) Indeed, the drapery will look very poor if they do not.

Then each line may be considered as the outer side
of two cords, which unite as they converge (A). In

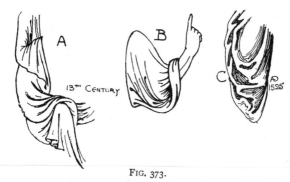

FIG. 373.

A and B from thirteenth-century stained glass, C from an early sixteenth-
century manuscript in the British Museum.

old glass-paintings this is generally represented as at B.
Or instead of keeping the added lines parallel (as in

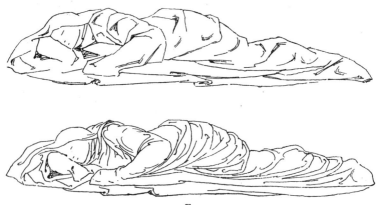

FIG. 374.

A and B), they may diverge, as did the original pair, thus
making room for others between them (as in C). And the
process may go on still further (as in D). In E the loops

are exaggerated, as in the drawings of Lucas Cranach and Albert Dürer. Dürer's drapery should be studied carefully. It is very strong, full of modelling, and has the details always carefully worked out. The drapery takes the form of cords when it is drawn closely upon the body, so that it cannot fall into large masses, the broad surfaces between the cords being produced by the masses of the figure. (Fig. 375, B.)

When the drapery departs from the cord-like, and expands into surfaces, the summits are the edges of the surfaces. In Fig. 374 the two kinds may be compared.

86. Various Kinds of Drapery.

THE form of the fold, and the general character of the drapery, will depend upon the kind of material used, the system on which it is made up into garments, and the length of time they are worn. All these matters must be studied in the drapery itself, and it is idle to attempt explanations of them.

But, although one hesitates to say so, there is a designer's drapery based upon laws which every one must admit are true, but which are inadequate to the production of the complex forms of nature. All designers will frankly admit this, but will have a sufficient excuse.

Every one who is at all acquainted with the history of Art knows that only occasionally do we meet with absolutely real drapery in old work. We might almost say that whenever the form or character of the drapery reveals the hand of a particular master, or the style of a particular period, it must be to some extent conventional And this is only what we might expect when we consider that

almost always the old masters were hotly pursuing some idea, the expression of which, and not mere likeness of detail, was the aim and end of their labour.

It may be that the draperies of the early periods I am about to mention were portraits of the actual clothing of the time; they certainly were to a great extent, but when the question of detailed form arises it would be difficult to say that the method employed was mere portraiture.

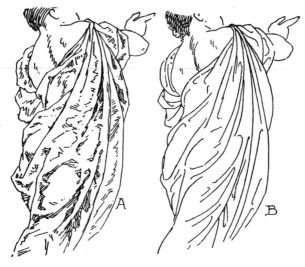

FIG. 375.

The costumes of those early periods were favourable to the study of the laws of drapery, and we shall see, in the briefest possible survey of the successive styles, the growing complexity of costume accompanied by closer research into the laws themselves.

In the Greek vase-paintings the drapery is generally represented by lines radiating from the points of support, sometimes hanging festoon-like, sometimes approaching one another from opposite systems, and terminating in

hooks. On the female figures two kinds of material are generally expressed, one having long folds, few in number and represented by single lines, rather pure in curve, another having many folds represented by irregularly-waved lines more parallel in direction. The outlines of the figure are rarely disturbed by the folds which pass round them. The folds often make angles with the outlines, and there is no attempt to keep them tangential to them.

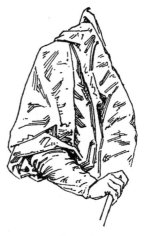

The next style is that exhibited in the ivories and manuscripts from say 300 to 700 A.D. It retains the pipe-like character of the ancient Roman, but the surfaces receding from the pipes or cords to the figure are neglected, and if the body shows at all, it appears as too rounded, with the cords of drapery stretched closely upon it.

FIG. 376.

From about 700 A.D. the folds become less curved, and are frequently very straight; festoon folds become V-shaped; and only rarely, if ever, are the lines broken. But the outlines of the figure are often disturbed, or crossed by folds passing round them.

In the twelfth and thirteenth centuries these simple styles are carried to perfection. In sculpture the receding surfaces could not be overlooked, and were necessarily developed. But the style remains essentially simple, the festoon lines are either curves of considerable purity, or are V-shaped. This dignified and unworldly kind of

drapery has been used by Sir E. Burne-Jones in his noble and beautiful 'Dies Domini' and 'Resurrection.'

The fourteenth century brings us the angular fold and greater attention to the receding flanks. The development continued to the end of the Gothic period, Dürer being one of the last masters of the style. His drapery is, however, more angular than a great deal of that produced at or before his time—particularly in sculpture.

In the Renaissance period, angularity survives in the

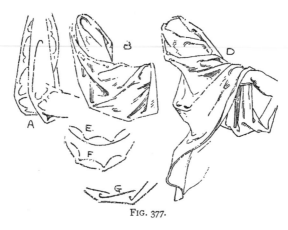

FIG. 377.

drapery of Mantegna, whose style seems to be somewhat followed in Sir E. Burne-Jones's 'Wheel of Fortune.'

The followers of Raphael developed a pipe-like style, which, if not abused, is very serviceable. Pipes or cords of drapery radiate from the points of support and clasp the figure, reducing the receding surfaces to a minimum, and exposing the figure between them as if the material were damp, and consequently clung to the form. Fig. 375, B is designed in this manner. The most typical examples are to be found on Urbino plates or Marc-Antonio's engravings. The chief faults as a rule are—an

insipid simplicity in the curvature of the "pipes," or, shall we say, india-rubber tubes, an absence of real form in the loops, and the apparent dampness of the material. Nevertheless it is a good style to commence the study of form and fold in, and need not necessarily have the faults named. Some of Mr. Walter Crane's designs are in a style very similar.

The last style, or peculiarity, we shall name is that which may be dated perhaps from Titian (Figs. 375, A, and 376). It is about his time that drapery begins to be represented *for its own sake ;* hitherto it had been merely an adjunct to the figure. The laws we have been examining require a figure or something to hold the drapery up, or a breeze to carry it out into the air, but now, although it is supported or blown out, and perforce must take certain forms, it yet has itself something to do in the making of folds. Throw a piece of drapery down upon the floor and it will take folds itself, it will provide points of support for itself, and in great numbers too. And to get rid of these folds inherent in the nature of drapery, we have to weight it by damping, or assume it blown by very violent gusts of wind. When the drapery is not thus simplified the lines of the large folds shake or wave irregularly ; and there are transverse creases or suggestions of such, from fold to fold. Then if any light is expressed on the folds it will not pass regularly down the pipe, but will zigzag in an irregular manner from side to side. These suggestions are all of value, but they must not be carried too far, as they elucidate nothing but the drapery. Fig. 377 will perhaps explain itself.

Many illustrations of drapery will be found in Volume II.

INDEX

ABDOMEN, 174
Acromion process of scapula, 123, 155
Adductor longus muscle of thigh, 274
,, magnus muscle of thigh, 275
'Aïgisthos,' The Death of, 10
Amorini, or "loves," 321, 323
Anconeus muscle of fore-arm, 231
Ankle, 301
Aponeurotis or sheet-tendon, 196
Arm, 215 *et seq.*
Arm-pit, 227
Astragalus, or talus bone of foot, 302
Atlas bone of neck, 123
Axis bone of neck, 123

Back, 205
Biceps cruris muscle of thigh, 274, 288
,, cubiti, muscle of arm, 225
Blade-bone or scapula, 124, 200
Bones of the cranium, 66
,, ,, face, 67, 70, 68, 86
,, ,, fingers, 258
,, ,, head, 67, 70, 68, 86
,, ,, hip, 169
,, ,, lower limb, 270
,, ,, neck, 123
,, ,, shoulder, 123
,, ,, trunk, 151, 156, 169, 209
,, ,, upper limb, 216
,, ,, wrist, 247, 315
Brachialis anticus muscle of arm, 225
Breast, 159 *et seq.*
Buccinator muscle of face, 80

Carpus or wrist, 245
Chest, 155
Chiaroscuro, a wood-cut in, 17
Child, Head and neck of a, 144
Chin, 101
Clavicle or collar-bone, 123, 155
Clodion, part of a frieze by him, 26
Coccyx, appendage to vertebral column, 169
Collar-bone or clavicle, 123, 156
Compressor nasi muscle of face, 79

Condyles of humerus, 217
Contour, drawing by, 9
Coraco-brachialis muscle of arm, 225
Coracoid process of scapula, 123
Coronoid process of ulna bone, 217
Corrugator supercilii muscle of face, 79
Cranium, 65
Crest of ilium bone, or lip of pelvic basin, 168, 284
Cricoid cartilage, 130
Crureus muscle of thigh, 274
Cuboid bone of foot, 302
Cuneiform bones of foot, 270, 302
,, bone of wrist, 315
Cylinder, the principle of it applied, 4

Deltoid muscle of shoulder, 157, 200
Depressor anguli oris muscle of face, 79
,, labii inferiores muscle of face, 79
,, labii superiores muscle of face, 79
Dilator nasi muscle of face, 80
Drapery, 336 *et seq.*
Drawing in line, 3
Dürer, Albert (1471—1528), 7

Ear, 105
Elbow, bones of, 218
Elbow-joint, 218
Erector spinæ muscles, 195
Expression, facial, 112
Extensor carpi radialis longior muscle
,, of fore-arm, 231
,, carpi radialis brevior muscle of fore-arm, 231
,, carpi ulnaris muscle of fore-arm, 231
,, communis digitorum muscle of fore-arm, 231
,, indicis muscle of fore-arm, 231
,, longus digitorum muscle of leg, 275

Extensor minimi digiti muscle of fore-arm, 231
,, pollicis muscles of fore-arm, 231
,, proprius pollicis muscle of leg, 275
External oblique muscle, 172
Eye, 85

Face, its bony structure, 67
Fascia lata of thigh, 276
Female abdomen, 176
,, arm, 239, 242
,, ,, proportions of, 265
,, back, 209
,, breast not to be relied upon to express sex, 148
,, breast illustrated, 161
,, chest, 152
,, ,, less bulky, 163
,, characteristics, 293, 329
,, ear, smaller and more obliquely placed, 108
,, foot, 309
,, gracefulness, 329
,, groin shallower, 170
,, hip, 282
,, iliac crests to show but delicately, 283
,, iliac crests less angular and more horizontal, 282
,, lower limb compared with male, 311
,, neck, 125, 136
,, nose, straighter and narrower, 97
,, pelvis wider and deeper, but less tall, 169
,, pelvis, falls forward, 169
,, rib, obliquity of first, 125
,, sacrum, wider, 196
,, skull, obliquity of, 73
,, thigh, 333
,, thorax, less square and smaller, 152
,, throat, 129
,, trunk, its proportions, 186
,, trunk, 148, 188
,, waist longer and more supple, 148
Femur, or thigh-bone, 270
Fibula, bone of leg, 272
Fingers, 257
Flabby flesh, the period of, 322
Flesh, appears tightly drawn in Renaissance, 322
,, effect of gravitation upon, 320

Flesh, flabby treatment of, 322
,, hard treatment of, by David, 322
Flexor carpi radialis muscle of forearm, 232, 254
,, carpi ulnaris muscle of forearm, 232, 252
,, longus digitorum muscle of leg, 276
,, digitorum sublimis muscle of fore-arm, 232, 254
,, longus pollicis muscle of leg, 276
Foot, 301
,, and hand compared, 314
,, bones of, 302
Fore-arm, muscles of, 230
Frontal bone of face, 68

Gasterocnemius, whether a flexor or extensor, 314
Gastrocnemius muscle of calf, 275
Gesture, 325
Glenoid cavity, 123
Gluteal muscles of hip, 273
Gluteus maximus, 273
,, medius, 274
,, minimus muscle, 274
Gracefulness of woman, 329
Gracilis muscle of thigh, 275
Gravitation, effect of it on the flesh, 320
Greek vase paintings, 10, 53, 244
,, drapery, 342
Groin of the abdomen, 175

Hair, 334
Hand, 254
,, and foot compared, 314
Head, 35 et seq.
Hip, 282
Holbein, Hans, the younger, 7
Humerus or arm-bone, 217
Hyoid bone of throat, 129

Iliac crest, the lip of the pelvis, 168, 284
Ilium, 268
Impressionism, 19
Infra-spinatus muscle of shoulder, 200
Ischium, 268

Jugular vein, 142

Knee, 293

Latissimus dorsi muscle, 196, 227
Leg, 296 et seq.

Levator anguli scapulæ muscle, 131
,, anguli oris muscle of face, 79
,, labii superiores muscle of face, 79
,, labii superiores et alæ nasi muscle of face, 79
,, menti muscle of face, 80
Ligmentum Nuchæ, 134
Lips, 102
Lower limb, 268 *et seq.*

Malar bone, 74
Malleolus or ankle, 270
Mantegna, Portrait of, 17
Masseter, muscle of face, 80
Mastoid Process, 66
Maxillary bone of face, 68
Metacarpus or bones of body of hand, 217, 257, 315
Metatarsal bones of foot, 302, 315
Method of drawing, 21
Michael Angelo, Models by, 111, 299, 300
Mouth, 101
Movement of bones of trunk, 193
,, of wrist and hand, 245
Muscles of arm, 220 *et seq.*
,, face, 78
,, fore-arm, 229
,, leg, 273
,, lower limb, 273
,, lower limb, remarks upon 276
,, neck, 126, 131
,, shoulder, 200

Neck, 123 *et seq.*
Nose, 96

Obliquity of certain details of form, 324
Obliquus externus muscle, 172
Occipital spine and protuberance 66, 67
Occipito-frontalis muscle of face, 79
Olecranon process of ulna, 217
Omo-hyoid muscle of neck, 131
Orbicularis oris muscle of face, 78
Orbicularis palpebrarum muscle of face, 79
Orbit or eye-socket, 86
Os calcis bone of heel, 301
Os magnum bone of wrist, 315
Outline, 12

Palmar surface of hand, 318
Palmaris longus muscle, 232, 253

Patella or knee-cap, 270
'Peasants,' by Dürer, 7
Pectineus muscle of thigh, 274
Pectoralis major muscle of chest, 154, 158
,, minor muscle of chest, 154
Pelvis, 166, 268
Peroneus brevis, longus, and tertius muscles of leg, 275
Phalanges, bones of fingers, 258
,, ,, toes, 303
Piazzetta, Giambattista, engravings after, 321, 323
Pisiform bone of wrist, 250, 252
Planes, drawing by, 8
Platysma myoides muscle of neck, 143
Pose, 325
Poupart's ligament, 167, 170
Pronation, a kind of rotation of fore-arm, 220
Pronator radii teres muscle of fore-arm, 232
Proportions of whole figure, 27
,, face, 62
,, head, 60
,, lower limb, 313
,, neck, 135
,, trunk, 186, 213
,, upper limb, 265
Pubes, 268
Pyramidalis muscle of abdomen, 174
,, nasi muscle of face, 79

Radius bone of fore-arm, 217
Rectus abdominis muscle, 172
,, femoris muscle, 274
Rhomboideus major muscle, 201
,, minor muscle, 201
Ribs, 151

Sacro-lumbalis muscle, 195
Sacrum bone, 169
Sartorius muscle of thigh, 274, 288
Scaleni muscles of neck, 131
Scaphoid bone of foot, 270, 302
,, ,, ,, wrist, 315
Scapula or blade-bone, 123
Semi-lunar bone of wrist, 315
Semi-membranosus muscle of thigh, 274
Semi-tendinosus muscle of thigh, 274
Serratus magnus muscle, 201
Shading, 5
Shoulder, 199
Shoulder-blade, 123, 199
Soleus, lower muscle of calf, 275
Spine of scapula, 123

Spine, superior anterior, the forward termination of the iliac crest, 168, 179
,, posterior superior of ilia crest, 168
Splenius capitis muscle of neck, 131
Sterno-cleido-mastoideus muscle of neck, 126
Sternum or breast-bone, 123, 151
Supination of fore-arm, 219
Supinator radii longus muscle of fore-arm, 231
Supra-spinatus muscle of shoulder, 200
Symphysis pubis, 269

Temporal muscle of head, 79
Tendo Achillis of leg, 280
Tensor muscle of thigh, 274, 288
Teres major and minor muscles, 200, 201, 227
Thick lines, drawing in, 12
Thigh, 287 et seq.
,, bone or femur, 269
,, muscles of, 273
Thirteenth-century drawing, 12
Thoracic arch, 152
,, ,, value of, in drawing a figure bending backwards, 150
Thorax, 151
Throat, 129
Thumb, 263
,, extensors of, 231
Thyroid cartilage, 130
Tibia or shin-bone, 270
Tibialis anticus muscle of leg, 275
,, posticus muscle of leg, 276

Torso or trunk, 146
Trapezium bone of wrist, 315
Trapezius muscle, 133
Trapezoid bone of wrist, 315
Triceps cubiti muscle of arm, 221 et seq.
Triceps cruris muscle of thigh, 274
Trunk, 146
,, proportions of, 213
,, sections of, 175
,, in woman, 184

Ulna bone of fore-arm, 217
Unciform bone of wrist, 315
Upper limb, proportions of, 265

Vagina femoris, or fascia lata, 276
Vastus externus muscle, 274
,, internus muscle, 274
Vein, external jugular, 142
Veins of arm, 240-242
Venus of Milo, 44, 50
Vertebra prominens, 123
Vertebral column, 191

Waist, 148
Wrist, 245 et seq.
,, extensor muscles of, 231

Xiphoid appendage to breast-bone, 124, 151

Zygoma, 70
Zygomaticus major and minor muscles of face, 79

A CATALOG OF SELECTED
DOVER BOOKS
IN ALL FIELDS OF INTEREST

CATALOG OF DOVER BOOKS

STICKLEY CRAFTSMAN FURNITURE CATALOGS, Gustav Stickley and L. & J. G. Stickley. Beautiful, functional furniture in two authentic catalogs from 1910. 594 illustrations, including 277 photos, show settles, rockers, armchairs, reclining chairs, bookcases, desks, tables. 183pp. 6½ x 9¼. 0-486-23838-5

AMERICAN LOCOMOTIVES IN HISTORIC PHOTOGRAPHS: 1858 to 1949, Ron Ziel (ed.). A rare collection of 126 meticulously detailed official photographs, called "builder portraits," of American locomotives that majestically chronicle the rise of steam locomotive power in America. Introduction. Detailed captions. xi+ 129pp. 9 x 12. 0-486-27393-8

AMERICA'S LIGHTHOUSES: An Illustrated History, Francis Ross Holland, Jr. Delightfully written, profusely illustrated fact-filled survey of over 200 American lighthouses since 1716. History, anecdotes, technological advances, more. 240pp. 8 x 10¾.
 0-486-25576-X

TOWARDS A NEW ARCHITECTURE, Le Corbusier. Pioneering manifesto by founder of "International School." Technical and aesthetic theories, views of industry, economics, relation of form to function, "mass-production split" and much more. Profusely illustrated. 320pp. 6⅛ x 9¼. (Available in U.S. only.) 0-486-25023-7

HOW THE OTHER HALF LIVES, Jacob Riis. Famous journalistic record, exposing poverty and degradation of New York slums around 1900, by major social reformer. 100 striking and influential photographs. 233pp. 10 x 7⅝.0-486-22012-5

FRUIT KEY AND TWIG KEY TO TREES AND SHRUBS, William M. Harlow. One of the handiest and most widely used identification aids. Fruit key covers 120 deciduous and evergreen species; twig key 160 deciduous species. Easily used. Over 300 photographs. 126pp. 5⅜ x 8½. 0-486-20511-8

COMMON BIRD SONGS, Dr. Donald J. Borror. Songs of 60 most common U.S. birds: robins, sparrows, cardinals, bluejays, finches, more—arranged in order of increasing complexity. Up to 9 variations of songs of each species.
 Cassette and manual 0-486-99911-4

ORCHIDS AS HOUSE PLANTS, Rebecca Tyson Northen. Grow cattleyas and many other kinds of orchids—in a window, in a case, or under artificial light. 63 illustrations. 148pp. 5⅜ x 8½. 0-486-23261-1

MONSTER MAZES, Dave Phillips. Masterful mazes at four levels of difficulty. Avoid deadly perils and evil creatures to find magical treasures. Solutions for all 32 exciting illustrated puzzles. 48pp. 8¼ x 11. 0-486-26005-4

MOZART'S DON GIOVANNI (DOVER OPERA LIBRETTO SERIES), Wolfgang Amadeus Mozart. Introduced and translated by Ellen H. Bleiler. Standard Italian libretto, with complete English translation. Convenient and thoroughly portable—an ideal companion for reading along with a recording or the performance itself. Introduction. List of characters. Plot summary. 121pp. 5¼ x 8½. 0-486-24944-1

FRANK LLOYD WRIGHT'S DANA HOUSE, Donald Hoffmann. Pictorial essay of residential masterpiece with over 160 interior and exterior photos, plans, elevations, sketches and studies. 128pp. 9¼ x 10¾. 0-486-29120-0

PSYCHOLOGY OF MUSIC, Carl E. Seashore. Classic work discusses music as a medium from psychological viewpoint. Clear treatment of physical acoustics, auditory apparatus, sound perception, development of musical skills, nature of musical feeling, host of other topics. 88 figures. 408pp. 5⅜ x 8½. 0-486-21851-1

LIFE IN ANCIENT EGYPT, Adolf Erman. Fullest, most thorough, detailed older account with much not in more recent books, domestic life, religion, magic, medicine, commerce, much more. Many illustrations reproduce tomb paintings, carvings, hieroglyphs, etc. 597pp. 5⅜ x 8½. 0-486-22632-8

SUNDIALS, Their Theory and Construction, Albert Waugh. Far and away the best, most thorough coverage of ideas, mathematics concerned, types, construction, adjusting anywhere. Simple, nontechnical treatment allows even children to build several of these dials. Over 100 illustrations. 230pp. 5⅜ x 8½. 0-486-22947-5

THEORETICAL HYDRODYNAMICS, L. M. Milne-Thomson. Classic exposition of the mathematical theory of fluid motion, applicable to both hydrodynamics and aerodynamics. Over 600 exercises. 768pp. 6⅛ x 9¼. 0-486-68970-0

OLD-TIME VIGNETTES IN FULL COLOR, Carol Belanger Grafton (ed.). Over 390 charming, often sentimental illustrations, selected from archives of Victorian graphics—pretty women posing, children playing, food, flowers, kittens and puppies, smiling cherubs, birds and butterflies, much more. All copyright-free. 48pp. 9¼ x 12¼. 0-486-27269-9

PERSPECTIVE FOR ARTISTS, Rex Vicat Cole. Depth, perspective of sky and sea, shadows, much more, not usually covered. 391 diagrams, 81 reproductions of drawings and paintings. 279pp. 5⅜ x 8½. 0-486-22487-2

DRAWING THE LIVING FIGURE, Joseph Sheppard. Innovative approach to artistic anatomy focuses on specifics of surface anatomy, rather than muscles and bones. Over 170 drawings of live models in front, back and side views, and in widely varying poses. Accompanying diagrams. 177 illustrations. Introduction. Index. 144pp. 8⅜ x11¼. 0-486-26723-7

GOTHIC AND OLD ENGLISH ALPHABETS: 100 Complete Fonts, Dan X. Solo. Add power, elegance to posters, signs, other graphics with 100 stunning copyright- free alphabets: Blackstone, Dolbey, Germania, 97 more—including many lower-case, numerals, punctuation marks. 104pp. 8⅛ x 11. 0-486-24695-7

THE BOOK OF WOOD CARVING, Charles Marshall Sayers. Finest book for beginners discusses fundamentals and offers 34 designs. "Absolutely first rate . . . well thought out and well executed."–E. J. Tangerman. 118pp. 7¾ x 10⅝. 0-486-23654-4

ILLUSTRATED CATALOG OF CIVIL WAR MILITARY GOODS: Union Army Weapons, Insignia, Uniform Accessories, and Other Equipment, Schuyler, Hartley, and Graham. Rare, profusely illustrated 1846 catalog includes Union Army uniform and dress regulations, arms and ammunition, coats, insignia, flags, swords, rifles, etc. 226 illustrations. 160pp. 9 x 12. 0-486-24939-5

WOMEN'S FASHIONS OF THE EARLY 1900s: An Unabridged Republication of "New York Fashions, 1909," National Cloak & Suit Co. Rare catalog of mail-order fashions documents women's and children's clothing styles shortly after the turn of the century. Captions offer full descriptions, prices. Invaluable resource for fashion, costume historians. Approximately 725 illustrations. 128pp. 8⅜ x 11¼. 0-486-27276-1

CATALOG OF DOVER BOOKS

MAKING FURNITURE MASTERPIECES: 30 Projects with Measured Drawings, Franklin H. Gottshall. Step-by-step instructions, illustrations for constructing handsome, useful pieces, among them a Sheraton desk, Chippendale chair, Spanish desk, Queen Anne table and a William and Mary dressing mirror. 224pp. 8⅛ x 11¼.
0-486-29338-6

NORTH AMERICAN INDIAN DESIGNS FOR ARTISTS AND CRAFTSPEO-PLE, Eva Wilson. Over 360 authentic copyright-free designs adapted from Navajo blankets, Hopi pottery, Sioux buffalo hides, more. Geometrics, symbolic figures, plant and animal motifs, etc. 128pp. 8⅜ x 11. (Not for sale in the United Kingdom.) 0-486-25341-4

THE FOSSIL BOOK: A Record of Prehistoric Life, Patricia V. Rich et al. Profusely illustrated definitive guide covers everything from single-celled organisms and dinosaurs to birds and mammals and the interplay between climate and man. Over 1,500 illustrations. 760pp. 7½ x 10⅛.
0-486-29371-8

VICTORIAN ARCHITECTURAL DETAILS: Designs for Over 700 Stairs, Mantels, Doors, Windows, Cornices, Porches, and Other Decorative Elements, A. J. Bicknell & Company. Everything from dormer windows and piazzas to balconies and gable ornaments. Also includes elevations and floor plans for handsome, private residences and commercial structures. 80pp. 9⅜ x 12¼.
0-486-44015-X

WESTERN ISLAMIC ARCHITECTURE: A Concise Introduction, John D. Hoag. Profusely illustrated critical appraisal compares and contrasts Islamic mosques and palaces—from Spain and Egypt to other areas in the Middle East. 139 illustrations. 128pp. 6 x 9.
0-486-43760-4

CHINESE ARCHITECTURE: A Pictorial History, Liang Ssu-ch'eng. More than 240 rare photographs and drawings depict temples, pagodas, tombs, bridges, and imperial palaces comprising much of China's architectural heritage. 152 halftones, 94 diagrams. 232pp. 10¾ x 9⅞.
0-486-43999-2

THE RENAISSANCE: Studies in Art and Poetry, Walter Pater. One of the most talked-about books of the 19th century, *The Renaissance* combines scholarship and philosophy in an innovative work of cultural criticism that examines the achievements of Botticelli, Leonardo, Michelangelo, and other artists. "The holy writ of beauty."–Oscar Wilde. 160pp. 5⅜ x 8½.
0-486-44025-7

A TREATISE ON PAINTING, Leonardo da Vinci. The great Renaissance artist's practical advice on drawing and painting techniques covers anatomy, perspective, composition, light and shadow, and color. A classic of art instruction, it features 48 drawings by Nicholas Poussin and Leon Battista Alberti. 192pp. 5⅜ x 8½.
0-486-44155-5

THE MIND OF LEONARDO DA VINCI, Edward McCurdy. More than just a biography, this classic study by a distinguished historian draws upon Leonardo's extensive writings to offer numerous demonstrations of the Renaissance master's achievements, not only in sculpture and painting, but also in music, engineering, and even experimental aviation. 384pp. 5⅜ x 8½.
0-486-44142-3

WASHINGTON IRVING'S RIP VAN WINKLE, Illustrated by Arthur Rackham. Lovely prints that established artist as a leading illustrator of the time and forever etched into the popular imagination a classic of Catskill lore. 51 full-color plates. 80pp. 8⅜ x 11.
0-486-44242-X

HENSCHE ON PAINTING, John W. Robichaux. Basic painting philosophy and methodology of a great teacher, as expounded in his famous classes and workshops on Cape Cod. 7 illustrations in color on covers. 80pp. 5⅜ x 8½.
0-486-43728-0

CATALOG OF DOVER BOOKS

LIGHT AND SHADE: A Classic Approach to Three-Dimensional Drawing, Mrs. Mary P. Merrifield. Handy reference clearly demonstrates principles of light and shade by revealing effects of common daylight, sunshine, and candle or artificial light on geometrical solids. 13 plates. 64pp. 5⅜ x 8½. 0-486-44143-1

ASTROLOGY AND ASTRONOMY: A Pictorial Archive of Signs and Symbols, Ernst and Johanna Lehner. Treasure trove of stories, lore, and myth, accompanied by more than 300 rare illustrations of planets, the Milky Way, signs of the zodiac, comets, meteors, and other astronomical phenomena. 192pp. 8⅜ x 11.

0-486-43981-X

JEWELRY MAKING: Techniques for Metal, Tim McCreight. Easy-to-follow instructions and carefully executed illustrations describe tools and techniques, use of gems and enamels, wire inlay, casting, and other topics. 72 line illustrations and diagrams. 176pp. 8¼ x 10⅞. 0-486-44043-5

MAKING BIRDHOUSES: Easy and Advanced Projects, Gladstone Califf. Easy-to-follow instructions include diagrams for everything from a one-room house for bluebirds to a forty-two-room structure for purple martins. 56 plates; 4 figures. 8 0 p p .
8¾ x 6⅞. 0-486-44183-0

LITTLE BOOK OF LOG CABINS: How to Build and Furnish Them, William S. Wicks. Handy how-to manual, with instructions and illustrations for building cabins in the Adirondack style, fireplaces, stairways, furniture, beamed ceilings, and more. 102 line drawings. 96pp. 8¾ x 6⅞. 0-486-44259-4

THE SEASONS OF AMERICA PAST, Eric Sloane. From "sugaring time" and strawberry picking to Indian summer and fall harvest, a whole year's activities described in charming prose and enhanced with 79 of the author's own illustrations. 160pp. 8¼ x 11. 0-486-44220-9

THE METROPOLIS OF TOMORROW, Hugh Ferriss. Generous, prophetic vision of the metropolis of the future, as perceived in 1929. Powerful illustrations of towering structures, wide avenues, and rooftop parks—all features in many of today's modern cities. 59 illustrations. 144pp. 8¼ x 11. 0-486-43727-2

THE PATH TO ROME, Hilaire Belloc. This 1902 memoir abounds in lively vignettes from a vanished time, recounting a pilgrimage on foot across the Alps and Apennines in order to "see all Europe which the Christian Faith has saved." 77 of the author's original line drawings complement his sparkling prose. 272pp. 5⅜ x 8½. 0-486-44001-X

THE HISTORY OF RASSELAS: Prince of Abissinia, Samuel Johnson. Distinguished English writer attacks eighteenth-century optimism and man's unrealistic estimates of what life has to offer. 112pp. 5⅜ x 8½. 0-486-44094-X

A VOYAGE TO ARCTURUS, David Lindsay. A brilliant flight of pure fancy, where wild creatures crowd the fantastic landscape and demented torturers dominate victims with their bizarre mental powers. 272pp. 5⅜ x 8½. 0-486-44198-9